HANDBOOK OF VISUAL ANALYSIS

EDITED BY

THEO VAN LEEUWEN AND CAREY JEWITT

SAGE Publications
London • Thousand Oaks • New Delhi

Introduction © Carey Jewitt and Theo van Leeuwen
Chapter 2 © Philip Bell
Chapter 3 © Malcolm Collier
Chapter 4 © Martin Lister and Liz Wells
Chapter 5 © Theo van Leeuwen
Chapter 6 © Gertraud Diem-Wille
Chapter 7 © Carey Jewitt and Rumiko Oyama
Chapter 8 © Charles Goodwin
Chapter 9 © Rick Iedema

First published 2001. Reprinted 2002, 2003

SAGE Publications Ltd
6 Bonhill Street
London EC2A 4PU

SAGE Publications Inc
2455 Teller Road
Thousand Oaks, California 91320

SAGE Publications India Pvt Ltd
32, M-Block Market
Greater Kailash – I
New Delhi 110 048

British Library Cataloging in Publication data

A catalogue record for this book is
available from the British Library

ISBN 0 7619 6476 2
ISBN 0 7619 6477 0 (pbk)

Library of Congress catalog card number 0000000

Typeset by Keystroke, Jacaranda Lodge, Wolverhampton
Printed in Great Britain by The Cromwell Press Ltd., Trowbridge,
Wiltshire

Contents

Figures

Tables

Contributors

Philip Bell is the Foundation Chair in Media and Communications, University of New South Wales, Australia. He has conducted content-analysis based research for various Australian government bodies and published widely on the representation of social and political issues in the media, including: the media representation of alcohol and drug misuse, and road safety. His books include *The Media Interview* (with Theo van Leeuwen) and *Implicated: the United States of Australia* (with Roger Bell).

Malcolm Collier holds an MA in Anthropology from San Francisco State University (1977), however, his primary training in visual anthropology has been in field settings in the United States, Latin America and the Arctic. He has worked for many years in the College of Ethnic Studies at San Francisco State University and has worked extensively in the fields of visual anthropology, anthropology and education, applied anthropology, and ethnic studies. He is co-author of the publication, *Visual Anthropology: Photography as a Research Method*, and is currently the president of the Society for Visual Anthropology in the American Anthropological Association.

Gertraud Diem-Wille is Associate Professor at the Institute for Interdisciplinary Research and Education, Universities of Vienna and Klagenfurt, Austria. Her fields of research include applied psycho-analysis, organisation development, and civic education. Her recent publications are, Diem-Wille, G (1996) *Femininity and Professionalism* (1997) 'Observed families revisited – two years on: a follow up study', in Reid, S. *Infant Observation: the Tavistock model.*

Charles Goodwin is Professor of Applied Linguistics at UCLA. His books include *Conversational Organization: Interaction between Speakers and Hearers*, and *Rethinking Context: Language as an Interactive Phenomenon* (edited, with Alessandro Duranti). In recent years he has published a range of articles relevant to visual communication, including 'Professional Vision' (American Anthropologist), 'Seeing in Depth' (Social Studies of Science), 'Transparent Vision' (in Ochs, Schlegoff and Thompson, eds, Interaction and Grammar), 'Practices of Color Classification' (Mind, Culture and Activity) and 'Action and Embodiment within Situated Human Interaction' (Journal of Pragmatics). His interest and teaching include video analysis of talk-in-interaction, gesture, gaze and embodiment as interactively organized social practices, language in the professions, and the ethnography of science.

Rick Iedema currently works as a Senior Research Associate with the School of Health Services Management, Centre for Hospital Management and Information Systems Research, University of New South Wales (NSW), Australia. He has been a researcher in the area of mental health policy planning (this also provided the basis for his PhD on organisational semiotics) and has written two major research reports for the NSW Department of Education, one focusing on the print and broadcasting media and one on the discourses of administration and bureaucracy. In addition, he has published articles on a range of linguistic and semiotic topics.

Carey Jewitt is an experienced social researcher with a particular interest in visual analysis. She is a Senior Research Officer at the Institute of Education, and is currently working on an ESRC funded project, The Rhetorics of the Science Classroom: a Multimodal Approach. Her research interests include, multimodal communication, and visual social semiotics. Her recent publications include a social semiotic analysis of how discourses of masculinities are visually realised, 'Images of men' (1997) *Sociological Research Online*, Vol 2, Issue 2.

Martin Lister is Head of the School of Cultural Studies, University of West of England. He has lectured in a range of subjects, including art history, photo-media and critical studies, and computers and culture. He has undertaken research, and published widely in the area of cultural studies, including, *Youth, Culture and Photography* (with A. Dewdney), MacMillan (1988), and edited *The Photographic Image in Digital Culture* (1995) London and New York: Routledge. In addition he has curated and produced numerous photo-text touring exhibitions dealing with aspects of contemporary culture.

Rumiko Oyama taught in the literature and linguistics department of Kobe College, and the department of Intercultural Communication, University of Kobe, Japan. She is currently researching the area of cross-cultural semiotics, and is particularly interested in the ways in which cultural value systems are realised visually.

Theo van Leeuwen is Professor of Communication Theory at the London College of Printing. He worked as a film and television producer before studying linguistics and becoming an academic. He has published widely in the areas of social semiotics and critical discourse analysis and, with Gunther Kress, is the author of *Reading Images – The Grammar of Visual Design* (1996), London: Routledge. His current work is on the semiotics of speech, music and sound.

Elizabeth Wells is a senior lecturer in film, video and photographic studies and Course Leader, MA Independent film and Video, at the School of Media, The London Institute: London College of Printing. She is editor of *Photography: a Critical Introduction*, Routledge (1997), and curated Viewfindings – women photographers: 'landscape' and environment, which toured Britain in 1994/95. She has contributed numerous essays and review articles to books and magazines within the field of visual and cultural studies.

Acknowledgements

The authors and publishers wish to thank the following for permission to use copyright material.

Network Photographers Ltd., for figure 4.2 *Un Regard Oblique*, Robert Doisneau and figure 4.8 *Food Convoy*, Mike Wells

Art and Commerce Anthology Ltd. for figure 4.4 *Clifton*, 1981 Copyright © 1981 The Estate of Robert Mapplethorpe

Magnum Photos Ltd. for figure 4.7 *Daily Life in Chad*, Chris Steele-Perkins

The Advertising Archives for figure 4.10 *Carl Lewis for Pirelli Tyres*

Sian Bonnell for figure 4.11 *Chalk Down*

National Gallery Company Limited for figure 5.4 *Virgin and Child with Saints Francis and Sebastian*, Carlo Crivelli and figure 5.9 *An Allegory of Prudence*,Titian

East London and the City Health Authority for figure 7.1 *Explore The Possibilities*

Family Planning Association and Comic Company for figure 7.2 for images from *4Boys*

Every effort has been made to trace all the copyright holders, but if any have been overlooked, or if any additional information can be given, the publishers will be pleased to make the necessary amendments at the first opportunity.

1 Introduction

THEO VAN LEEUWEN AND CAREY JEWITT

INTRODUCTION

This book evolved from our different relationships to the visual and from our experiences with visual analysis. Carey had recently evaluated a young men's sexual health clinic which had included analysis of the images in sexual health leaflets and posters available for young men (Jewitt, 1997, 1999). The images reinforced stereotyped forms of masculinity which, had they been put into words, would have been unacceptable to most sexual health workers. Interestingly, these resources had been rejected by many of the young men who used the clinic; the images were key in this rejection, but most people found it difficult to articulate why they disliked them. Finding a way to 'articulate why', to understand 'what might otherwise remain at the level of vague suspicion and intuitive response', had been difficult (Iedema, this volume: 201). One of the difficulties was accessing useful information about visual analysis. Theo had often been involved in a search for this kind of information by postgraduate students and colleagues in linguistic discourse analysis and pragmatics, and had rarely been able to fully satisfy them. At our initial meeting to discuss some of the difficulties involved in visual analysis we came up with the idea for this book. We wanted above all to produce a book which would be a useful resource for researchers investigating the visual representation of significant social issues, and which provided exemplification of a range of methods and perspectives of visual analysis in sufficient detail to make it possible for readers to actually use the approaches explained in the book.

By way of introduction we will first give a brief description of the chapters and then discuss some issues that arise from reading them. One of our aims in doing the latter is to show how elements from different approaches might be combined according to the requirements of specific research projects.

DIFFERENT PERSPECTIVES AND METHODS OF VISUAL ANALYSIS

Content analysis (Chapter 2) has long been associated with investigations of the way social issues are represented in the mass media, and it has the distinct advantage of being understood and accepted by most people, including journalists. Philip Bell

shows how it can handle large quantities of data, typically in relation to confirming comparative hypotheses ('expectations'), such as that women are more often represented as engaged in domestic activities than men, or that professionals in the movies or television series of a given period are more often played by white rather than black actors. But, as Bell points out in the chapter, it can equally well be applied to formal issues (for example, whether yellow is more often used on magazine covers than green), or, indeed, to any issue that allows the formulation of clearly definable categories and comparative hypotheses. The chapter provides enough detail to allow readers to construct their own content analyses, including the necessary statistics.

Visual anthropology (Chapter 3) is concerned with the use of visual records for the description of the present and past ways of life of specific communities. In the case of past ways of life, visuals are often (very successfully) used to elicit memories from informants. In this chapter, Malcolm Collier draws on a wide range of examples, including studies of Anglo immigration in New Mexico agricultural communities, student behaviour in Cantonese bilingual classes in San Francisco, and community schools in Alaska and the Navajo Nation in Arizona. It is very much oriented towards the practice of visual research, discussing what kinds of photographic and video records are most useful for the purposes of anthropological research, and what kinds of contextual information to keep. The chapter ends with a challenging call for the development of a visual language for intellectual discourse.

Cultural Studies (Chapter 4) has recently developed a specific sub-field of visual cultural studies, which, as Martin Lister and Liz Wells describe, is premised on the unprecedented importance of imaging and visual technologies in contemporary society, and concerned with all kinds of visual information, its meanings, pleasures and consumption, including the study of all visual technologies, from oil painting to the Internet. The chapter sees Cultural Studies as an interdisciplinary field, and describes it, not as a specific methodology, but as an agenda of questions and issues for addressing specific images. These questions and issues are then matched to the conceptual frameworks and methodologies of a range of different disciplines. This approach makes the chapter particularly useful as a model for integrating the various approaches discussed in this volume as a whole. The chapter draws primarily on examples of mass media and art photographic images, from global cigarette advertising campaigns to documentary photographs of famines in Africa – the latter, as Lister and Wells point out, having played a key role in constructing a Eurocentric view of Africa and its peoples as 'economically and technologically weak, dependent victims of natural disaster' (p. 78).

The chapter on semiotics and iconography (Chapter 5) written by Theo van Leeuwen discusses the visual semiotics of Roland Barthes and the iconographical method of visual analysis developed by art historians such as Edgar Wind, Erwin Panofsky and Meyer Schapiro. Both methods are premised on the idea of layered meaning, of images consisting first of all of a layer of representational or denotative meaning (the layer of who and what are depicted here) on which is then superimposed a layer of connotative or symbolic meaning (the layer of what does it

all mean). Both methods provide specific pointers for distinguishing and analysing these layers, and specific criteria for arguing whether or not a layer of symbolic or second-order meaning is present. The main difference between the two is that iconography uses both textual and contextual criteria for arguing symbolic meaning, while Paris school semiotics restricts itself mostly to textual criteria, to pointers within the image itself. Although iconography has mainly been applied to art works from the past, the chapter attempts to demonstrate that it can also be applied to contemporary images, using Jan Nederveen Pieterse's (1992) history of the European and North American depiction of Africans and Afro-Americans as a main source of examples.

The chapter on psychoanalytical image analysis (Chapter 6), written by Gertraud Diem-Wille, a Viennese psychoanalyst specializing in the treatment of children, argues that children, within the special context of the psychoanalytic session, produce drawings that are based on the same primary processes of representation as dreams. Their meanings can therefore be brought out through psychoanalysis, just like those of dreams. Diem-Wille then goes on to apply this method to what could be called a socio-psychoanalytical study of what drives highly successful career men and women. Here the projective drawing technique is seen to lower interviewees' defences, enabling them to visually express what they are inhibited from verbally expressing. Although Diem-Wille is reluctant to generalize, the cases she discusses reveal patterns which have wider validity in understanding the influence of parental relationships on career choices, and paths, and the role of work in the formation of identity.

Social semiotic visual analysis (Chapter 7) provides a detailed and explicit method for analysing the meanings established by the syntactic relations between the people, places and things depicted in images. These meanings are described as not only representational, but also interactional (images do things to or for the viewer), concerned with the modality or perceived truth value of images, and compositional (for example, positioning images and written text in certain ways). In this chapter Carey Jewitt and Rumiko Oyama characterize social semiotics as concerned with the study of images in their social context, and as a critical form of visual discourse analysis which does not necessarily stop at description but may also seek to influence the semiotic practices it describes. The chapter shows the method at work in three different research projects: the study of sexual health materials already mentioned, an ethnographic/semiotic study of the primary school science classroom and a study of some of the cross-cultural differences in visual syntax which distinguish British and Japanese exit signs and magazine advertisements.

In the case of conversation analysis and ethnomethodology (Chapter 8), visual analysis is not so much a matter of analysing images (with or without consideration of their context) as of analysing the dynamic unfolding of specific social practices in which non-verbal communication (pointing, gaze work, and so on) and images (including signs, maps and diagrams) play a role. The chapter begins by showing how, without taking account of visual communication, conversation analysis might not only miss out on information but lead to inaccurate conclusions. Charles Goodwin discusses the role of a range of different kinds of

image in the work of scientists and other experts. Both the production of images (for example, map-making by archaeologists) and their interpretation (for example, the interpretation of the Rodney King videotape by police experts during the infamous trials) take place in situated interactions that use a variety of communication modes – speech, non-verbal communication (for example, pointing and gaze work) and images (for example, the archaeologists' map or the Rodney King video). The same images, moreover, may be used differently by different participants (for example, a schedule of plane arrivals and departures is used differently by baggage handlers and gate agents). The chapter provides specific pointers for analysing existing images (and for producing useful video recordings for research purposes), and argues powerfully for studying visual communication in its socially specific and multi-modal contexts.

The chapter on film and television analysis (Chapter 9) discusses a television documentary which depicts the conflicts between the clinical and administrative sections of a large hospital, and demonstrates how this film is systematically constructed to favour one point of view over others, and how a study of this kind of bias might be conducted. Combining elements from film theory and social semiotic genre analysis, Rick Iedema describes the different levels at which film and television texts can be studied (the frame, the shot, the scene, the sequence, the stage and the genre), and then looks at key variables and methods relevant to each of these levels. At the time of writing the chapter, the author was working as a research consultant for a large hospital, and hence the chapter is an example of applied visual analysis, of a form of critical analytical practice taking place inside an institution, with the aim to influence and change the practices of that institution.

THE IMAGE AS RECORD AND AS CONSTRUCT

Some of the chapters in this volume describe the analysis of images specially produced for research purposes (Chapters 3 and, in part, 8). Such images are produced to serve as records of reality, as documentary evidence of the people, places, things, actions and events they depict. Their analysis is a matter of extracting just that kind of information from them. The same applies to the therapeutic use of drawings described in Chapter 6. The analysis of these drawings must bring out, for instance, what the family relations in a given subject's childhood were like and how they were experienced by the subject. Art historians, too (Chapter 5), often analyse images as sources of factual information, even though, in this case, the images may not have been specially produced for this purpose. Researchers who use images in this way are of course aware of the limitations of images (including photographic and video images) as sources of factual information. Good research images, as Collier describes them (Chapter 3), should not be overly constructed, or complex, and therefore harder to read than images produced for the media or as art images; also they should not be isolated from the series of images to which they belong (for as he points out, single images and images without extensive contextual annotation are problematic for research purposes). However, despite their limitations, images are, in this context,

regarded as a reliable source of factual evidence, and Collier in fact prefers them over the 'deceptive world of words' (p. 59).

In other cases images are analysed, not as evidence of the who, where and what of reality, but as evidence of how their maker or makers have (re-)constructed reality, as evidence of bias, ideologically coloured interpretation, and so on. This is common in Cultural Studies and semiotic analyses (for example, Chapters 4, 5, 7 and 9), and in ethnomethodological research when the process of (re-)constructing reality itself is documented, such as in studies on the way scientists change the apparently unruly and messy world of photographs into the more orderly world of diagrams by 'filtering', 'uniforming', 'upgrading' and 'defining' photographs (Lynch, quoted in Chapter 8: 163). From these perspectives the image is more unreliable and slippery as a source of factual information. In this volume Lister and Wells, like Sekula whom they quote, mistrust the 'evidence' of photojournalism and documentary photography: '. . . when photographs are uncritically presented as historical documents, they are transformed into aesthetic objects. Accordingly, the pretence to historical under-standing remains although that understanding has been replaced by aesthetic experience' (Sekula in Chapter 4: 89).

The point for us is not to construct theoretical arguments in favour of reality or construction, or to arbitrate in the debates on this issue from our editorial position. Rather we think the point is to urge you to keep the distinction in mind when reading the chapters in this volume, and to consider that the choice of an appropriate method of analysis is dependent on the nature of the project in which it is to be used, on the visual material that is being investigated, and on the goals of the research project. Indeed, sometimes several methods may be necessary. One of us is currently engaged in a research project dealing with children's toys. The project investigates both the meanings offered to the child by the toy industry and the mass media (through the texts and pictures on toy packaging, in toy catalogues, in toy advertisements, and so on) and the way in which these (and other) meanings are taken up in parent–child interactions and in the child's actual playing with the toys. Clearly the former requires a mode of analysis in which the various packaging texts, catalogues and advertisements are treated as constructs, and the latter the analysis of videotapes specially produced for the research as ethnographic evidence of parent–child interaction and children's play with toys.

The issue of 'record' versus 'construct' exists because many images have an element of both and so require a mode of analysis which is sensitive to both. Clearly advertising images are in the first place constructs and their analysis must reveal the nature of these constructs. Equally clearly construction has to be minimal (or, where images are specially produced for research purposes, minimized) if images are to be used as records of people, places, things, actions or events. Again, it is no accident that studies aiming at changing practices of representation often choose a detailed and explicit method of analysing construction and its effects, so as to avoid the idea that it is all in the eye of the beholder, which in this case would be counter-productive (cf. Chapters 2, 7 and 9); alternatively they could of course document the very processes of that construction, as happens in ethnomethodological research (Chapter 8).

THE UNITS OF ANALYSIS: SINGLE IMAGES VERSUS COLLECTIONS OF IMAGES

Some of the approaches to visual analysis described in this volume are based on the analysis of collections of images, others on the analysis of single images. Chapter 2 shows that content analysis requires at least two different sets of data (for example, images from two different periods or publications) for the purpose of comparison, and that each of these sets needs to contain a sufficiently large number of similar images (for example, all advertisements containing images of women from a given period of time) in order to be both representative and statistically significant. Visual anthropology (Chapter 3) also uses collections of images, but for different purposes. Collier describes two kinds of collections: first, collections of many different images of the same subject (for example, wide views, details and a range of angles of the same street) which are put together to allow patterns to become visible; and second, collections of images made to help identify what is depicted in a given image (for example, a 60-year-old image of an elderly man engaged in wheat harvesting was compared to other photos of the same man in different settings, other photos of the area and other photos of wheat harvesting, in order to establish exactly who the man was, where he was photographed and what he was doing). As discussed in Chapter 5, art historians also use this method when they want to establish the exact who, where and what of art works of the past. As noted by Collier and Goodwin in Chapters 3 and 8, films and videos are always collections of images.

In other cases single images are discussed. But, as indicated in Chapters 2, 5 and 7, any method of visual analysis which provides a wide enough range of clearly defined specific image features and connects them convincingly enough with particular meanings and/or communicative effects can be used either for the analysis of single images or quantitatively.

TEXT, CONTEXT, SOCIAL PRACTICE

There is another way in which the various approaches described in this volume do not use the same units of analysis. Visual analysis may be based only on what is visible within the image or collection of images (in the text), as is the case, by and large, with content analysis (Chapter 2) and also with various types of semiotic analysis (Chapters 5, 7 and 9). It may draw on contextual information, whether gleaned from interviews, as in the case of visual anthropology (Chapter 3) and the therapeutic interview (Chapter 6), or from archival research and background reading, as in the case of iconography (Chapter 5). Or, as in the case of Cultural Studies (Chapter 4), it may use a range of different kinds of information. The approach of Chapter 8 is different again. Here the unit of analysis is not the text, or the text together with external, contextual information, but the enacted social practices in which images are used.

The same applies to the question of word and image. Images may be analysed without any recourse to the verbal or written information which may accompany

them (for example, the catalogue of an exhibition or the introduction to a book of artistic photographs). The images may have been designed to be self-sufficient, or capable of being inserted into many different contexts, as certainly is the case with much contemporary fine art and 'classic' photojournalism (such as Cartier-Bresson in Chapter 4). At the very least there is as much of a case here for analysing the broader, supra-contextual meaning potential of images, as for analysing their meanings in a particular context, for example a particular exhibition. But visual analysis may also include the accompanying text, or even see word and image as one indivisible unit of analysis, as in the social semiotic analysis of layout (Chapter 7). In such an approach the catalogues, text panels, and so on of an exhibition would be included in the analysis, as a secondary source of information, serving, for instance, to anchor who or what is depicted or what is symbolized. But the analysis would still not include the way this meaning potential is actually taken up in the interactions of specific social actors visiting the exhibition, as would be the case in an ethnomethodological approach. Again, the choice of method depends on the nature of the material analysed and on the goals of the analysis. There are good arguments for analysing images in relative independence of their context (for re-contextualizing them, in other words), and for analysing them together with the physical context and or social interaction in which they are embedded (as, for instance, in the analysis of reading advertisements on hoardings or in magazines in Chapter 4).

TEXT, PRODUCER, VIEWER

These different perspectives on text, context and social practices have implications for the way in which the producers and viewers of images may be included or implied in the analysis. A mode of analysis which restricts itself to the evidence of the text may not, as Bell puts it, 'by itself demonstrate how viewers understand and value what they see or hear' (Chapter 2: 26), or what producers, deliberately or otherwise, intend to communicate. On the other hand, text analysis can show what representations include and exclude, what they prioritize and make salient, and what differences they construct between different people, places and things.

The degree to which producers and viewers should be included and how this is to be achieved again depends on the kinds of images analysed, and on the aims of the research. Research aimed at discovering how a general audience understands advertising images should perhaps not include information about the production of advertisements which such an audience would not be familiar with. On the other hand, if a researcher wanted to change the audience's perceptions, for instance through media education, a 'look behind the scenes' might become relevant. Again, research aiming at critiquing, say, racism or sexism in certain representational practices clearly has an interest in linking these practices to specific social institutions, but in the analysis of art images (Chapters 4 and 5) producers may be depicted, not in terms of the formal or informal institutions within which their work is (or was) situated, but as individuals working on the basis of traditions, influences and inspirations – and here the audience will be less often taken into account. Important

and innovative research often thrives in the 'blind spots' of specific research approaches and methods, applying the methods of one approach to the kind of material studied in another – for instance, considering the individual in an area where most research has concentrated on institutions, or institutions in an area where most research has concentrated on individuals.

When social practices are taken as the units of analysis (as in Chapter 8), the difference between producers and consumers is much diminished. Both the archaeologist showing an apprentice how to construct an archaeological map and the police expert showing a jury how to interpret the Rodney King video use the resources of their expert knowledge to construct meaning. This method could also be used to show how the script of a television series is produced, or how university students learn new interpretations of a television series in Media Studies courses – all aspects of visual communication which could never be revealed, for instance, through content analysis. At the same time, this approach would not bring out what aspects of social life television series more generally include and exclude, what kind of interpretations are generally favoured in the mass media, and so on – questions which content analysis and semiotics are well placed to answer.

CONCLUSION

Clearly some methods of analysis are more methodical than others. Some lay down very precise criteria for analysis, so that the impression may arise that visual analysis can be done 'by rote', and described as a kind of recipe, a procedure to be followed step by step, without the need for any form of initiative, let alone inspiration. Content analysis, with its more or less mechanical statistical processing of data, and social semiotic analysis, with its proliferation of features and precise criteria for analysing them, tend most clearly in this direction. Anyone who has actually tried these methods knows that there is a great deal more room for initiative and, indeed, inspiration than is sometimes acknowledged in the way these methods are described. These methods remain an art of interpretation, but one that follows certain rules of accountability.

Other forms of analysis provide less precise rules for conducting the analysis. Cultural Studies and ethnomethodology, for instance, certainly depart from precise theoretical positions, research questions and principles of research, but they do not provide a large number of analytical categories and nor do they explicitly construct research work in terms of a 'step-by-step procedure'. The approach described by Collier in Chapter 3 provides an intermediary position. Collier sees visual analysis as a complex process which alternates between stages that require an intuitive grasp of the whole and stages that require the hard work of structured analysis, of careful and methodical checking and double-checking. For Collier, it is both necessary to 'observe the data as whole', to look at, listen to 'its overtones and subtleties', to 'trust your feelings and impressions' and to 'go through the evidence with specific questions – measure distance, count, compare. Produce detailed descriptions' (Chapter 3: 39). He sees visual analysis as both art and science: 'It is both necessary and legitimate to allow ourselves to respond artistically or intuitively to visual images . . . However,

while creative processes are essential to discovery, artistic processes may produce only fictitious statements if not combined with systematic and detailed analysis' (p. 59). In our opinion, this can be usefully applied to all visual analysis.

REFERENCES

Jewitt, C. (1997) 'Images of men', *Sociological Research Online*, 2 (2).

Jewitt, C. (1999) 'A social semiotic analysis of male heterosexuality in sexual health resources: the case of images', *International Journal of Social Research Methodology*, 1 (4): 263–79.

2 Content Analysis of Visual Images

PHILIP BELL

INTRODUCTION

Cleo is a magazine aimed at female readers from eighteen to thirty-five years of age. First published in Australia in 1972, it celebrated its twenty-fifth birthday by reproducing all three hundred of its front covers in its November 1997 spectacular with Kylie Minogue as its model on the cover. The first and last twenty covers from the quarter of a century of *Cleo* are reproduced as Figures 2.1 and 2.2 respectively.

What differences can be seen if one compares the two groups of covers published 23–5 years apart? How has *Cleo*'s 'image' (and the images which make up its 'image') changed? To answer this, either in conversation at the hairdresser's or as an academic thesis, requires identification of observable dimensions of the images in question (for example, are the models who are depicted older or differently dressed?), as well as a judgement about how frequently various visual features appear in the periods that one chooses to compare. In short, the answer requires a (visual) content analysis.

This chapter outlines the assumptions, practices, limitations and advantages of explicit, quantifiable analysis of visual content as a research method. It then returns to the *Cleo* covers to exemplify the process.

CONTENT ANALYSIS AND WHEN IT CAN BE USED

Generalizations about what is shown on television, in the press or in advertisements require observable, more or less 'objective' evidence. Consider the ubiquitous claims and counter-claims about, say, the depiction of women in magazine advertisements or the prevalence and effects of televisual or cinematic violence. When such issues are debated, the frequency and the meaning of identifiable classes of discrete visual content are at stake (as opposed to more complex forms like narrative structures or the complexities of different genres).

Whether it is explicitly labelled content analysis or not, making generalizations about the relative frequencies of visual representations of particular classes of people, actions, roles, situations or events involves implicit or explicit classification and quantification of media-circulated content.

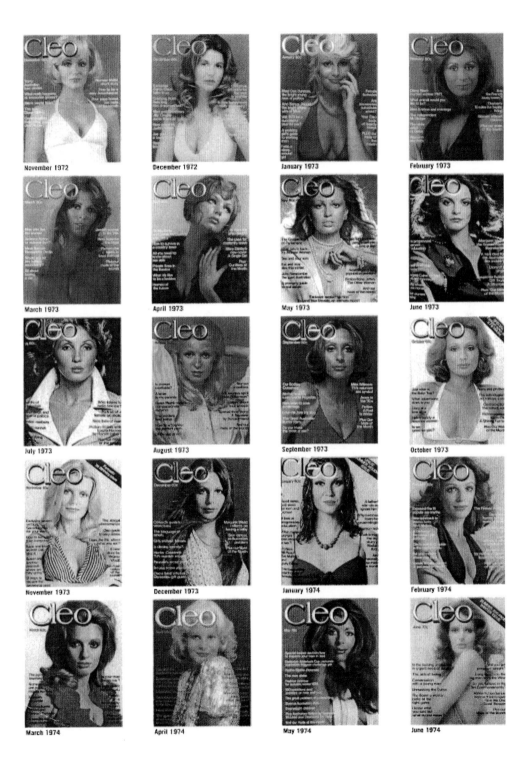

Figure 2.1 The first twenty covers of a quarter of a century of *Cleo* magazine (1972–74).

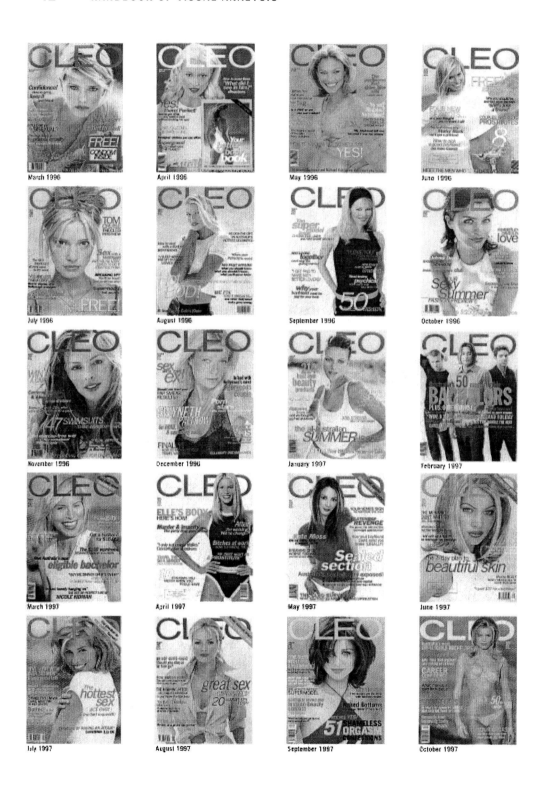

Figure 2.2 The last twenty covers of a quarter of a century of *Cleo* magazine (1996–7).

Not surprisingly, therefore, content analysis has provided one of the most widely cited kinds of evidence in Media Studies for many decades. First, in relation to newspapers and radio (for you can analyse verbal content as well as visual) and, later, directed at television and occasionally at the cinema. Perhaps the method has been widely used because it seems like the 'commonsense' way to research what the media show, or because it appears to require little theoretical analysis. In short, it is the most basic way of finding out something about the media's meaning and allows for apparently general statements to be made about aspects of representation which non-specialists, journalists and experts alike can understand. However, as will be clear in the following discussion, content analysis is quite a technical procedure. It is also of limited value in many research contexts, and might best be thought of as a necessary but not sufficient methodology for answering questions about what the media depicts or represents. Content analysis alone is seldom able to support statements about the significance, effects or interpreted meaning of a domain of representation. For example, using content analysis to show that prime-time television depicts a high level of physical inter-personal aggression does not, by itself, show that viewers are affected in any particular way (either by imitating what they see or by inhibiting their own aggressive behaviours). Claims about the effects of what is shown raise questions which need to be addressed by further, different kinds of research which are not considered in this chapter (see Chapters 4 and 9).

Let us now become more precise and technical in defining and describing the range of procedures for visual analysis that content analysis refers to. First, a general definition: content analysis is an empirical (observational) and objective procedure for quantifying recorded 'audio-visual' (including verbal) representation using reliable, explicitly defined categories ('values' on independent 'variables').

To illustrate each component of the definition, consider the example of making generalizations/representations about women and men in advertisements in 'women's' compared with 'men's' magazines. To begin to observe how women and men are depicted requires an explicit hypothesis (or hypotheses) without which the complex field is too diverse, ill-defined and therefore unable to be systematically analysed.

So content analysis begins with some precise hypothesis (expectation) or question about well-defined variables. In our example, these variables could include types of magazine, size of published advertisement, (defined) pose of represented models (say, standing, seated, walking, running) and depicted context (e.g. office, home, outdoors). One explicit hypothesis might be that women will be depicted in fewer outdoor situations than men, in both kinds of magazines. Only when one or more hypothesis is formulated will the relevant variables become apparent.

Note that the kinds of hypotheses which content analysis usually evaluates are comparative. That is, the researcher is usually interested in whether, say, women are depicted more or less frequently than men in relation to some variable or quality, not in the absolute frequency of certain depictions taken in isolation. Obviously, if 20 per cent of women in television commercials are shown in 'outdoor' settings, these data tell the researcher very little unless the comparable frequency for men (in otherwise similar contexts) is known. Content analysis is used to test explicitly comparative hypotheses by means of quantification of categories of manifest content.

Let us continue discussing our (admittedly quite simplified) examples by drawing attention to other aspects of content analysis. First, the choice of the scope, number or scale of the visual content to be studied must be explicitly described before detailed observations begin. This involves deciding what 'corpus' or what 'sample size' or what 'field' or 'domain' of representation is to be studied: how many magazines, how many advertisements, how many editions of one or more newspapers, and so on (see Chapter 3). For example, because it is comparative, a hypothesis might specify two or more periods (say, five years before World War II and five years after) during which to compare some aspects of gender representation. Because World War II brought women increasingly into the paid workforce this hypothesis would be of sociological interest. In all such cases, the question arises of how many data are enough? Can we generalize from our samples of images to the population from which it has been selected? This question ultimately requires statistical decisions and inferences, but it is clearly important to ensure that the corpus (the sample(s)) is representative of the variables specified in the relevant hypotheses. Obviously, if a researcher only samples from one women's magazine she or he could not generalize the findings to all women's magazines, nor even draw conclusions about the particular magazine beyond the period sampled. (Women's magazines have changed radically in the last several years.) We will return to this issue after outlining the technical procedures to follow when conducting a well-designed content analysis.

To summarize this introductory discussion: visual content analysis is a systematic, observational method used for testing hypotheses about the ways in which the media represent people, events, situations, and so on. It allows quantification of samples of observable content classified into distinct categories. It does not analyse individual images or individual 'visual texts' (compared with psychoanalytical analysis, discussed in Chapter 6, and semiotic methods, discussed in Chapters 4, 7 and 9). Instead, it allows description of fields of visual representation by describing the constituents of one or more defined areas of representation, periods or types of images.

Typical research questions which may be addressed using content analysis include:

1 Questions of priority/salience of media content: how visible (how frequently, how large, in what order in a programme) different kinds of images, stories, events are represented? 'Agenda Setting' studies of news broadcasts would be an example of this kind of question.
2 Questions of 'bias': comparative questions about the duration, frequency, priority or salience of representations of, say, political personalities, issues, policies, or of 'positive' versus 'negative' features of representation.
3 Historical changes in modes of representation of, for example, gender, occupational, class, or ethically codified images in particular types of publications or television genres.

WHAT TO ANALYSE: 'ITEMS' AND 'TEXTS'

What is the 'content' of content analysis? As the examples mentioned already indicate, the material analysed by means of content analysis may be visual, verbal,

graphic, oral – indeed, any kind of meaningful visual/verbal information. To analyse is to break a thing down into its constituent elements. So the visual/verbal units of meaning which are the objects of content analysis are those defined by the medium in which they are produced as isolable, self-contained or separate, like paragraphs, framed images, pages or news photographs. I will call these 'texts' whether or not they are verbal. A display advertisement is a visual text. A news item (on television) is also a text, because it has a clear frame or boundary within which the various elements of sound and image 'cohere', 'make sense' or are cohesive. Texts, then, are defined within the context of a particular research question and within the theoretical categories of the medium (gallery painting, television) and genres (such as portraits, news or 'soaps') on which the research focuses.

The texts that are to be analysed are the meaningful and cohesive units framed within the medium and genre(s) at issue. Visual content analysis usually isolates framed images (in publications) or sequences of representation (scenes or shots in television or film). But, unlike semiotic analysis, content analysis classifies all the texts on specified dimensions (what will be called 'variables' in this chapter) to describe the field or totality. It is not concerned with 'reading' or interpreting each text individually. By contrast, semiotic analysis is qualitative and usually focuses on each text or text-genre in much the way that a critic focuses on a particular gallery painting or on the aesthetics or cultural connotations of a particular film or class of films (see Chapters 4, 7 and 9; in addition, Chapter 5 demonstrates an iconographic approach to individual texts and Chapter 6 describes a psychoanalytical approach to individual texts).

HOW TO DO CONTENT ANALYSIS

Like all research methodologies, content analysis is an effective procedure only if precise hypotheses and clearly defined concepts underpin its use. Categories of (visual) content must be explicitly and unambiguously defined and employed consistently ('reliably') to yield meaningful evidence relevant to an hypothesis. To observe and quantify categories of content it is first necessary to define relevant *variables* of representation and/or salience. Then, on each variable, *values* can be distinguished to yield the categories of content which are to be observed and quantified. The concepts of variables and values are critical to an understanding of the procedure, so I will define these more completely below.

Variables

Visual or verbal representations differ from each other in many ways – on many dimensions or qualities. A content variable is any such dimension (size, colour range, position on a page or in a news bulletin); or any range of options of a similar type which could be substituted for each other – for example, a list of represented participants (male/female; adult/child) or a number of alternative 'settings' such as kitchen, bathroom, street, automobile, shop, and so on. Variables like size, represented

participants, settings, priority, duration and depicted role consist of the set of options which are of the same class or type as defined for the purposes of the research project. Notice that in content analysis a variable refers to aspects of how something is represented, not to 'reality'. So if someone is shown as elderly in a television 'soap' (by means of make-up or clothing) it is this which the researcher observes, judges and classifies, not the 'real' age of the actor. This point is sometimes referred to as judging the 'manifest content' of an image or text. It is the content as represented that is analysed, not some independently or 'externally' defined, and certainly not any aspect of 'reality' not actually depicted. So all the variables defined are those on which particular representations differ from one another.

Values

A variable consists of what we will call values. These are elements which are of the same logical kind. That is, elements can be substituted for each other because they belong to the same class: these constitute the values on a particular variable. For example, all the occupational roles in which people are, or could be depicted in television commercials would constitute a variable. But such a 'role' variable would be distinct from, say, the variable of 'depicted physical setting', from which it is conceptually independent. Of course, some roles usually occur in particular settings, but that is an empirical contingency and does not imply that the two variables are the same (Chapter 9 provides a more detailed discussion of this issue). To ensure that one does not confuse two variables, a useful test is as follows: could a defined value on one variable be substituted for another on that variable or not? If not, one has confused two distinct variables.

To summarize, then, a content analysis begins with the definition of relevant variables and of the values on each. Each variable is logically or conceptually independent of every other distinguished in a particular research project.

The values defined on each variable should also be *mutually exclusive and exhaustive* (another technical criterion which will be discussed below).

Schematically, the specification and definition of variables and the values of each can be represented as in Table 2.1. Here, four variables have been distinguished. Within each, a different number of values have been specified. In research on gender representation, to continue one of our hypothetical examples, the table might appear as in Table 2.1.

Note again the logic of such a system: each variable is independent of all others. All values on a given variable are then mutually exclusive: any observed element of representation can only be classified into one value on each variable, and values that are defined should be exhaustive – the values should cover all the possible categorizations on the respective variable. This may require a 'miscellaneous' or 'other' value to be allowed on some variables as it is not always possible for the researcher to anticipate the complete range of values (for instance, occupational roles, to continue our example) that may be found during the course of research. So 'politician' may be a value or role which is only infrequently found. It may be included in a 'miscellaneous'

value if its limited visibility is not considered important for the hypotheses being evaluated. However, the fact that a role is only infrequently depicted may be of great interest to the researcher, in which case such a value should be explicitly included in the range of values which make up the defined variable.

Table 2.1 Gender depictions in magazine advertisements: hypothetical values on four variables.

	Variables			
	Gender	Role	Setting	Size
Values	Male	House duties	Domestic	Full page
		Nurse		
	Female	Business executive	Public	Half full page
		Flight attendant		More than half page
		Teacher		Double page
	2	5*	2	4

* These values are purely indicative; in fact there are likely to be many more values on this variable.

Definitions of variables and values

The principal difficulty confronted by researchers wishing to conduct a comprehensive content analysis is to define unambiguously both the variables and values so that observers (usually called 'coders') can classify represented content consistently (reliably).

Instead of speaking of 'categories', I have distinguished variables and values. Each variable, and within it each value, should be defined in terms of one principal feature of representation. This is important even when a variable is physical and seems to be relatively unambiguous. The 'duration' (in seconds) of television advertisements is clearly an unambiguous measure, but the size of display advertisements may not be. Magazines vary in size. So the absolute size (area in square centimetres or inches) of an item such as an advertisement may not be an appropriate variable to allow comparison across magazines. If it is not, the researcher needs to define the variable (size) and its values to best demonstrate comparative salience or 'noticability'. In the example in Table 2.1 this was done by classifying the size of the published advertisement relative to a standard page of the respective publication (as two page, one page, half page, etc.).

Other 'subjective' variables (those which require coders to make subjective judgement) demand very clear definitions and criteria. Otherwise judges (coders)

may apply inconsistent criteria, or one coder may change her or his criteria through the course of coding a large number of instances.

Apart from physical features of images or other visual items (such as size, duration and monochrome/colour) the overall topic or subject of news items or the product category of advertisements will generally be of interest to researchers. In such cases, the question of the appropriate scale of analysis becomes important. Does one need to define, say, camera angles or shot lengths in relation to represented participants (such as political figures) in analysing television news? Or is a global judgement about the focus of news items all that is required? In the latter case, the variable will be named something like 'news story topic', and values will be defined to permit coders to classify items to show the 'agenda' of issues of one or more news programmes. For instance, Bell et al. (1982) compared the agendas of different networks' news coverage during an Australian Federal (National) Election by defining values such as the following on the 'news topic' variable:

(a) Celebrities & personalities: Major emphasis given to the personality(ies) per se, rather than their expertise or skills. Item focuses on the person as newsworthy owing to glamour/wealth/bravery/prestige, or as embodiment of some other desirable or undesirable characteristic(s). Excludes Vice Regal, Monarchy (see Vice Regal & Monarchy). For example:

 – Kirk Douglas arrives for Australian Film Awards.
 – Former beauty queen graduates from police academy.

(b) Crime: Major emphasis given to the manifest criminal event or its consequences: robbery, murder, swindles etc. or to technical or biographical stories of crime/criminals. For example:

 – Inquiry into penetration of the Painters and Dockers Union by organized crime.
 – Jewel thieves arrested.

(c) Disasters: Major emphasis given to climatically induced phenomena causing human suffering (flood, heatwaves), geological events of similar kind (earthquakes, avalanches). Excludes accidents (see Accidents & Chance Events). For example:

 – Newcastle district bushfire.
 – New South Wales Government aid to drought areas.

As these definitions show, coding something as complex as audio-visual news stories demands general, yet precise definitions. The kinds of data that are yielded by analysing a large corpus of material such as television news coverage during an election campaign are illustrated in Table 2.2 taken from the same research monograph.

Table 2.2 Duration of content emphasis categories in rank order, pre-election period, *per se* and as percentage of total Channel 9 broadcast time.

	Content	mins:secs	%
1	Sport	112:16	24.6
2	Federal Election	81:38	17.9
———	**10%**		
3	Accidents and chance events	35:31	7.8
4	Crime	27:42	6.1
5	Celebrities and personalities	24:24	5.3
6	Disasters	23:00	5.0
7	War	21:21	4.7
8	Arts, entertainment and leisure	13:00	2.8
9	Demonstrations and protests	11:45	2.6
10	Health and safety	10:12	2.2
11	Investment and shares	9:21	2.0
———	**2%**		
12	Economy	7:51	1.7
13=	Industrial relations and disputes	7:17	1.6
13=	Prisons	7:17	1.6
15	Defence	6:50	1.5
16	Energy	6:48	1.5
17	Elections – other	6:01	1.3
18	International relations	5:51	1.3
19	Vice regal and monarchy	5:25	1.2
———	**1%**		
20	Police	3:58	0.9
21	Legal	3:32	0.8
22	Security	3:23	0.7
23	Transport	3:02	0.7
24	Science, medicine and technology	2:54	0.6
25	Environment	2:36	0.6
26	Minerals and resources	2:28	0.5
27	Communications	1:55	0.4
28	Administration	1:50	0.4
29	Rural	1:42	0.4
30	Trade unions	1:40	0.4
31	Weather	1:37	0.4
32	Social welfare	1:30	0.3
33	Employment	0:25	0.1
34	Education	0:22	0.1
———	**0%**		
35=	Aboriginal affairs	0:00	0.00
35=	Animals	0:00	0.00
35=	Housing	0:00	0.00
35=	Migrant and ethnic affairs	0:00	0.00
35=	Religion	0:00	0.00
35=	Women's issues	0:00	0.00
	Total time	**7:36:24**	

Note that some content values are *not* represented in Channel 9's coverage. These may be very significant as absences (as issues *not* on the broadcaster's 'agenda' despite their sociopolitical importance, for instance, the low priority of Aboriginal issues).

Visual content analysis may focus on more 'micro'-level variables than does the above. Indeed, there is no limit to how precise and finely grained an analysis may be other than the ability of the researcher to define clearly, and coders to apply reliably, the specified criteria. Whether a model smiles or not, whether they look at the camera, whether they are clothed in certain ways, their skin or hair colour, can all be subjected to content analysis and then to quantification. But whether a model is 'attractive', 'young' or 'American' (as depicted) is unlikely to be clearly and unambiguously definable. This is because each of these variables is a composite of more specific variables. Like 'size' (above) each would require analysis into specific dimensions (variables) of definable values which are one-dimensional rather than 'composite' (and therefore potentially vague).

Quantitative results: comparisons and cross-tabulations

Content analysis classifies extensive fields of representation in quantitative terms. As was emphasized earlier in this chapter, the kinds of hypotheses which such quantification helps to test are those which compare one field of representation with another. The examples referred to above included comparisons between 'men's' and 'women's' magazine advertisements in terms of visual representations of gender roles. The data set out in Table 2.2 are not comparative. However, that table was originally published with relevant comparison tables showing how other television channels prioritized their respective agendas during the same period (according to the same variables and values, of course). Such tabulation of data by more than one variable (here, television station by topics) is typical of the comparative cross-tabulations which result from content analysis.

Another example illustrates this more succinctly. In Table 2.3, advertisements showing one or more female or male figures, or parts of the body (for example, an arm wearing a watch), or groups of males or females, have been analysed according to the 'visual modality' of the respective advertisement published in popular magazines. 'Modality' here refers to the 'truth value' or credibility of (linguistically realized) statements about the world (Kress and van Leeuwen, 1996) (see Chapter 7). These authors point out that visual images also 'represent people, places and things as though they are real . . . or as though they are imaginings, fantasies, caricatures, etc.' (Kress and van Leeuwen, 1996: 161). The data in Table 2.3 are based on defined values of modality according to visual features which have then been cross-tabulated by the gender of represented participants (persons).

These data support the following conclusions (among others):

1 Males are more likely than females to be shown in 'factual' style advertisements.
2 Most magazine advertisements (approximately two-thirds) adopt a standard modality.

3 When more than one model is shown, gender makes no difference to advertising modality.

4 Women are depicted in approximately 70 per cent of advertisements in the magazines in question; men in approximately 30 per cent of comparable advertisements.

Table 2.3 Modality and gender in magazine advertisements.

Person	Modality			
	Standard	**Factual**	**Fantasy**	**Total**
Male n	139	54	40	233
%	59.7	23.2	17.2	100.0
Female n	310	54	92	456
%	68.0	11.8	20.2	100.0
Body part n	27	2	11	40
%	67.5	5.0	27.5	100.0
Female group n	36	10	6	52
%	69.2	19.2	11.5	100.0
Male group n	29	9	8	46
%	63.0	19.6	17.4	100.0
Total n	541	129	157	827
%	65.4	15.6	19.0	100.0

Such conclusions are relevant to a visual content analysis based on theoretical concepts from semiotics. As has been emphasized earlier in this chapter, any theoretically specific variable and the values of which it is comprised, can be quantified provided that it is explicitly defined and can therefore be reliably coded.

RELIABILITY

'Reliability' refers to the degree of consistency shown by one or more coders in classifying content according to defined values on specific variables. Reliability can be demonstrated by assessing the correlation between judgements of the same sample of relevant items made by different coders ('inter-coder reliability') or by one coder on different occasions ('intra-coder reliability').

Measuring reliability

As content analysis claims to be objective and therefore capable of being replicated, it must be reliable or consistent if its results are to be of value. Reliability is a simple

but important concept. It can be thought of as a quantitative index of the consistency or lack of measurement error in a particular content analysis. Obviously, if a tool used for measuring any quality (say the lengths of objects) does not yield the same value each time it is applied to a given object, then it is not a reliable or consistent tool. Although content analysis is not literally a tool in the physical sense, it is a method of classification and of quantification, so its definitions must be precise enough to be used reliably.

To achieve high levels of reliability, the researcher must:

(a) Define the variables and values clearly and precisely and ensure that all coders understand these definitions in the same way.
(b) Train the coders in applying the defined criteria for each variable and value.
(c) Measure the inter-coder consistency with which two or more coders apply the criteria (definitions) using a set of examples similar to, but not part of, the research corpus.

If only one coder is to be employed a pilot (trial) study should be conducted to measure intra-coder reliability. Have the coder classify 50–100 examples on all relevant variables. A week later, repeat the procedure (without, of course, referring to the previous results). Correlate the two sets of classifications.

Several methods have been devised for quantifying reliability. The two which require the least mathematical sophistication are per cent agreement and 'pi'.

Per cent agreement

Simply calculate how frequently two coders agree in their judgements, ensuring that they are both tested on the same, large number of items (that is, on a representative range of variables and values). For the mathematical, an index can be calculated as in the example of Table 2.4, which tabulates (hypothetical) data from a pilot trial of 100 classifications with four coders.

Table 2.4 Hypothetical data from a pilot trial of 100 classifications with four coders.

% Agreement	Coders
80	1, 2
60	1, 3
90	1, 4

Calculating reliability – average the three percentages:

Reliability = (80 + 60 + 90)%/300 = 76.7% (0.767)

If these were actual results, the researcher might choose not to employ the most 'aberrant' coder in the next stages of the research project, so that the average reliability (between the other three coders) was higher (0.85). Even here, however, the level of reliability is below what is usually recommended, namely 0.9 or 90 per cent.

With four coders, such an index is rather artificial. It assumes (arbitrarily) that one coder is the norm and averages the others' respective agreements with this norm.

There are two rather technical points to bear in mind. First, a high frequency of items classified as 'miscellaneous' or 'other' will spuriously inflate the apparent level of reliability. Less than ten per cent of items should fall into this category on any variable. Second, the fewer values there are on a given variable, the more likely there is to be agreement between coders which is based on chance rather than on similar judgements according to the definitions. So binary or tripartite classifications would need to be close to 100 per cent reliable.

'Pi': a more sensitive measure of reliability

Because the index (above) ignores the fact that two coders may agree in their judgements purely by chance (and that this is, of course, a function of how many values have been specified on particular variables), a better index has become more widely used. For example, if a coder is asked to judge whether images show either a male or female, 50 per cent agreement could occur by chance (without even looking at the images). With five values on a variable, 20 per cent agreement would be expected. And so on. But such agreement is not really indicative of reliability. So Scott (1955) has proposed one of several more subtle formulae for assessing reliability by taking account of chance agreements based on the number of values distinguished in a given content analysis: 'pi'.

Pi = (per cent observed agreement) – (per cent expected agreement)/(1 per cent expected agreement)

However, this assumes that the researcher can state the expected percentages for all values on all variables in advance of the coders' judgements being made. This is because the percentage of expected agreement is the sum of all the squared percentages of all categories. So if there are six values on a variable, and if the expected and obtained percentages are as below, the pi coefficient or index would be calculated thus:

Variable: occupational role	Expected frequency	E.f. squared
Business	20% (0.20)	0.0400
Hospitality	10% (0.10)	0.0100
Sport	30% (0.30)	0.0900
Academic	20% (0.20)	0.0400
Leisure (non-sport)	15% (0.15)	0.0225
Other	5% (0.05)	0.0025

Expected frequency = sum of the squares of the e.f. values = 0.2050.

If two coders classifying a sample of 100 images depicting occupational roles in advertisements, for instance, agreed on 95 per cent of cases, then the reliability index would be: (0.950–0.205)/(1.00–0.205) = 0.94 (the 'pi' value).

However, if the obtained agreement between the coders in the pilot or trial were found to be low, or if there were fewer or less evenly distributed 'expected frequencies', the value of the index would be reduced. As a rule of thumb, a 'pi' value of at least 0.80 should be obtained. If this is not achieved in a pilot trial, the researcher should re-train coders and/or redefine values and re-test the degree of reliability.

LIMITATIONS AND EXTENSIONS

The main limitations of quantitative content analysis concern the relatively un-theorized concepts of messages, texts or 'manifest content' that it claims to analyse objectively and then to quantify (see Chapter 4).

The categories of visual 'content' which are most frequently quantified in media research arise from commonsense social categories, such as 'roles' depicted, 'settings' shown, gender and age of represented participants in images. Such variables are not defined within any particular theoretical context which analyses visual semiotic dimensions of texts. That is, the framing, visual 'angles', scale of photographic 'shot', and so on, that are part of the discourse of visual analysis are seldom incorporated into (visual) content analysis (Chapter 7 discusses these in terms of 'semiotic resources'). Nor are categories from, say, Marxist or neo-Marxist theory (to take another contentious theoretical paradigm) seen as appropriate to quantifi-cation. Indeed, T.-W. Adorno (the famous cultural critic) has quipped that 'culture' is, by definition, not quantifiable. Other critics of content analysis point out that the inferences that are made from quantification to qualitative interpretation (especially those involving notions of 'bias') are fraught with difficulties. The cultural complexity of visually coded texts means that either only the most simplistic, socially conventional cate-gories can be studied, or content analysis imports tendentious or highly inter-preted abstractions into its ostensibly 'objective' definitions of variables and/or values. Winston (1990) argues that research purporting to demonstrate televisual bias against businessmen fails because, in part, it fails to understand the (semiotic) codes of television – the way television means to its audience. The result is that coding categories used in research into this question were frequently moralistic and decon-textualized. For instance, whether a programme depicting a businessman is a comedy or a drama would be relevant to how an audience 'reads' that character's behaviour as 'negative' or 'positive'. However, *Crooks, Conmen and Clowns*, the study criticized by Winston, ignored the ways in which different genres are understood by their respective audiences. (The genres and semiotic codes of tele-films are discussed in Chapter 9.)

In a widely influential paper, Stuart Hall (1980) makes a similar point: 'violent incidents' in cinematic genres like the Western are meaningful only to audiences who know the genres' respective codes – the goodie/baddie opposition, the conventions relating to resolving conflict, and so on. In short, content analysis cannot be used as though it reflects unproblematically or a-theoretically the social or ideological world outside the particular context of the medium studied. Second, content analysis cannot

be easily compared with some assumed 'reality' by which to make claims of 'bias' or 'negative', let alone 'true' or 'false', representation. Winston (1990) discusses these 'inference' problems in convincing detail. Third, generalizing from content analysis results can be difficult, and claims made for the consequences of the quantitative picture of media content may go beyond what is validly licensed by the data. For example, it is sometimes assumed that users (viewers, audiences) understand or are affected by texts, genres or by media content generally in ways that reflect the kinds of analytical categories used in content analysis itself. An example is that of 'bias' in television reporting of political issues. It is often assumed that more coverage of one political party than its competitors means that viewers will be more likely to favour it. But this is, obviously, an unwarranted inference. At the very least, such an inference would require additional research in order to be validated.

Visual representations raise further theoretical problems of analysis. Many highly coded, conventional genres of imagery (the footballer saving a goal, the 'cover girl' from *Cleo*, the politician engulfed by microphones, the academic expert in front of rows of books) have become media clichés. To quantify such examples is to imply that the greater their frequency, the greater their significance. Yet, the easy legibility of clichés makes them no more than short-hand, stereotypical elements for most viewers who may not understand them in the way that the codes devised by a researcher imply (see 'Looking: form and meaning' in Chapter 4 on page 70).

VALIDITY: GOING BEYOND THE DATA

To conduct a content analysis is to try to describe salient aspects of how a group of texts (in our case, images or visual texts) represents some kinds of people, processes, events, and/or interrelationships between or amongst these. However, the explicit definition and quantification that content analysis involves are no guarantee, in themselves, that one can make valid inferences from the data yielded by such an empirical procedure. This is because each content analysis implicitly (or, sometimes, explicitly) breaks up the field of representation that it analyses into theoretically defined variables. In this way, it is like any other kind of visual or textual analysis. Semiotics posits as semantically significant variables such as 'modality' or 'represented participants', or conceptual versus narrative image elements (see Chapters 4 and 7). All systematic methods of visual analysis (even psychoanalytic or iconographic – see Chapters 5 and 6) postulate some features of images (and not others) as semantically significant, within the images' usual contexts of exhibition and reception. Content analysis does this also. What is at stake in conducting this, or any form of visual analysis, is the degree to which the resulting statements about the field analysed can be said to describe features that are, in fact, semantically significant for viewers/spectators/'readers' of the images. In other words, does the analysis yield statements that are meaningful to those who habitually 'read' or 'use' the images?

This brings us back to the point at which this chapter began. Whenever we generalize about differences between sets of images, we must implicitly define as

well as observe and quantify the visual material in question. We might, for example, claim that the front pages of broadsheet newspapers show more, although smaller, images, of more active participants, than do tabloid papers published concurrently. Such a claim is a hypothesis which content analysis could test. To accept the claim as true is to accept that something like a systematic content analysis could be conducted and that it would demonstrate the differences claimed.

The criticism that is most frequently levelled against content analysis is that the variables/values defined (the 'categories') are somehow only spuriously objective. It is claimed that they are as subjective as any semantic variables despite being 'measured' or at least counted. However, such a criticism can be turned around, to point to the fact that not only content analysis but all visual or verbal semiotics, formal and informal, are only as valid as the explicitness and reliability of their respective theoretical concepts.

To make inferences from the findings of a content analysis or any kind of theoretical analysis of a group of images means that one goes 'beyond the data' making a prediction about the salience, the social or ideological importance, the visual significance of one's findings. So it is best to think of these findings as 'conditional' – as bound by their theoretical and methodological contexts, but as 'true' until and unless they are contradicted by further evidence.

New theories will propose that different variables of images are semantically significant and posit new definitions by which new generalizations can be tested. The principal virtue of content analysis is that it is explicit, systematic and open to such theoretically motivated, but empirically grounded critique. Thoughtful, provisional content analysis need be no more 'positivistic' or 'pseudo-scientific' than competing methodologies, but it is important to propose the findings of such analyses as conditional to their context. Some questions are not usefully analysed by such methods, and many claims have been made for content analysis which are impossible to justify. But, as one approach among others to describing how and what images mean, content analysis can be a useful methodology. The question of how one can generalize or 'go beyond the data analysed' (as I have put it) is the problem of 'validity', to which I now turn.

Content analysis, by itself, does not demonstrate how viewers understand or value what they see or hear. Still, content analysis shows what is given priority or salience and what is not. It can show which images are connected with which, who is given publicity and how, as well as which agendas are 'run' by particular media. Or, to put these claims more cautiously, content analysis can demonstrate such patterns of media representation provided that one accepts the validity of the categories (values and variables) defined in the research.

'Validity' refers to the (apparently circular or tautological) concept of how well a system of analysis actually measures what it purports to measure. Valid inferences from a particular content analysis, given this definition, will reflect the degree of reliability in the coding procedures, the precision and clarity of definitions adopted and (a less obvious factor) the adequacy of the theoretical concepts on which the coding criteria are based. Validity refers to the confidence one can have in the results showing that the stated theoretical concepts offer a discriminating description

of the field being analysed. 'Images of violence' (to return to a controversial example) will be defined in different ways by different theoretical and pragmatic interests. For instance, a media student might see the televising of accidental causes of physical injury or death as a depiction of 'violent' episodes. However, an alternative theory of televised violence might exclude accidents, arguing that 'violence' should only refer to what, in their dramatic contexts, are visibly intentional actions which are shown to cause physical and/or psychological harm. The relative validity of a particular content analysis, given theoretical differences in the terms in which an hypothesis can be formulated, refers to the degree to which inferences are justified from the findings to the theoretical statements. Whereas reliability refers to 'internal' consistency in one's method, validity refers to the external or inferential value of one's research, given its theoretical context. This cannot be quantitatively assessed, but it is important to ask of one's own (and, indeed, of others') research whether it actually demonstrates what it purports to demonstrate, whether the variables and values do allow one to 'measure' the concepts incorporated in the hypotheses and their respective theories.

As we have seen, content analysis provides a quantified dimensional description of fields of representation. The methodology can be used to provide a background 'map' of a domain of visual representation. Having conducted a content analysis, the researcher can then interpret the images or the imagery in qualitative ways (using semiotic or some other more individual, text-oriented theory such as those described in the other chapters of this volume). Typical or salient examples can be further analysed to fill out the qualitative description of 'what the data mean'. So, having shown how frequently and in what contexts, say, images of passive females occur, a researcher might discuss the psychoanalytic or ideological significance of the images in terms of metaphors, photographic style, historical or social context (see Chapters 4 and 7).

AN EXAMPLE: TESTING SEMIOTIC HYPOTHESES

Images carry connotations and invite individual reminiscence. They may convey a sense of duration or of nostalgia through codes of colour, framing and through their public context. An image can engage the viewer in a fetishistic and compulsive urge to look and look again, encouraging the sense that the viewer 'owns' the image or that it is part of his or her 'identity' (see 'Looking: recognition and identity', in Chapter 4, page 83). None of these experiential possibilities can be defined and quantified very reliably. Yet dimensions of 'interactive' meaning (involving how the viewer is invited to relate to an image) and of 'textual' meaning (including how images are formally composed or balanced) can be defined and their frequency counted.

In Chapter 7 of this book, the systemic functional (semiotic) approach to image analysis is presented. By definition, it is the 'manifest content' of images that content analysis dissects and counts, so any unambiguously definable aspect of a group of images can be quantified. Insofar as semiotics also involves an empirical (observational) methodology, it is possible to use the analytical concepts derived from

this type of theory as the basis for quantification and, hence, for comparative generalization. So to conclude this chapter, I will illustrate how it is possible to quantify some important dimensions of what Kress and van Leeuwen (1996) call the *inter-personal* semiosis of images focusing on depictions of women on women's magazine covers. I will use their semiotic model to define three variables, each with several values. These are meant only to illustrate the way in which a content analysis of explicitly semiotic variables could be conducted.

The specified variables and values will be used to code the two sets of twenty cover-page images from *Cleo* magazine reproduced as Figures 2.1 and 2.2. These will be the basis of a partial or small-scale content analysis to illustrate that:

1　Comparative hypotheses can be formulated and tested using reliable categories relating to the semiotics of visual images.
2　Content analysis can be conducted by giving precise definition to theoretical concepts (in this case from semiotics).
3　Objective criteria need to be specified for categorizing visual material. The criteria must be defined unambiguously.

This small-scale analysis of media content will be set out in a conventional 'social science' format, as one might find in psychology or sociology, for example: Hypotheses will be formulated; a Procedure (or Method) will be described; Results and discussion sections of a typical empirical report will be presented. Under these headings, other conventional sub-sections will be named (such as variables, values, reliability). So this 'worked' example of a theoretically motivated empirical analysis will serve as a summarizing overview of the method of visual analysis (content analysis) that has been the subject of this chapter.

Figures 2.1 and 2.2 show respectively twenty front covers of Australian *Cleo* magazine from 1972–4 and twenty from 1996–7. These will be compared by means of a content analysis.

Hypotheses

Following Kress and van Leeuwen (1996) it is hypothesized that the inter-personal meaning of *Cleo* front pages has changed between 1972 and 1997 in the following ways:

1　The later images present models as more socially distant than in 1972–4 covers.
2　The modality of the images in 1996–7 is lower than in the earlier period.
3　The models' gaze at or gaze away from the camera is *not* different between the two sets of images, but the pose of the models (their head, body dispositions) are less 'powerful' in the more recent examples.
4　The 1996–7 models are more frequently blonde, less frequently brunette, than in the earlier period.
5　The later covers depict models who look younger than do those from the earlier period.
6　Models occlude the magazine logo more frequently in the later period.

Method: definitions and criteria

Let us begin by defining each variable and the respective values on each before using these as criteria to code our small samples of images. For the sake of exposition, I will simplify relevant theoretical semiological concepts (which are the basis for the definition of variables and values in the terminology of this chapter).

Variable 1: social distance

Kress and van Leeuwen relate the represented social distance of participants in an image (in our examples, the depicted models) to Hall's (1966) discussion of 'proxemics' (the psychology of people's use of space):

> In everyday interaction, social relations determine the distance (literally and figuratively) we keep from one another. Edward Hall (e.g. 1966: 110–20) has shown that we carry with us a set of invisible boundaries beyond which we allow only certain kinds of people to come. The location of these invisible boundaries is determined by configurations of sensory potentialities – by whether or not a certain distance allows us to smell or touch the other person, for instance, and by how much of the other person we can see with our peripheral (60 degree) vision. . . .
>
> With these differences correspond different fields of vision. At *intimate distance*, says Hall (1964), we see the face or head only. At *close personal distance* we take in the head and the shoulders. At *far personal distance* we see the other person from the waist up. At *close social distance* we see the whole figure. At *far social distance* we see the whole figure. At far social distance we see the whole figure 'with space around it'. And at *public distance* we can see the torso of at least four or five people. It is clear that these fields of vision correspond closely to the traditional definitions of size of frame in film and television, in other words, that the visual system of size of frame derives from the 'proxemics', as Hall calls it, of everyday face-to-face interaction. (Kress and van Leeuwen, 1996: 129–31, italics added)

On this basis a variable of visual representation, social distance, can be divided into six values:

(a) Intimate.
(b) Close personal.
(c) Far personal.
(d) Close social.
(e) Far social.
(f) Public.

These are defined in terms of how much of the (human) participant's body is represented in the frame of the respective image, as in Kress and van Leeuwen above (see Chapter 9 for a discussion of social distance in relation to the analysis of tele-films).

Variable 2: visual modality

Again, following Kress and van Leeuwen, visual modality results from

The degree to which certain means of pictorial expression (colour, representational detail, depth, tonal shades, etc.) are used. Each of these dimensions can be seen as a scale, running from the absence of any rendition of detail to maximal representation of detail, or from the absence of any rendition of depth to maximally deep perspective. And on each of these scales there is a point that represents the way the given pictorial dimension is used in what could be called standard naturalism. To the degree that the use of a dimension is reduced, it becomes, at least in one respect, more abstract, 'less than real'. To the degree that is amplified, it becomes 'more than real', and we associated this with a 'sensory coding orientation', an emphasis on sensory pleasure (or displeasure, as in the case of 'more than real' horror images), and an attempt to come as close as possible to a representation that involves all the senses. (Kress and van Leeuwen, 1996: 256)

However, the authors argue that modality is context dependent. That is, modality is coded according to particular 'orientations' appropriate to different conventional domains of representation. The domains they distinguish include scientific/technological, abstract, naturalistic and sensory. A 'sensory' coding orientation is appropriate to images which provide sensuous and sensory pleasure to the viewer. Highly saturated colour conveys high modality in paintings such as nude or 'still life' genres and in most modern display advertising (see Chapter 7).

So a variable, modality, can be defined as the represented 'realism' of an image, given the sensory coding orientation, based on degrees of colour saturation. Three values could be distinguished on this variable: 'high', 'medium' and 'low'. These are relative terms and criteria may be difficult to specify. But, as has been pointed out in the introduction to this chapter, all values must be defined clearly if reliable classifications are to be made, so, in principle, the case of modality poses no unique methodological difficulties. We might, then, set the criteria for the three values thus:

(a) High sensory modality: image uses highly saturated colours naturalistically.
(b) Medium sensory modality: image uses, for example, less saturated, 'washed out' or 'ethereal' use of pastels.
(c) Low sensory modality: image is monochrome (black–white) only.

Variable 3: behaviour

Kress and van Leeuwen also discuss the way interaction between the viewer and the people shown in images is affected by the gaze of the represented participants. Simplifying this to allow our illustrative example to be outlined, the principal differences between what they call 'image acts' relate to the ways in which images make 'offers' or 'demands', as it were, to their respective viewers (see Chapters 7 and 9):

There is . . . a fundamental difference between pictures from which represented participants look directly at the viewer's eyes, and pictures in which this is not the case. When represented participants look at the viewer, vectors, formed by participants' eyelines, connect the participants with the viewer. Contact is established, even if it is only on an imaginary level. In addition there may be a further vector, formed by a gesture in the same direction. . . .

This visual configuration has two related functions. In the first place it creates a visual form of direct address. It acknowledges the viewers explicitly, addressing them with a visual 'you'. In the second place it constitutes an 'image act'. The producer uses the image to *do* something to the viewer. It is for this reason that we have called this kind of image a 'demand': the participant's gaze (and the gesture, of present) demands something from the viewer, demands that the viewer enter into some kind of imaginary relation with him or her. Exactly what kind of relation is then signified by other means, for instance by the facial expression of the represented participants. They may smile, in which case the viewer is asked to enter into a relation of social affinity with them; they may stare at the viewer with cold disdain, in which case the viewer is asked to relate to them, perhaps, as an inferior relates to a superior; they may seductively pout at the viewer, in which case the viewer is asked to desire them. . . . In each case the image wants something from the viewers – wants them to do something (come closer, stay at a distance) or to form a pseudo-social bond of a particular kind with the represented participant. And in doing this, images define to some extent who the viewer is (for example, male, inferior to the represented participant, etc.), and in that way exclude other viewers. (Kress and van Leeuwen, 1996: 122–3)

From a different theoretical perspective, Goffman (1979) has analysed the ways in which gendered bodies are represented in advertisements, distinguishing several 'rituals of subordination' or 'infantile' bodily poses. These include 'head canting' (tilting the head down or sideways while looking up), 'bashful knee-bending' (where one knee is bent) and self-touching (as opposed to holding or performing work with one's hand(s)). He analyses these represented behaviours in terms of power: that is, that these three actions (or behaviours) signify powerlessness, and place the viewer in a position of superiority to the represented participant (model). (Chapter 8 analyses behaviour within an ethnomethodological approach.)

Combining the image act analysis of Kress and van Leeuwen's semiotics and Goffman's observations, we could distinguish the following values on the variable called behaviour.

(a) Offer/ideal: the model depicted offers herself/himself as an idealized exemplar of a class or attribute, looking away from the viewer (for example, the statuesque pose of a female model displaying clothes).
(b) Demand/affiliation (equality): model looks at the viewer, directly, smiling.
(c) Demand/submission: model looks down at viewer, not smiling.
(d) Demand/seduction: model looks up at the viewer, head canted, smiling or 'pouting'.
(e) None of the above.

So in our hypothetical study, three variables can be defined, with several values on each, as shown in Table 2.5.

Hypotheses relating to each variable have been formulated, in Table 2.5.

Procedure

To carry out the actual analysis, two coders would have been trained to classify images according to the specified definitions. Their reliability would be calculated

and, if below 0.90, further training would be given until this level of reliability was attained.

Coders would be presented with the two sets of images which they classified according to the definitions. Each image needs to be presented separately and individually. The order of presentation would therefore be randomized. So that the coders brought no potentially biasing expectations to the tasks, they should not know the hypothesis being tested. Presenting the images grouped chronologically as they are in the magazine being analysed would be likely to lead coders to make similar judgements about each set. (Psychologists call these potentially biasing conditions of experimental procedures 'demand characteristics'. They may lead to coders or subjects in a psychological experiment, or even the researchers themselves, unconsciously increasing the likelihood of a hypothesis being confirmed.)

Table 2.5 In our hypothetical study three variables can be defined, with several values on each.

Variable		Value	
1	**Social distance**	1.1	intimate
		1.2	close personal
		1.3	far personal
		1.4	close social
		1.5	far social
		1.6	public
2	**Modality**	2.1	high
		2.2	medium
		2.3	low
3	**Behaviour**	3.1	offer – ideal
		3.2	demand – affiliation
		3.3	demand – submission
		3.4	demand – seduction
		3.5	other

Results and analysis

A numerical set of results would be produced, as in Table 2.6 (these are, of course, hypothetical).

Statistical analysis (such as appropriate 'Chi-square' tests) would be applied to show whether the distributions of values for each variable are significantly different between the two periods being compared.

Discussion

Accepting the data as presented in the table, some of the hypotheses can be confirmed without explicit definition of criteria. For example, the hypothesis that the 1996–7

Table 2.6 Classification of distance, modality and behaviour of female models on the front covers of *Cleo*, 1972–4 and 1996–7.

		1972–4 %	1996–7 %
1 Social distance	1.1	0	0
	1.2	30	5
	1.3	40	10
	1.4	25	75
	1.5	5	10
	1.6	0	0
2 Modality	2.1	85	0
	2.2	15	25
	2.3	0	75
3 Behaviour	3.1	0	0
	3.2	40	40
	3.3	30	60
	3.4	30	20
	3.5	0	0

models are more frequently blonde, and less frequently brunette, than in the earlier period: in 1996–7, only four of nineteen models are not blonde, whereas in 1972–4, ten out of twenty could be judged 'not blonde'. (It could be argued that there are more redheads in the 1972–4 period as well.) The hypothesis that the later covers depict models who look younger than do those from the earlier period required judgements which would need to be confirmed by more than one coder or judge acting independently, perhaps using a series of 'judged age-ranges' as the basis of classification (18 years and under, 19–25 years, 26–30 years, 30 years and over, for example). You will notice that these judgements can be very difficult and that it is unlikely that highly consistent judgements would be made unless the values on this variable reflected quite broad age ranges. Perhaps only two categories could be judged: 'less than' and 'more than' 25 years.

The hypothesis that models occlude the magazine logo more frequently in the later period would be clearly confirmed by observation, being an objective feature of the images: *Cleo* has changed its graphic conventions during the period under review. Trivial although this observation may appear, it is a feature of the visual meaning of the covers that could be significant in showing how the magazine presents its 'identity', and so could be analysed as part of the quantitative content analysis.

In terms of the more semiotic hypotheses, the hypothetical data show that women on the covers of *Cleo* magazine are represented differently in 1996–7 compared with 1972–4. Specifically, the later images in the publication are more distant, less close-up, than those of 25 years earlier. Second, modality (in terms of colour saturation) is lower in the more recent magazines' covers. Third, the models depicted in the 1990s are more likely to be shown in less powerful poses, even though they address (gaze at) the viewer equally frequently. The implications of these findings could be discussed in terms of changing roles of women, the comparative youth of

recently famous fashion models, the demography of *Cleo*'s market (now aimed at younger buyers), or possibly the increased 'sexualization' of youth culture (and/or of consumerism more generally).

CONCLUSION

Content analysis allows researchers to make quantitative generalizations about visual and other forms of representation, on the basis of reliable classification and observation. In the example presented above, schematic and simplified for the purposes of illustration, empirical results (data) could be used to support or to refute particular sociological or cultural arguments. I hope to have demonstrated how to conduct and how to report such a content analysis, and how it could be used to evaluate subtle theorization of important aspects of semiosis. Ideally, however, research adopting this methodology should supplement and extend its findings by means of detailed analysis of typical examples. Especially in the analysis of visual texts, content analysis should be seen as only part of the methodological armoury that a researcher can employ. As in all research, the significance of the information yielded by this method is only as valuable as the theoretical precision of its hypotheses and hence of its defined variables and values.

REFERENCES

Bell, P., Boehringer, K. and Crofts, S. (1982) *Programmed Politics: A Study of Australian Television.* Sydney: Sable Publishing.

Goffman, E. (1979) *Gender Advertisements.* London: Macmillan.

Hall, E. (1966) *The Hidden Dimention.* New York: Doubleday.

Hall, S. (1980) 'Encoding/decoding', in S. Hall et al. (eds), *Culture, Media, Language.* London: Hutchinson.

Kress, G. and van Leeuwen, T. (1996) *Reading Images: The Grammar of Visual Design.* London: Routledge.

Scott, W. (1955) 'Reliability of content analysis: the case of nominal scale coding', *Public Opinion Quarterly,* 17: 321–5.

Winston, B. (1990) 'On counting the wrong things', in M. Alvarado and J.O. Thompson (eds), *The Media Reader.* London: British Film Institute.

3 Approaches to Analysis in Visual Anthropology

MALCOLM COLLIER

INTRODUCTION

Analysis of visual records of human experience is a search for pattern and meaning, complicated and enriched by our inescapable role as participants in that experience. This chapter provides thoughts on processes of analysis that may build on both the tangible character of visual records and on our varied 'lenses' of personal and cultural identity and experience (see Chapter 4).

This discussion assumes that photographs and other optical records of human experience may be both creations and concrete reflections of what is visible within the scope of the lens and frame. Much has been said regarding the 'constructed' character of photographs, video and film, heightening our awareness of the influences of individual, cultural, political and other variables on the making, viewing and analysis of visual records. While this discourse has enriched our understanding of images it can also create an illusion that they contain nothing beyond their constructed content. Leaving aside planned fabrications, it may be said that photographs, video and film are, ultimately, complex reflections of a relationship between maker and subject in which both play roles in shaping their character and content (see Chapter 8). When we use the camera to make a visual record we make choices influenced by our identities and intentions, choices that are also affected by our relationship with the subject. People are rarely simply the passive subjects commonly assumed in much scholarly discussion; they, too, participate directly, not infrequently manipulating it for their own ends.

Moreover, any visual image that is the product of pointing a camera at the world also contains all the optically visible aspects of that world within the confines of the frame and the capabilities of the lens (see Chapter 4). This visual field usually contains a complex range of phenomena, much of which is outside our awareness as camera person or subject. Consequently, the content of the visual image is rarely shaped only by the constructive influences of recorders and subjects, a fact reflected in the frequent discovery of previously unseen phenomena and relationships in the process of visual analysis. Much of the promise and value of visual images in research is based on this aspect of their character.

All of the elements of an image may be important sources of knowledge through analysis, if only we can identify them and sort them out. The challenge is to responsibly address the many aspects of images, recognizing that the search for

meaning and significance does not end in singular 'facts' or 'truths' but rather produces one or more viewpoints on human circumstances, and that while 'reality' may be elusive, 'error' is readily achieved.

TYPES OF ANALYSIS AND THE IMPORTANCE OF CONTEXTUAL INFORMATION

A considerable range of visual analytic processes are productive (as the chapters in this volume demonstrate). In broad terms a distinction may be made between those which directly examine the content of images as data (see Chapter 2) and others which use images more indirectly as vehicles or triggers for information not necessarily present in the images themselves (see Chapter 6). While the boundary is not absolute, the distinction has value because, while virtually all visual images and records have potential use in indirect analysis, many are not responsibly subjected to direct approaches.

We are frequently faced with visual records that lack strong contextual information, that are divorced from any systematic annotation, or are isolated records. Such images may be analysed directly only if care is taken to properly annotate and establish contextual relationships and to work within the limitations of the images. Establishing such contextual background often involves making use of indirect forms of analysis as well as considerable archival and other research. In the analysis of single images caution should be exercised; indeed direct analysis of single images apart from larger collections is often best avoided, although such images may often be very useful in indirect analysis.

The process of establishing a context for analysis may be illustrated by a photograph from one of my current research projects shown in Figure 3.1. This powerful image of a elderly man apparently engaged in wheat harvest is part of an unannotated and fragmented documentary (not research) photographic collection made in our home village in New Mexico, USA, by my father, John Collier, Jr., early in his photographic career. Despite the power of this image, its analytic potential was limited by the lack of substantial internal contextual information and absence of annotation. My challenge was to develop the contextual information and other annotation almost sixty years later so that the full research value of this and other photographs in the collection might be realized.

I started with the photographs themselves, hoping that they might collectively provide some context for each other. I looked at other photos of the same man; these show him in other activities and with other people associated with a particular extended family, some of whom I recognized from my own childhood in the community. I looked for other images of the wheat harvest, and determined that hand-cutting of wheat was not restricted to this field or this man. Drawing on memory and other photographs, I examined the background in the photograph and was able to identify the precise field where it was made. I could not identify the man, who (as I later found out) died before my birth.

I then moved to the study of correspondence, which provided a likely date for the photographs, and to photo elicitation sessions with neighbours and relatives. These

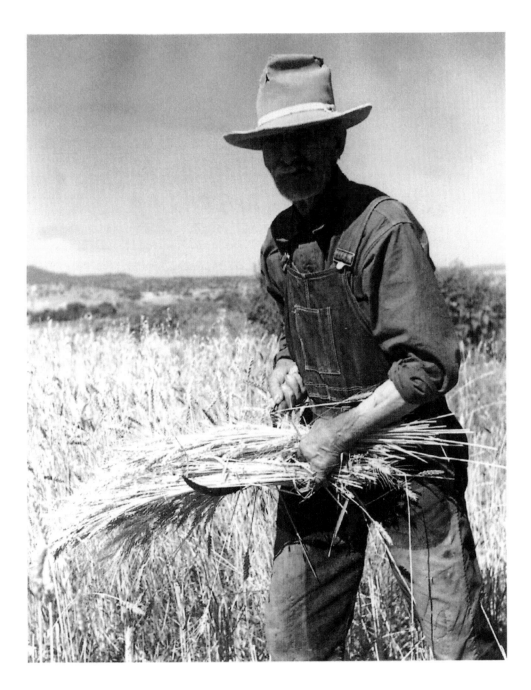

Figure 3.1 Antonio Romo in his wheat field, Rio Chiquito/Talpa, New Mexico (USA). Photograph by John Collier, Jr., 1939.

A 'good' photograph, its strength as a single image – simplicity of content, close-up view, semi-posed classic harvest stance – all work against its value as data without additional contextualization. Worn, patched overalls, ancient hat, rugged and worn hands, all these reflect a life of hard work and poverty, as does the fact of hand-cutting the wheat in an era when the better-off farmers cut with machines. Use of photo elicitation provoked a wide range of responses and information, both specific and general.

provided a name for the man and most of the other people seen in the larger collection, as well as much additional information and interesting stories. With this added information, I can now responsibly engage in direct analysis of this photograph and the rest of the collection.

This example illustrates several important points. First, a 'good' photograph is not necessarily good data if it lacks the necessary contextual information and annotation to make it analytically intelligible. Second, it may be possible to reconstruct such context and annotation both through comparative study of related images and through other forms of research. Finally, it provides a moral for responsible photographic recording in anthropology, best stated by an elderly member of the community, Mr Eloy Maestas, during the course of a session in which I was asking him to help identify people and places. Frustrated, he placed the images on his kitchen table and (in Spanish) said, with considerable irritation, 'John was so careless, he should have written the date, the names of the people, and the places on the back of each photograph!' What better statement of the need for systematic methodology in visual anthropology!

Numerous images, both historical and contemporary, are similar to this one and may require even more extensive research to establish any direct analytic potential. Unfortunately, many 'documentary' photographs, films and other visual images of cultural experience have limited responsible potential as data either because they are overly constructed, are single isolated images, or because they lack sufficient contextual annotation. This is not a matter of 'good' or 'bad' photography. 'Good documentary' images and 'strong' photographs are often of limited analytic value for the very reasons that make them compelling images to our eyes. They are often framed to exclude complexity of context or ambiguity of message and they are often presented to us as single images, divorced from the larger photographic series from which they come. The demands of a good image for a publication or a display are not the same as those required for research analysis. Good research images contain complexity, they record associations and relationships, they are often unremarkable at first glance and take time to read.

The ideal situation is a carefully made visual research collection with comprehensive temporal, spatial and other contextual recording, good annotation, collection of associated information and maintenance of this information in an organized data file. Strong visual research collections present rich and intimidating potential because they may be productively analysed in many different ways, both direct and indirect. It is the relative rarity of such systematic collections that leads many scholars to underestimate the true potential of photography, film and video as reliable sources of cultural information. Field methodologies for making good visual research collections are beyond the scope of this chapter and readers are referred to other sources (see Collier and Collier, 1986).

DIRECT ANALYSIS

When we examine the content and the character of images as data, we are engaged in direct analysis. This examination may seek information on the subjects seen in

the images or it may extract understanding regarding the making and functions of the images as well as the perspectives of their makers. As other chapters in this volume examine the analysis of the constructed character of images, I will focus on handling images as data regarding the subjects they record. This discussion assumes a reasonably well-made visual research collection but many of the techniques can be modified to work with less ideal records.

Any major analysis should begin and end with open-ended processes, with more structured investigation taking place during the mid-section of this circular journey. This approach provides us with an opportunity to respond to larger patterns within the whole that may reveal the new and unforeseen, that provide significant meaning to otherwise chaotic details. Because more structured analysis inevitably involves focus on already defined details or points of interest, early descent into focused examinations is likely to limit true discovery and foster imposition of prior bias in our analysis. The following model adapted from Collier and Collier (1986) outlines a structure for working with images.

A basic model for analysis

First stage
Observe the data as a whole, look at, 'listen' to its overtones and subtleties, to discover connecting contrasting patterns. Trust your feelings and impressions, and make careful note of them, identifying the images which they are a response to. Write down all questions that the images trigger in your mind; these may provide important direction for further analysis. See and respond to the photographs (or film, etc.) as statements of cultural drama and let these characterizations form a structure within which to place the remainder of your research.

Second stage
Make an inventory or a log of all your images. Depending on what you are trying to find out, design your inventory around categories that reflect and assist your research goals.

Third stage
Structure your analysis. Go through the evidence with specific questions – measure distance, count, compare. The statistical information may be plotted on graphs, listed in tables, or entered into a computer for statistical analysis. Produce detailed descriptions.

Fourth stage
Search for meaning significance by returning to the complete visual record. Respond again to the data in an open manner so that details from structured analysis can be placed in a context that defines their significance. Re-establish context, lay out the photographs, view images in entirety, then write your conclusions as influenced by this final exposure to the whole.

Open viewing

Open immersion provides opportunity for the images and through them, we hope, the cultural circumstances to 'speak' to us in their own terms. The procedure is not complicated. The images, be they photographs, film or video, should be viewed repeatedly, grouped initially in an order that approximates the temporal, spatial and other contextual relationships of the subject-matter they reflect. Once this 'natural' set of relationships has been well understood, they may be grouped in other ways that allow comparisons of similar and contrasting circumstance. Comparative stages of open analysis are frequently the most productive phase, helping refine understanding of patterns through identification of recurrent and contrastive elements.

While we should begin by simply looking at the images, as we continue we can start asking broad questions of the visual record. These questions may derive from our original research concerns or they may have evolved from what we have seen in our initial open immersion. Our goals are a thorough familiarity with the character and content of the visual records and, we hope, identification of possible patterns of significance within the content of the images. Careful records should be kept that clearly describe both findings and questions as they evolve, including notation of what 'tells' us what we think we see. Particular attention should be devoted to unanticipated findings, as these may be clues to new discovery. The whole process should be seen as a foundation on which to build subsequent stages of the analysis.

This analytic evolution can be illustrated by my analysis of cultural landscape photographs made above my home in New Mexico shown in Figure 3.2. A series of 180-degree panoramas were made from precisely the same location, beginning in 1964 and continuing on a regular basis to the present. Printed and mounted on long folding panels, these panoramas provide a ready appreciation of significant changes over time and distinctions in how change are manifested in different parts of the valley, as illustrated in a selection from two of the panoramas.

The top image is from a panorama made in 1964, the lower image shows the same section in 1996. The area seen is a largely Hispanic[1] village, with most land still in hands of long time families, which contrasted sharply with another section of the valley (not shown here) in which land had passed into the hands of land speculators and is now largely occupied by incoming Anglos[2] from other parts of the country. Changes in density are immediately visible in the illustration; less obvious is a relative continuity in community spatial patterns. Housing is still largely placed on non-agricultural lands and much of the housing is still comprised of extended family compounds located along ditch and road lines. The changes in the Anglo-occupied area were different: housing has moved on to agricultural land without restraint; the scale of growth is greater; and homes are not as closely grouped, being spread about on larger residential lots.

While these and other patterns were readily apparent, I felt the need to be more specific. To that end, I made a careful study of different sections of the region, counting the number of homes, noting their location and construction types, examining the distances between homes, noting the shape or character of land holdings, the presence or absence of homes on irrigated lands and the evolution of

Figure 3.2 (a) Excerpt from larger panorama of Taos Valley, New Mexico (USA) made in 1964. Photograph by Malcolm Collier.

Figure 3.2 (b) Excerpt from larger panorama of Taos Valley, New Mexico (USA) made in 1996. Photograph by Malcolm Collier. Casual examination identifies growth and increased residential density, while more careful analysis reveals remarkable consistency in spatial organization of residential functions. The volume of information in these panoramas is immense and they are fascinating to local residents. Letter 'A' and round dots are reference marks for use in analysis.

agricultural activity. This analysis has provided information that allows me to make quite precise statements about the changes and their character. The particular phenomena I studied in detail were, however, identified by the initial open viewing.

Structured processes

The move to detailed examination of particular images is an engagement in 'closed' or 'structured' analysis. The product of this stage is descriptive specificity that serves both to test initial findings and provides precision to our descriptions of those findings. While rarely producing new discoveries, it can serve to challenge or modify an initial hypothesis and preliminary findings we have made during initial open analysis. It is in this stage of analysis that we might count the incidence of particular phenomena, measure or describe particular spatial relationships and compare specific content. Most investigators find this stage of analysis the most time consuming and exhausting.

The variables we examine might include precise proxemic relationships, content analysis (see Chapter 2), identification of participants, records of temporal shifts, tracking of behaviour, details of gesture, expression, posture or other kinesic detail and any number of other visible variables. If we are working with records that include sound as well as images, as is usually the case with video, we might look at the relationships between the audible and the visible (see Chapter 9). The precise focal points will be defined by our original research needs and, ideally, by the findings of our initial open investigation.

An investigation made some years ago of non-verbal factors affecting student response and behaviour in Cantonese bilingual classes in San Francisco provides examples of structured analysis. The fieldwork phase of the study produced a large body of film, video and still photographs of classes from pre-school through to fifth grade. Direct observations and open viewing suggested that students' behaviour was significantly different when Cantonese was spoken as compared to those circumstances where only English was used, with concurrent differences in the proxemic relationships of students and instructors. As I moved to structured analysis I examined the film record of each instructional unit with attention to details of spatial relationships, duration and evolution of student involvement in instructional activities, length in minutes of each lesson, language of communications and a number of other variables. This effort produced specific qualitative statements and a considerable body of statistical data which was analysed for correlations among different variables. The resulting findings permitted a confident statement that moving students closer to each other and to the instructor was, in and of itself, likely to lead to more sustained student involvement in instruction activities. Analysis also suggested that changes in language tended to trigger changes in proxemic and other aspects of non-verbal behaviour. While these general conclusions were initially reached without the aid of structured analysis, specific details came from close examination of many images. Several months were spent carefully examining spatial relationships, tracking eye behaviour, posture, attention to assigned tasks, identifying language of instruction

and conversation, and a range of other specific elements of student and teacher behaviour. This detailed analysis made possible responsible statements describing the findings and assisted the articulation of explanations and recommendations (Collier, 1983).

An illusion of numerical tangibility can tempt one to focus structured analysis on the generation of statistical information but caution is advised regarding the significance of such statistics. Quite aside from obvious and not so obvious sampling issues, statistics from microanalysis will reflect only what we choose to count or measure and as such should be seen as providing important descriptive precision rather than absolute verification. Numerical description may be important but no more so than other, more qualitative, details.

Sometimes structured analysis modifies or contradicts the findings of open analysis. When this occurs an evaluation should be made as to the significance of such differences. An example comes from the Cantonese bilingual study just described. Initial open analysis suggested the crucial distance between students and instructors was about three feet: distances less than that were consistently associated with improved responses, while beyond three feet was associated with a drop. This was consistent with other research, including that of Edward Hall (1966), so initial examination used three feet as the crucial distance in comparing different sessions. This produced enigmatic results in that a not insignificant number of sessions with interpersonal distances of less than three feet had response patterns similar to those in which these distances were much more than three feet. As the results were not fully conclusive, a rapid, open re-examination of contrasting sessions was carried out. This reaffirmed that distance was important but suggested that my lumping of all sessions with distances of less than three feet in one group was obscuring the analysis. A new detailed analysis was carried out, looking at distances of one, two, three and five feet as separate categories. The result was a finding that the crucial transition point was someplace between one and two feet.

Return to the whole view

The volume of possibly important detail generated by detailed analysis may overwhelm the investigator, hiding the true significance and meaning of visual record. For this reason, analysis is best completed with open re-examination of all of the images before conclusions are made. The myriad details may now be seen in their larger context and a coherent statement of meaning and significance made, supported but not obscured by detail. Failure to engage in this final step is likely to produce conclusions and research reports that flood the reader with particulars but give little hint as to their importance.

This reality can be illustrated by two film studies of schools with which I have been associated. The first was a pioneering film examination of schooling in Alaska. Twenty hours of film of classes from several villages were brought back for analysis by a research team, who engaged in both open and detailed study of each class. This effort produced volumes of detailed information from which a final conclusion and

a report had to be completed by John Collier, Jr. Initial attempts, working from the detailed findings, were unproductive. Was a year-long effort of a five-person team of no value? In frustration, John Collier, Jr. returned to a running, unstructured viewing of all the footage. The details of analysis now fell into a coherent whole, providing lively detail and reality to the larger conclusions (Collier, 1973).

While successful, none of us appreciated the significance of the process that had led to a successful conclusion. The next project entailed a study of a well-known community school on the Navajo Nation in Arizona. Building on the Alaska project, this project involved systematic field recording and structured analysis which generated more extensive and refined details than those produced in the Alaska study. Again, an attempt was made to write up the findings directly from the detailed analysis. An extensive manuscript was produced, rich in specifics but ultimately lacking cohesion or clear message (Collier and Collier, 1986).

The return to the overview is therefore a search for larger form that may move us above minutiae, allowing us to make full use of the power of the visual record to define and convey meaningful statements.

Photo elicitation in direct analysis

The value of using images in formal and informal interviews is under-appreciated. Commonly referred to as photo elicitation or photo interviewing, this can be an important aspect of direct analysis and is the foundation of indirect analysis.

During direct analysis we can show images to informants and they can identify items, places, people, processes and activities. They can provide their own open-ended readings and comment on ours. This process may provide rapid and accurate information, greatly enhancing our larger analysis and understanding. (For instance, consider the panoramic view in Figures 3.2 (a) and (b) discussed earlier.) Used in interviews with a resident of the community one could obtain the names of families and details of kinship, knowledge of land ownership, names of crops, information on agricultural practices and building techniques, an understanding of land tenure and inheritance, names of different communities and much more.

In particular, visual records allow the participants in an activity or process to look at and discuss those circumstances themselves, providing an inside viewpoint, as was done in my research into Cantonese bilingual classrooms. Film of class sessions was shown to several of the teachers, who then supplied detailed information on their classes and, more significantly, their own commentary on the communication patterns seen in the footage. Such participant photo elicitation would also be crucial to the understanding of many craft and ceremonial processes.

Photographs often make informants more precise in their interview information. Thoric Cederstrom, while investigating the economic relationship between migrants in urban Mexico and their rural communities of origins, was frustrated by vague responses to interviews. Remembering that he had made photographic housing studies, including material cultural inventories of home interiors, he started using these in his interviews. Now informants, with photos in hand, became specific – 'my

uncle sent the money for that sofa', 'I built that room with money from my brother in Puebla', 'my son brought the TV from Mexico [City] when he visited last year'.[3] A more complete picture of economic interconnections rapidly developed.

Above all, photo elicitation can often make use of visual records lacking the contextualization that is a normal requirement for direct analysis. If the informant can provide the contextual information out of their own experience, even poorly annotated images may be used as data.

INDIRECT ANALYSIS

Enlightening as direct examination may be, it is not necessarily the most productive form of analysis. Perhaps the least known research potential of images is their use as vehicles to knowledge and understanding via the responses they trigger in photo elicitation sessions. (Chapter 6 discusses the use of drawing as a process of elicitation within a theraputic context.) When we use images in this manner we are engaged in indirect analysis. Previously mentioned limitations may restrict the potential of many images as data, but alternative procedures associated with photo elicitation provide the opportunity for rich returns from a wider range of visual records.

The richest returns from photo elicitation often have little connection to the details of images, which may serve only to release vivid memories, feelings, insight, thoughts and memories. This potential can be seen in the results of a research experiment carried out by Suzanne Levine while a graduate student at San Francisco State University.[4] With experience in both visual media and anthropology she wished to apply both to an investigation of the feelings and emotions of disaffiliated Jews. She made a collection of 'found' photographs from postcards, family albums, magazines and other sources that she hoped might evoke responses from her informants. Most of these were unremarkable images with little direct analytic potential and she began her largely open-ended photo interview sessions with low expectations. To her delight the photos triggered a flood of comments, memories and intense emotional statements of identity, relationships to families and tradition, and much more. Indeed, her delight soon turned to a new apprehension – too much data!

A particular attribute of photographs is that they give birth to stories, which themselves are important sources of information. A 1939 photograph (Figure 3.3) of wood hauling in New Mexico, for example, generated not only information on the challenges of getting firewood without pick-up trucks but a host of stories about the elderly man in the photograph which illustrated many aspects of community social and economic relationships. Other stories were related to working with animals, including an enigmatic reference to the particular burro, as a man who would have been about nine years old when the photo was made said 'I remember that burro . . . [long pause] I *remember* that burro!', and that was all, leaving to our imaginations a story unspoken.

Another aspect of indirect analysis is that the investigator can use a wide range of images and is not limited to those that are part of documentary or research studies. Even single images with little annotation may be useful, depending on their character.

Many anthropologists have significant collections of photographs made as an adjunct activity to their fieldwork that, while, perhaps, of limited direct value as data, could readily be used as tools in interviews but are usually used simply to illustrate lectures and publications. Countless times I have looked at such photographs and asked 'Have you used these in interviews?' The almost inevitable response is negative – the idea had never crossed their minds. Nor is the process limited to documentary images. I have had students use advertising images in projects that explored Asian-American feelings of identity and there is no reason one could not use paintings, drawings and other art productions in interviews, depending on the nature of the research. The formal and informal use of images in interviews may be the most overlooked application of photographs to research in the whole field of anthropology.

Figure 3.3 Unloading firewood in Romo year, Talpa, New Mexico (USA). Photograph by John Collier, Jr., circa 1939.

Antonio Romo on the right, Eustacio Romo behind burro. A common scene – few families had motorized vehicles until the late 1940s. This photograph was particularly productive when used for photo elicitation, both in this community and in others in the region, because it evoked so many memories of the past.

PRAGMATIC ISSUES

Visual analysis is both an intellectual and a craft process, in which a variety of choices and procedures can make the investigator's efforts easier and more productive. The following practical comments are presented towards that end.

Visual data files and research records

Photographs and other visual records need clear identification that indicates their relationship to each other and provides connections to associated contextual annotation. Ideally, this begins in the field with consistent and clear record-keeping of locations, times and other crucial information or, alternatively, as described earlier, such information may be reconstructed later. In either case, it is best that simple but crucial information be built into the identification codes attached to each record so that its 'home' is apparent. There are many ways to structure such codes; for example, in my own files a photograph numbered '8523–12' is immediately identifiable as being frame 12, roll 23, shot in 1985. Further information can then be obtained by looking at the shooting log for that year. (Only soft pencils should be used to write on the back of photographs, since inks may bleed through and affect the image. Fine-point permanent ink markers can be used to write on the edges of negatives and slides.)

Most video cameras and some modern still cameras allow direct printing of dates and/or times directly on to images. While it may not be desirable to have that information on every image, it should go on the first image of a roll or tape and at the beginning of each major new sequence. Readable time codes can be recorded in video, either in the field or later, and are essential to any systematic analysis of behaviour and communication. The rapidly developing technology of digitized still imaging also provides opportunities for locking important annotation to still photographs as they are stored in computer files.

Beyond contextual annotation, it is crucial to maintain systematic research files as the volume of information generated from visual analysis can rapidly overwhelm our capacity to remember its details and associations. In particular, you need to know what images generated which information or responses. This is as true with open-ended analysis as with structured examinations and is equally important in various types of indirect analysis. One of the main reasons for having good identification codes for the images is to assist in record keeping during analysis.

Logging and inventory

After initial open viewing of a visual collection it is usually desirable to create a log or an inventory of the collection, producing an organized listing of content; this can often be linked to the annotation and record keeping described above. The inventory process is a good way to become better acquainted with your images, as during open-ended analysis you may easily skip over portions that do not quickly catch your eye.

Still versus motion analysis

The basis processes for analysis of still and moving images are similar but each has different strengths. Comparative analysis is easier with still photography because it is

possible to place photographs next to each other and scan back and forth between them. Rapid, open-ended searches for broad patterns are usually easier with still photographs as many prints can be spread out and more readily seen as a totality. Still photographs facilitate detailed analysis of content (see Chapter 2), as in studies of material culture (see Chapter 4), the cultural geography of a neighbourhood, identification of participants in an event, and certain details of spatial and proxemic patterns. Conversely, analysis of non-verbal behaviour, communication, kinesics and other moving processes is more productive with film and video; indeed they have made analysis of such topics possible (see Chapters 8 and 9).

The comparative strengths of stills and film may be illustrated by the photograph of three men in conversation shown in Figure 3.4. This still image allows easy reading of proxemic relationships, and shows dress, expressions and gesture in a frozen moment. It invites a reading based on those variables and provides a glimpse of the setting, an auto repair shop. But we cannot read the pace of movement, we do not know what came just before and after and, above all, our reading of the emotional quality of the interaction will derive from our projection into the scene of what we think happened before and after. Worse yet, the reading of behaviour in a still photograph is influenced by the precise moment in which it is made. My own experiments have shown that fractions of a second differences in exactly when a still photograph of interactions is made can significantly change how it is read. Consequently, the informational content is more heavily influenced by the skills and choices of the photographer. With film, and especially video, the continuously running record not only shows the interaction in process (together with sound) but also reduces the likelihood that information crucial to our understanding will be missed.

It is harder to use film and video for indirect analysis, although many people have done so. People are often more active in their response to still images, getting more involved in the viewing, lingering over this image, skipping that one, going back to yet another. Presented with film or video they may fall into an audience mode and just watch. Still photographs can be viewed almost anywhere, while film and video require equipment, power and places that accommodate or supply these.

Repetition, stop action, slow motion and high-speed viewing

At the risk of stating the obvious, visual records may be viewed in ways that are often impossible while observing 'real life,' a characteristic that is often crucial to analysis. The potential for repetitive viewing is most important because it allows us to comprehend complex details that might otherwise remain unseen or fleeting. This ability to look at exactly the same circumstances again and again is at the foundation of all direct visual analysis. Operating in real time we often have but one chance to observe, record and comprehend what we see; once past we cannot return and we inevitably miss much in the complexity of the circumstances. With good visual records we can study a scene at leisure, return after days, months, years and re-examine them in the

Figure 3.4 Conversation in Santistevan's auto repair shop, Ranchos de Taos, New Mexico (USA). Photograph by Malcolm Collier, 1984.

Guillermo Santistevan on left, Andres Martinez on right, man in centre not identified at this time. Picture is from a set recording the operation of the business, including the social functions reflected in this image. Part of an in-progress project that explores the community from 1930 to the present.

light of new knowledge or experience and with new questions. Almost anyone who has engaged in this repeated study of visual records has come away astonished that there is almost always more to see.

Film and video can be viewed at different speeds; while obvious, the full significance of this fact has to be experienced to be appreciated. I first realized this promise of the motion image in the 1960s when Edward T. Hall showed me super 8 footage of mundane scenes of a fiesta crowd in northern New Mexico. At normal speed the activity was familiar and unremarkable but when projected in slow motion it became magical, revealing the dramatic differences in patterns of non-verbal behaviour and cultural style among Indians, Hispanics and Anglos that I had previously sensed but could not articulate. The slow-motion view provided the possibility for precise descriptive statements regarding what had before been intangible.

It is possible to view motion records as a series of still images, in frame by frame analysis (see Chapter 9). Single-frame analysis, like that of still photographs, provides very detailed description of static phenomena but hides the fluid flow of movement in studies of communication and behaviour, for which reason it is at best an adjunct process rather than the foundation of such studies. It is very time consuming and I have found slow-motion analysis almost always more productive.

Conversely, and somewhat illogically, it can be productive to look at film or video at faster than normal speeds. I discovered this when showing research footage back to grade school children whose classes I had been filming. They loved viewing it at high speeds because of the exaggerated behaviour, and I was struck by the fact that, while slow motion reveals the subtlety of particular moments, faster than normal screening revealed macro patterns that were sometimes obscured from notice by the passage of time at normal or slow speeds. In effect, high-speed viewing is somewhat similar to juxtaposing two contrasting still images.

Comparisons and juxtaposition

The primary reason for organizing and maintaining good contextual annotation of a visual image collection is to allow for meaningful comparative analysis, one of the most productive aspects of working with images and part of all stages of research. Comparisons are most effective when done directly, that is by placing images side by side, as illustrated in the panoramic study described earlier. This is easy with photographs but more difficult using film and video, with which comparisons usually have to be sequential, although it is possible to screen moving images side by side or on split screens. In the Cantonese bilingual study, I compared key segments by splicing a short series together and rolled them back and forth sequentially in an analyser projector. In other cases, I pulled still images out of the film and made prints which were used for comparative study of details of spatial patterns. A similar process can be followed with video, dubbing out sequences for motion viewing or using a digitizing device with a good computer to take off still images of key frames.

An interesting and sometimes productive comparative procedure is to take a set of photographs and shuffle them, then lay them out in the resulting unstructured order to see if unanticipated relationships may be seen.

Counting and measuring

Counting and measuring may be important in structured analysis, generating both descriptive detail and quantitative information. The first step is to determine what phenomena or variables are to be examined; this decision should evolve primarily from your initial open-ended study (see Chapter 2). The variety of phenomena subject to this process is large – we can count people, objects, occurrences of particular behaviours, and much more. We can measure spatial relationships, size of objects, speed of movement, the beat and pace of actions and communications. A key step is

to develop a standardized code sheet that provides consistency for what is counted or measured – this facilitates later comparative analysis.

Sound and images

This chapter concentrates on visual analysis but many aspects of visible culture also have audible associations, as is most obvious in studies of communication and behaviour (see Chapter 9). The advent of good quality video recording has made it possible for almost anyone to obtain synchronized sound and image records of a wide range of cultural circumstances. Analysis of such records requires attention not only to the visual and audible components in their own terms, but also to their interrelationships. Many of the approaches described here for handling visual content can also be profitably adapted to working with sound. (Adequate discussion of combined analysis of sound and image is beyond the scope of this chapter; however, readers interested in this aspect of analysis are referred to the work of Frederick Erickson – see Erickson and Mohatt, 1982 – and Adam Kendon.)

Special concerns in photo elicitation

Photo elicitation requires some care. Procedurally, it is important to keep records of the order in which images are presented to informants and, obviously, which responses are associated with which images. It may be useful to experiment with different combinations of images to see which are most productive. Results may also vary depending on whether sessions are with groups of people or with single individuals – again some experimentation may be in order.

As with the larger analysis process, photo elicitation best begins with open-ended viewing, first allowing the informants to say whatever they wish. This approach is more likely to produce unforeseen information and commentary. If you immediately start with very specific questions, the informant is likely to get the message that those are the only topics you want information on and restrict their subsequent commentary to those points or other details that you bring up.

There is considerable variation, both cultural and individual, in people's response to photo elicitation. Our own work in the American Southwest, for example, suggests that both Navajo and Pueblo informants tend to begin with very specific descriptive reading of images, moving to more projective responses later or not at all, in contrast to the more immediately projective responses of Anglos, who sometimes require specific questioning to produce detailed readings. Some individuals have strong visual memories and responses while others do not, which can affect results when working with historical photographs. I once interviewed a woman who had been a practising musician in a community in northern New Mexico for over sixty years, hoping to obtain identifications of musicians in a collection of excellent photographs of festivals in which she had participated in the 1930s. The results were not as expected as she

proved to have a strong musical memory but a poor visual one and I came away with many interesting stories about musical traditions but few identifications of musicians. Conversely, another person, confronted with a photograph of the audience at a school play proceeded to identify practically everyone in the crowd.

The photograph shown in Figure 3.5 illustrates the need for patience in photo elicitation as well as the plastic nature of memory. The picture was taken in New Mexico in the 1930s and had absolutely no annotation. From the shape of the hill I could identify the location within fifty metres but the buildings were a mystery. They were very familiar – I knew that I had passed them countless times – but I could not place them, nor could anyone else. Interviews with long-time residents produced comments on the high quality of the plastering but person after person failed to specifically identify the homes. Returning to work in San Francisco, I interviewed a migrant from the village who had moved to California over forty years before and had seldom returned even for visits. When he saw this photograph he immediately said, 'That's Tio Alberto's house', and proceeded to give detailed information on each of the buildings and their residents in the past.

Once he said it, I too recognized the buildings and was left wondering why identification had been so difficult. On return to New Mexico I went to the location

Figure 3.5 Alberto Tafoya home, Rio Chiquito/Talpa, New Mexico (USA). Photograph by John Collier, Jr., 1930s.

A simple image that proved extremely hard to identify and has yet to be precisely dated. The photograph reveals the care with which people maintained their homes, the open yards, no sign of cars, trees neatly trimmed by goats and a central placed oven. Today, the yards are filled with plants (no more livestock) and driveways, while the homes are hard plastered. Another productive image in photo elicitation.

and studied it: everything was still there but the details had changed. Trees had grown up, a fence bisected the view, trim had been altered. Perhaps those of us who had remained in the community on a regular basis had our perceptions, our memories, altered by the changes through time, whereas the long-absent migrant's memory was frozen in the earlier time period, uncluttered by the overlay of intervening years.

An area of caution in photo elicitation involves images of people's private circumstances and events, especially if pictures are shown to other people in the same community. The fact that your relationship to individuals may have permitted photography by you does not necessarily extend to letting others look at those photographs. It is probably best to avoid using photographs of people in private settings in interviews with others unless you have gained specific permission, although a significant passage of time or distance that provides anonymity might modify this advice (see Collier and Collier, 1986: 135–6).

Team analysis

Team analysis has special promise in visual analysis because it provides an opportunity to exploit an important feature of visual records – the ability for multiple views of precisely the same phenomena. As different people study the images, their various readings may be compared and linked to identifiable phenomena in the visual records. Equally important, discussion of team findings may help clarify which results are a product of tangible elements in the images and which are more clearly the product of the cultural experiences we bring to our analysis. If the analysis process can be guided by a standardized code sheet or a set of common questions and processes, team analysis can also provide means for more rapid analysis of large quantities of images.

Photo maps and other models

Still photographs may be arranged as photo maps and other models that assist in the discovery of information within them. If systematic photographs of an urban neighbourhood, for example, are mounted on folding boards or rolls of paper they can become a photo map that compresses the larger visual reality of the locale into a more comprehensible space, while maintaining basic spatial relationships. Figure 3.6 shows a section of a larger photo map of a street in San Francisco Chinatown. The images across the bottom of the map provide continuous, wide-angle views of the street, while mounted above them are detail photographs made in the location above which they are placed. The full map records eight blocks on both sides of the street and stretches for over twenty feet.

These maps can be arranged on the floor in correct spatial association to each other. We can move back and forth among these images, examining details, and we can also look at them as a collective single image in which details are seen in their relationship to each other and to the whole. They can be studied through rapid open viewing and structured analysis to arrive at understanding of the spatial and functional

Figure 3.6 Excerpt from photo map of Stockton Street, San Francisco Chinatown made by class in Asian American Studies at San Francisco State University. Photos by Frances Lee, Hernan Cortez, Suzanne Canieros and Mark Johnson, 1985.

Wide views at bottom, details above. Map shows wide view and specifics of different parts of the neighbourhood, permitting analysis of the broad functions, visual character of the community and the specifics of each section. Subsequent mapping of the same neighbourhood provides a record of change over time, supplying data for analysis of community evolution.

Figure 3.7 A photo map spread out for analysis, Asian American Studies class, San Francisco State University. Photograph by Malcolm Collier, 1986.

Large photo maps contain a considerable volume of information and are suited to team analysis. They are also good vehicles in which to engage students in examination of neighbourhoods while providing training and experience in visual observation and analysis.

organization of the locale, the range of people who frequent it, the styles and content of displays, and much more (see Figure 3.7). These models can be temporal, functional or socially structured, and can be either two- or three-dimensional.

Digital possibilities

The advent of digital cameras suggests new possibilities for visual analysis. Some are merely technical advances, as in the greater ease of constructing nicely matched panoramic photographs, but others involve more significant methodological innovations in both data gathering and analysis. In particular, a digital camera, in conjunction with a laptop computer, provides opportunity for rapid feedback of images. A field worker can make digital records of a place, an activity or other phenomena, load them into a laptop computer and immediately show them to people for quick acquisition of annotation and analysis via photo elicitation. This elicited information can be incorporated into visual-based data files for further analysis at one's leisure.

In many circumstances, a good ink jet printer can be used to produce gift photographs, an important aspect of human relations in visual research.

Digitized images can be transmitted to other people rapidly, assuming they have the appropriate equipment, facilitating team analysis and photo elicitation. It is also possible, with some experience, to 'rescue' faded and degraded photographs via computerized adjustments. For instance I have done this with badly faded historical images of San Francisco Chinatown, discovering possibly important details of street scenes that raise some questions about the universality of standard accounts of family life in that community a century ago.

Views from within and without

Most discussions of visual analysis, including this one, assume a research process largely carried out by people who are not themselves participants in the circumstances recorded in the images. What happens when this assumption is incorrect, when visual records of cultural process are made and analysed from 'within' (see Chapter 4)?

Such inside explorations are becoming more common. My own work has included teaching a photographic exploration course in which Asian-American students record and express different aspects of Asian-American life, most commonly those that they are themselves associated with. Fifteen years of experience with these students has revealed significant differences when working from within. As might be expected, the photographs (and some video) are more intimate, personalized and contain information that is not readily available to an outsider. From an analytic point of view, I have found that analysis can proceed more rapidly, primarily because the students bring important contextual information to their research. This allows them to make definitive statements without as much dependence on logging, annotation and other steps that are normally taken to ensure reliable reading of images, although their work is usually enhanced by such processes.

A more formal example of research from within, using both visual and other methodologies, has been carried out by a group of Yup'ik Eskimo educators in south-western Alaska over the past ten years. Seeking to both understand and articulate the skills and needs of Native teachers, they videotaped their own classrooms and carried out their own analysis, incorporating the results into their larger project (see Lipka and Mohatt, 1998).

Working with imperfect collections and images

Most visual records of cultural circumstances are less than ideal for analytic purposes. Even well-made 'documentary' images are often weak research records, as is true of many of the photographs anthropologists make for themselves. What forms of analysis are possible in such cases?

As has already been suggested, several approaches can be taken to make responsible use of such images. Steps can be taken to reconstruct contextual information

and to provide the needed annotation to directly analyse images. These steps may include archival work, photo elicitation, a search for internal clues within images themselves and a careful evaluation of what is and is not possible. It is then possible to make reasonable analysis of many types of images. Finally, most images have potential functions in indirect analysis, as is described elsewhere in this chapter and book.

As demonstrated by the range of visual data analysed in this volume, visual analysis is not limited to photographs, film or video. Obviously, any visual creation can be used in studies of cultural expression and as a reflection of cultural values. Drawings, paintings and other art forms are often as readily productive as photographs in indirect analysis and may sometimes be used in direct analysis, providing there is adequate contextual information and the cultural conventions of the artist are understood.

FINDING MEANING AND MAKING CONCLUSIONS

Rich detail is of limited value if it is not articulated in meaningful conclusions. I have suggested that analysis should involve a return to the visual whole so that details may be seen as larger patterns, the discovery of which are crucial to understanding the significance of our research. But patterns alone do not produce meaning and our search for it is complicated by our dual role as investigators and cultural beings. The cultural lenses through which we operate inevitably shape our analysis, especially as we seek conclusions. While this reality may limit our comprehension of unfamiliar cultural phenomena, it is equally true that our existence as cultural beings provides us with the ability to recognize and respond to cultural patterns. This capability is essential as we reach to define the significance of our findings.

The search for patterns is the first step toward meanings and conclusions. Patterns may be found in structured descriptions and quantitative products of detailed analysis but the most important ones are usually those that we perceive during the less structured study of our images. Both as a visually oriented species and as cultural beings we are quite adept at perceiving patterns in the visual world, so visual investigators should have faith in their ability to see patterns. Once identified, patterns can be tested via structured analysis, repetitive viewing, team analysis, photo elicitation and other analytic processes.

The reason we look for patterns is that the world, especially the cultural world, is significantly, although not totally, made up of patterned relationships. It is reasonable to assume that, when you discover and confirm patterns within a collection of images, film or video, those patterns may have meaning and significance.

Art and science

A particular promise of visual records in research is the opportunity for a productive combination of artistic and scientific processes. No amount of well-organized data

or refined processes of analysis guarantees a sound and responsible research con-
clusion. Conclusions lie beyond information and description; as such they entail
creative and artistic processes. It is both necessary and legitimate to allow ourselves
to respond artistically or intuitively to visual images in research, both during earlier
stages of analysis and as we articulate conclusions. However, while creative processes
are essential to discovery, artistic processes may produce only fictitious statements if
not combined with systematic and detailed analysis. The dangerous temptation of
artistic approaches in visual anthropology is abandonment of the responsibility to
connect findings to concrete visual evidence. If conclusions cannot be supported with
detailed information, descriptive or otherwise, from an organized process of analysis,
then they should be re-examined.

Presentation of findings

Although changes may be on the horizon, one of the frustrations of visual research is
that we are usually required to present our findings primarily in written form. We still
swim in a sea of words and more words, in which visually based communications are
not taken as serious intellectual products. How are we to translate the richness and
promise of our visual discoveries into the deceptive world of words? Words that have
often become tired and abused through time and with which we must struggle to let
our readers see what we have seen but may not show them. The answer is not clear
but, as we await the development of a visual language of intellectual discourse, we can
use our images, our visual analysis, to breath a bit of new life into our translations.

Experience has shown that systematic incorporation of descriptive detail
from analysis into written accounts of the research can help provide clarity and vali-
dation to more generalized conclusions. The best way to achieve this goal is to write
from the images, not from the abstracted data or analysis. Procedurally, as you write you
should have the images in front of you, drawing both description and inspiration
from their constant presence. In this manner the basis of your knowledge remains
fresh and the translation direct.

This chapter has sought to provide principles and ideas from which to develop
your own plans for research. The visual world is rich beyond dreams and each visual
investigation must define new approaches. In the end we must play with images until
they speak to us directly and from that dialogue we draw our findings.

NOTES

1. 'Hispanic' is a highly unsatisfactory term used in this context to identify a people of mixed
 Spanish and American Indian origins who have lived for several centuries in central and
 northern New Mexico and southern Colorado, USA.
2. 'Anglo' is used in the American Southwest to refer to people of European origins, broadly
 defined, who are neither American Indian nor Hispanic.
3. Thoric Cederstrom, personal communication.
4. Suzanne Levine, personal communication.

REFERENCES

Collier, J., Jr. (1973) *Alaskan Eskimo Education: A Film Analysis of Cultural Confrontation in the Schools.* New York: Holt, Rinehart and Winston.

Collier, J., Jr. and Collier, M. (1986) *Visual Anthropology: Photography as a Research Method.* Albuquerque: University of New Mexico Press.

Collier, M. (1983) *Nonverbal Factors in the Education of Chinese American Children: A Film Study.* San Francisco: Asian American Studies, SFSU.

Erickson, F. and Mohatt, G. (1982) 'Cultural organization of participant structures in two classrooms of Indian students', in G. Spindler (ed.), *Doing the Ethnography of Schooling: Educational Anthropology in Action.* New York: Holt, Rinehart and Winston.

Hall, E.T. (1966) *The Hidden Dimension.* New York: Doubleday.

Lipka, J. and Mohatt, G. (eds) (1998) *Transforming the Culture of Schools: Yup'ik Eskimo Examples* (Sociocultural, Political, and Historical Studies in Education Series). New Jersey: Lawrence Erlbaum Assoc.

4 Seeing Beyond Belief: Cultural Studies as an Approach to Analysing the Visual

MARTIN LISTER AND LIZ WELLS

The relationship between what we see and what we know is never settled. (Berger, 1972: 7)

INTRODUCTION

Cultural Studies

Cultural Studies centres on the study of the forms and practices of culture (not only its texts and artefacts), their relationships to social groups and the power relations between those groups as they are constructed and mediated by forms of culture. The 'culture' in question is not confined to art or high culture. Culture is taken to include everyday symbolic and expressive practices, both those that take place as we live (and are not aimed at producing artefacts), such as shopping, travelling or being a football supporter, and 'textual practices' in the sense that some kind of material artefact or representation, image, performance, display, space, writing or narrative is produced. As an academic field, Cultural Studies is interested in the enabling and regulating institutions, and less formal social arrangements, in and through which culture is produced, enacted and consumed. In practice, it is seldom, if ever, possible to separate the cultures of everyday life from practices of representation, visual or otherwise.

The focus of such studies is normally on contemporary and emergent practices, studied within their formative historical contexts. These are mainly those of the late eighteenth, nineteenth and twentieth centuries: the 'modern' period of industrialization, the formation of the nation-state, the rise of the type of the modern individual, imperialism and colonialism, and the commodification of culture. Such contexts are now importantly extended to include globalization and the range of shifts which are gathered up under the terms 'post-modern' and 'post-colonial', as the legacies and cultural forms of the earlier period are seen to be radically restructured and fragmenting at the end of the twentieth century.

A distinctive feature of Cultural Studies is the search to understand the relationships of cultural production, consumption, belief and meaning, to social processes and institutions. This has resulted in a refusal to see 'society' as simply the context, climate

or background against which to view a cultural practice or text; rather the production of texts is seen as in itself a social practice. There is a similar refusal to see cultural practices and texts as merely symptoms or documentary reflections of a prior set of social determinations. Instead, Cultural Studies insists upon the constitutive role of culture in sustaining and changing the power relations enacted around issues of gender, sexuality, social class, race and ethnicity, colonialism and its legacies, and the geopolitics of space and place within globalization. It examines these in terms of the ways of seeing, imagining, classifying, narrating, and other ways of investing meaning in the world of experience, that cultural forms and practices provide.

Media Studies

The version of Media Studies which is closely connected with Cultural Studies largely arose within the same post-war intellectual project to comprehend the impact of industrialization and advancing capitalist social formations on new, mass forms of communication, representation and consumption. Part of the impetus was to do this in ways that were more flexible and responsive and less value-laden than the responses to the mass media found in the traditional canonical disciplines such as literary studies or art history. In particular these disciplines' preoccupation with the idea of individual authorship as a source of meaning was criticized in itself and as manifestly inadequate for the study of advertising, popular cinema and television. A parallel impetus was to pay much closer attention to a wider range of expressed or represented experience, however informal, popular, sub-cultural and apparently trivial, than was characteristic of mainstream social science. Feeding into these central impulses have been other traditions: sociological research and empirical study of audiences for mass media, especially television; critical studies of media power; the political economy of the media; studies of media politics and the public sphere; media and communications theory; and specific histories of radio, television, the press, new media and communication technologies.

The study of visual culture

More recently, there have been attempts to define a specific field of Visual Cultural Studies. While recognizing a formative relation to a wider field of Cultural Studies (which always contained an interest in the visual), its proponents do not see this as merely a specialized sub-division or extension of Cultural and Media Studies, but as a reworking of the whole field of concern. With the late twentieth century's explosion of imaging and visualizing technologies (digitization, satellite imaging, new forms of medical imaging, virtual reality, etc.), they suggest that everyday life has become 'visual culture'. This can be seen as an acceleration of a longer history involving photography, film, television and video. However, some argue that this new visuality of culture calls for its own field of study concerned with all kinds of visual information, its meanings, pleasures and consumption, including the study of all visual technologies, from 'oil

painting to the internet' (Mirzoeff, 1998: 3). From this perspective, it is argued that the study of visual culture can not be confined to the study of images, but should also take account of the centrality of vision in everyday experience and the production of meaning. As Irit Rogoff puts it:

> In the arena of visual culture the scrap of an image connects with a sequence of film and with the corner of a billboard or the window display of a shop we have passed by, to produce a new narrative formed out of both our experienced journey and our unconscious. Images do not stay within discrete disciplinary fields such as 'documentary film' or 'Renaissance painting', since neither the eye nor the psyche operates along or recognizes such divisions. (Rogoff, 1998: 16)

The primary purpose of this chapter is to demonstrate and critically discuss the validity and usefulness of a range of methodologies which have been brought into play for analysing photographic images which have been a major element of visual culture in modern industrial societies. We shall show how insights and methods drawn from semiotics (see Chapters 7 and 9), psychoanalytic cultural theory, art history (see Chapter 5), the social history of media technology, aesthetics and the sociology of culture are drawn upon in order to investigate how meaning, pleasure and power are articulated through specific images. Such images are produced and consumed within a wide range of social, economic and cultural contexts, including those of advertising, the making of news, social documentary, medicine, the law and social control, education, the family, leisure and entertainment.

First, we briefly discuss Cultural Studies and methodology. The following three sections focus upon distinctive questions asked of the photograph within Visual Cultural Studies and demonstrate some of the key concepts employed within the field through analyses of a diverse range of photographs. Analysing examples of photographs from advertising and reportage along with images made for gallery exhibition, we discuss contexts of viewing, contexts of production, form and meaning and looking and identity.

Cultural Studies: methodologies

Cultural and Media Studies is a compound field, elements of which are differently organized in different institutions. It is generally understood as an interdisciplinary field, rather than as a discrete discipline, which appropriates and re-purposes elements of theoretical frameworks and methodologies from other disciplines, wherever they seem productive in pursuing its own enquiries.[1] Therefore, it is hard to identify for Cultural and Media Studies its own singular and strict set of disciplinary protocols. However, and while differences of emphasis exist, most research methodology courses within Cultural and Media Studies include elements of ethnographic, sociological, semiotic, psychoanalytic and critical textual methods.

One way of approaching a definition of Cultural Studies is to consider its objects of enquiry as the ways it understands the complex concept 'culture'. These include, for instance, the 'ordinariness' or 'everydayness' of culture, an interest in culture as

the process through which a society or social group produces meanings. There is a stress upon the 'how' as well as the 'what' of culture, on productions as well as context. Cultural Studies is, then, not only methodologically eclectic, but open and experimental in the ways that it frames its objects of study. While it may borrow its methodological resources, it seldom assumes that it unproblematically has a set of objects 'out there' or before it, about which it can then ask questions formulated by and inherited from other disciplines.

Pragmatically, its achievements have to be judged in terms of the coherence and insights of the accounts that it gives of its objects. Its methodological rigour lies in the responsible way that a researcher uses the intellectual resources that they borrow and apply. Even though an orthodox historian or sociologist may gibe at the taking of their methodological tools into interdisciplinary hands, the vitality and suggestiveness of much Cultural and Media Studies has been widely influential on other academic disciplines and criticism and has had an impact upon print and television journalism.

How do these general points inform what we attempt here? While much of our attention is given to specific photographs, we analyse them without separating them from social processes. Except for the practical purposes of staging our analysis – we cannot do everything at once! – we resist reifying or hypostatizing the images. That is, we work hard not to see pictures as rigid and fixed things – beginning and ending at their frames (see Chapter 8).

Another way to put this is that we approach the images as part of what has been described as 'the circuit of culture' (du Gay, 1997). Each one can be thought of as passing through a number of 'moments' and its passage through each moment contributes to the meanings – plural, not singular – which it has and may have. In short, they are socially produced, distributed and consumed; within this cycle there are processes of transformation taking place and also of struggle and contest over what they mean and how they are used. To sum up we offer a check-list of the main features of the analysis which follows. These will be restated as more focused questions within the analysis itself.

1 We are interested in an image's social life and its history.
2 We look at images within the cycle of production, circulation and consumption through which their meanings are accumulated and transformed.
3 We pay attention to an image's specific material properties (its 'artifactualness'), and to the 'medium' and the technologies through which it is realized (here, as photographs).
4 While recognizing the material properties of images, we see these as intertwined with the active social process of 'looking' and the historically specific forms of 'visuality' in which this takes place.
5 We understand images as representations, the outcomes of the process of attaching ideas to and giving meaning to our experience of the world. With care and qualification, much can be gained by thinking of this process as a language-like activity – conventional systems which, in the manner of codes, convey meaning within a sign using community.
6 We temper point 5 with the recognition that our interest in images and other visual experiences (and, indeed, lived and material cultural forms) cannot be reduced to the question of 'meaning' and the intellectual processes involved in

coding and decoding. As human beings, and as the members of a culture, we also have a sensuous, pleasure-seeking interest in looking at and feeling 'the world' including the media that we have put in it.

7 We recognize that 'looking' is always embodied and undertaken by someone with an identity. In this sense, there is no neutral looking. An image's or thing's significance is finally its significance for some-body and some-one. However, as points 1 to 6 indicate, this cannot be any old significance, a matter of complete relativism.

ANALYSIS

Context of viewing

We need first to ask where the image is. What is its location (or locations) in the social and physical world? Our answer to this question will tell us much about how we meet or encounter the image; that is, how we attend to it. Is it, for instance, met in the public or private part of our lives? Is it something on which we can concentrate and be absorbed by in a single-minded way or is it one contingent element amongst others in our busy daily transactions, in our leisure time or as part of our work or education? Did we deliberately seek out the image, in a library or a gallery? The context influences how we look at the image through constructing certain expectations. For instance, the gallery adds an aura of seriousness of intellectual or aesthetic intent to the picture.

Second, why is the viewer looking at the photograph? What information or pleasures do they seek? How are they intending to use the image? Is their interest idle or purposeful? If the look is purposeful, as in, for instance, studying the images with which we have chosen to illustrate this chapter, then it is important to know what editorial judgements have been made and how this has influenced the selection. Writing this chapter, and in particular choosing images (which will be reproduced several thousand times within copies of this book) and then discussing them in certain ways, is a small exercise of power. What are our reasons, our interests or purposes, in selecting the images we have? What view of the traffic in images are we promoting? Uppermost in our minds has been the exemplification of the methodological points we wish to make. Not all images would serve as well to do this although, in principle, if the concepts and methods we use are of value then they should be applicable to a wide range of images. However, here we have favoured 'strong' examples of the concepts that we are dealing with, in order to help elucidate points.[2]

The image (Figure 4.1) of the 'redneck' in a Marlboro cigarette advertisement is situated on a super-site hoarding. This is positioned to the side of a roundabout on a major ring road in a large provincial city. The photograph of the image was difficult to take because the hoarding is hardly accessible on foot. It is positioned within a major road complex where no provision is made for pedestrians (they are actively discouraged) and is clearly intended to be seen by passing motorists or motorists in the frequently slow-moving traffic that is typical of this main approach to the city during peak commuting hours. The same image was also reproduced in glossy magazines and the magazine sections of major Sunday newspapers. Literally, then, a photographic original

Figure 4.1 Marlboro cigarette advert, circa 1995.

– also a digitally manipulated image (see Henning, 1995: 217) – has been translated into two kinds of print of vastly different scales. We can reasonably speculate that one may be seen through the frame of a car window while on the move, while the other could be draped across the lap of a reader or browser while reclining on a sofa or travelling on a train. Alternatively, it might be read at a desk when the reader takes a break from the work they otherwise do there. In this sense the images are located, both in the physical world and in our everyday social worlds, quite differently.

Taking two of these scenarios further, we can begin to say something about how the one image is experienced in different contexts. In the case of the car driver or passenger (this itself may be an important distinction), the image is experienced in time or as the spectator travels in space. It will loom up to confront the spectator and then recede from their field of vision. Their encounter with the image will not be the result of an intention to look at it; it presents itself to them. The image – as a publicly sited hoarding – will be seen in the context of the (sub)urban environment: the intersection of motorways stretching away from the viewer, the backs of working-class housing behind it, the sound of traffic passing in other directions, the smell of traffic on hot (or wet) tarmac, and so on. The image is not a passive element in this scene. It depicts a man (who looks in the same direction as the viewer) who is himself beside a major road looking on at an American-style truck. There are hills in the background as there are in the actual location in which the image is sited. What is depicted in the image echoes or resonates with the situation of the driver/passenger/reader of the image.

On the sofa, another viewer looks at the image in their domestic space. They have sat down, positioned themself, chosen the magazine in which the image is printed,

Figure 4.2 Robert Doisneau. 'An oblique glance', 1948/9.

opened it and alighted on the image. They may, in the first instance, have chosen and bought the magazine in which the advert appears. They hold the image and focus on it. In a different sense from the first example, they too experience the image in time, or more precisely, within a sequence of images and written words offered by the other contents of the magazine. They might consume the magazine in a linear fashion working their way through from beginning to end, or more selectively, working back and forth through its pages, in effect producing their own juxtapositions between its various features and advertisements. We can ask more questions of this situation. Is the magazine, and for some moments the advert, their sole object of attention? Is the television on? What is being broadcast? How does it, at some level of consciousness, interact with the image? Might it be a programme about some other aspects of life in the United States? A 'road movie'? Perhaps music is playing – the image may have a soundtrack. Perhaps the 'reader' is not alone but looks at the magazine with a friend or partner; they discuss, judge, joke and elaborate via anecdotes and connections on the image.

Our second chosen example (Figure 4.2) is an older photojournalistic image, one which still, on first encounter, may raise a smile. 'An oblique glance', by French

photographer Robert Doisneau, which shows a couple looking into the window of a Parisian antique shop, has been reproduced in books and exhibitions about Doisneau, the photographer, as well as being referenced in a number of discussions of French humanist photography shown in major international exhibitions on documentary or on post-war French photography. The image was first published in *Point de Vue* (photo-magazine).

In contrast to the Marlboro advert, the contemporary viewer is likely to encounter this image within the context of the work of the particular photographer, or as an example within a more general discussion of reportage photography of the period. The photograph may be reproduced in a book, or, indeed, the viewer may be pursuing historical research concerned with photojournalism, with Doisneau or with French humanist photography. Whilst the reader of *Point de Vue* in 1949 may have come across the image in circumstances equivalent to our putative sofa reader of the Marlboro advert (perhaps whilst listening to the radio), contemporary viewers of this image may approach it rather differently. On the one hand, Doisneau's work has been extensively recycled as posters and postcards, and is familiar to many who would not necessarily know the provenance of the image or the name of the photographer. On the other hand, precisely because the work is now acclaimed as exemplary of its genre and era, many viewers are likely to have in some way sought out the circumstances of viewing, whether borrowing or buying a book, or visiting an exhibition. (The same is true of the work of Robert Mapplethorpe which we discuss below.)

The photograph has a title, which indicates to the viewer its primary humorous focus, and it is specifically authored. The naming of the photographer lends status to the image as a work of art and, indeed, the context of viewing may be a gallery exhibition within which the image is hung as a fine print, perhaps as one in a series of similarly carefully reproduced photographs. We are generally familiar with the convention of the gallery, with the ritual of progressing from image to image, attending to each one for a short space of time, then, perhaps, starting to make comparisons between one image and another in terms of subject-matter and in terms of aesthetic form. Like the Marlboro adverts, the experience of the encounter is inter-discursive in the sense that situation, contemporary references and resonances inform our experience, whether we merely glance at the image or study it more intently. Questions of social history also obtain. For example, whilst viewers, both in the 1950s and now, may see the Doisneau photograph as offering information about Paris after the war (for instance, the clothing worn by the boys across the street and the style of dress of the couple), this information inevitably holds differing implications for those considering the picture some fifty years later.

Context of production

Our next question is: how did the image get there? This question shifts our attention from how we encounter the image to ones about its production by others and its distribution – to the intentions and motives of others, and the institutional and other social contexts, imperatives and constraints in which they work.

Here the contrast between the Doisneau photograph and the Marlboro advertisement is instructive. Most obviously, the first was produced as a narrative image, as photojournalism, whilst the other was constructed as an advertisement. Also the manner of production differs. Doisneau's photograph is about an event which has not been specifically directed by him – although the setting up of his camera inside the shop with the painting of the naked woman placed at an angle in the window, orchestrated the possibility of responses from passers by. His conceptual approach is in line with Henri Cartier-Bresson's famous definition of photography as 'the simultaneous recognition in a fraction of a second of a significance of an event as well as of a precise organisation of forms which give an event its proper expression' (Cartier-Bresson, 1952). For the photographer the skill is one of recognizing the 'decisive moment', both when taking the image and in the process of selection and editing. Here it is clear that photography was not seen as somehow inherently objective but, rather, reportage was used by photographers as an opportunity for interpretative commentary. The point was to find 'telling' photos, or 'photo-novels', sequences of images for publication in illustrated magazines such as *Life* (USA), *Vu* (France) and *Picture Post* (Britain), which were popular and widely distributed from the 1930s to the 1950s. Whilst his work was more along the lines of social observation than 'hard' news, that is the reporting of major contemporary events, a sense of 'news values' will have informed the decision to shoot this series of images from within the shop.[3]

Doisneau made this image at a time which predates television as the primary conveyor of visual information and was informed by pre-war documentary film and photo movements. By the 1930s in France, there was an established 'humanist' focus upon ordinary people and everyday life which took as its subject-matter people at work and at leisure, depicted in streets, cafes and brothels, or at special events such as fetes. Doisneau described Paris as a theatre of images: 'It doesn't matter where you look, there's always something going on. All you need to do is wait, and look for long enough until the curtain deigns to go up' (in Hamilton, 1995: 182).

In our example, Doisneau has set himself up in the shop in order to observe events; he has constructed a scenario within which it is likely that interesting events may occur. By contrast, advertising imagery is overtly directorial, constructed purposefully in line with a particular brief and taking specific account of the intended means of communication (hoarding, magazine advertisement, etc.). The photographer for the Marlboro advert is not named; there is no attribution of authorship. Unlike photojournalism, the dictates are entirely commercial. In advertising the photographer or art director are named only if they are famous enough for their name to condone the product.[4]

The Marlboro image is an advertisement for cigarettes and will have been designed and produced for that company by a specialist advertising agency as part of the Philip Morris company's wider marketing and advertising strategies. This advert belongs to a whole series for Marlboro cigarettes which, in part, are a response to the early 1990s ban on advertising cigarettes on British television and the anticipation that this ban will be extended to all forms of advertising. This accounts for the way that the advert (and the others in its series) contains no written or explicit reference to

either cigarettes or the Marlboro brand. Ironically, the clear reference to smoking cigarettes which connects the image to the product is given in the government health warning which runs along the bottom of the image.

The producers of these Marlboro ads have to solve a problem, that of how to reference a brand of cigarettes and how to promote a product that is widely understood to be seriously dangerous to health. In the 1970s and 1980s Marlboro advertising associated the cigarettes with the figure of the 'cowboy', itself a vehicle for making a connection between cigarettes, white masculinity, 'loner' subjectivity and the untamed nature of the mythological American West. At that time it was possible to include the brand name and copy which recommended smoking (Marlboro cigarettes in particular) as natural, pure and relaxing within the advert. More recent government restrictions on such practices have led designers and producers of the adverts to use other strategies. They know that the distinctive red colour of the Marlboro packet and logo can live on after the packet or name itself ceases to be shown. A significant red detail, 'the sunburnt neck, a light on top of a police car, a traffic light', appear in the more recent images as the only coloured elements in what look like black and white stills from art-house movies. Furthermore, the producers use stills which reference movies which critically rework the myth of the West: *Bagdad Café, Paris, Texas* and *Gas, Food, Lodging* (Henning, 1995: 223–8). These postmodern reworkings of Western mythology also allow the advertisers to shift the connotations of smoking from the natural and relaxing toward the dangerous and the 'romance of living on the edge' (Henning, 1995).

This advertising image is then a deliberate and skilful response to legal constraints and shifts in the culture of health on the part of producers whose task it is to maintain markets for their client's product. The features of the image which we have discussed here are not arbitrary but the result of a complex interaction. This is between the profit-making demands of capitalist economics, the restrictions imposed by anti-smoking campaigners, health professionals and the law, as well as factors such as the modes of organization, division of labour and work processes which obtain at any specific advertising agency and the knowing semiotic practices of advertising 'creatives'. In our example, the image takes its form from, and depends for its success as an 'advertisement' on, such factors. Producers employ particular strategies, which will not be the only solutions that could have been adopted, but they are outcomes of intention and 'producerly' knowledge and skill. Whether we, as receivers or consumers of the image, directly take or accept the meanings they have intended to give the image is another question (see Chapter 8).

LOOKING: FORM AND MEANING

We can note that at this point in our analysis we still have not begun to deal with what we may call the image 'itself' or 'in-itself'. This actually raises some difficult and vexed questions about the boundaries of an image or a 'text'. What is the image in itself? What are the inherent properties of a text when considered apart from individual acts of looking at it and making sense of it?

Conventions

Two uses of the concept of a convention, understood as a socially agreed way of doing something, one with literary and art historical roots, the other sociological, play a part in the visual analysis of photographs. We start our discussion of codes and conventions with an example from art history. This is useful as a way of recognizing that traditions of analysis employed by these specialists in studying the narrow range of images which makes up the history of art have always offered Cultural Studies something, especially the study of iconology and iconography (Panofsky, 1955; see also van Leeuwen, Chapter 5 in this volume). While it is probably true to say that, in Cultural and Media Studies, these methodological branches of art history and theory have always been overshadowed by the use of semiotic methods imported initially through Continental structuralism, we give them some time here. This is because they immediately offer ways of talking about pictures in terms of the key concept of 'convention'. They also allow us to start from noticing things about images rather than about written language and then seeking to apply linguistic concepts to images.

Pictorial conventions

The art historian Michael Baxandall offers a brief but exceptionally clear analysis of the pictorial conventions simultaneously employed in a fifteenth-century woodcut shown in Figure 4.3:

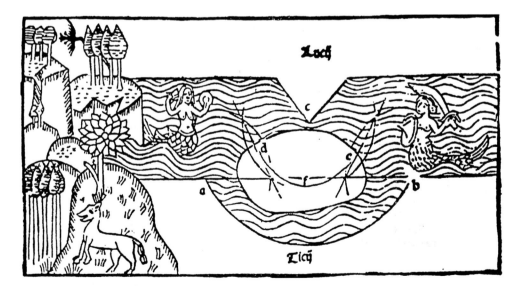

Figure 4.3 De Fluminibus. Woodcut, 1483.

[Plate 15] is the representation of a river and at least two distinct representational conventions are being used in it. The mermaids and the miniature landscape on the

left are represented by lines indicating the contours of forms, and the point of view is from a slightly upward angle. The course of the river and the dynamics of its flow are registered diagrammatically and geometrically, and the point of view is from vertically above. A linear ripple convention on the water surface mediates between one style of representation and the other. The first convention is more immediately related to what we see, where the second is more abstract and conceptualised – and to us now rather unfamiliar – but they both involve a skill and a willingness to interpret marks on paper as representations simplifying an aspect of reality within accepted rules: we do not see a tree as a white plane surface circumscribed by black lines. (Baxandall, 1988: 32)

A number of points are worth drawing out of this paragraph. First, Baxandall talks about 'marks on paper' and the ways they are signs for flowing water, (imagined) bodies and land. He draws attention to a material surface and what it carries as the ground (literally and metaphorically) of a pictorial representation. He is aware of the materiality of the image that he analyses. This is important because a medium like a woodcut clearly offers different signifying resources than, say, an oil painting or a photograph.

Second, he sees the meaning of these marks on a surface (that is, flowing water) as dependent on interpretative skill and, even prior to that, a willingness or interest on the part of the viewer to interpret them. So he sees that the image implies something about its viewer and her or his competence in looking.

Third, he notes that several kinds of marks are doing different work within the one image: some are diagrammatic and others are 'more immediately related to what we see' (Baxandall, 1988: 32). (Lines, for example, are used to indicate or describe the edges of human forms. Of course, no such lines are to be found at the edge of our limbs but certain situations do arise when we perceive a contrast between a limb and a lighter or darker surface against which it is seen, the drawn line acts as a conventional equivalent for this contrast.) He sees these different kinds of marks as lying on a spectrum of possibilities which runs from the less to the more abstract. They all simplify reality and they are all subject (for the sense they make) to accepted rules, rules which may or may not be familiar to us given our membership of a historically or culturally specific sign community.

Semiotics and codes

Baxandall's description of these pictorial conventions comes close to the semiotic notion of an iconic sign, in which the signifier (the physical mark or material thing/ object/quality) bears some kind of resemblance to what it signifies (what it means or stands for). It also approaches, at the more abstract end of his spectrum, the semiotic premise that many kinds of sign are 'arbitrary'; that is their meaning is not directly dependent upon some intrinsic qualities that they have. Rather, within a culture, a certain kind of mark has been matched (and agreed by all who can understand the convention, the language, or the code, that it is so matched) with a certain kind of object or quality of objects in the real world.

Semiotics proposes that there are whole ranges of visual, material, pictorial and symbolic signs which are conventional in the way that Baxandall identifies, for

example in bodily movement and gesture, in the camera work, narrative devices and editing of film and television, in the weight, spacing and shapes of typographic forms. In this way the concept of a convention is extended to that of a 'code' – an extended system of signs which operates like a language (itself a code of uttered sounds or printed marks) (see Chapter 9).

There have been many attempts (within Cultural and Media Studies and elsewhere) to analyse images using elaborate and systematic semiotic theories of codes or of signification (the operation of signs) based upon the paradigm of language. Over repeated attempts, often under the sway of changing intellectual fashions (structuralism, post-structuralism, deconstructionism), it has become clear that a too rigid application of systematic methodologies for visual analysis, which take written or spoken language as a model, is self-defeating. There is always a tendency in such attempts to miss the specificity of the medium, and the practices built around it in social use, where signification actually takes place. Hence, in a good example of the (sometimes very productive) tensions inherent in Cultural Studies which were remarked upon at the beginning of this chapter, the application of de-coding methodologies or the practice of textual analysis are often challenged by insisting on the need to stress the negotiated, dialogic and sometimes resistant and subversive dimensions of human communication. In fact, it is this stress on the plural, messy, contested and even creative nature of our discourse with the visual and with images, the manner in which this is a site of a struggle over what something means, which often makes the Cultural Studies analyst wary of the very term 'communication', preferring instead 'representation' or 'mediation'.

Photographic conventions

Convention and meaning enter into the business of making photographs at the most basic technical level. Indeed, it has been pointed out that meaning is even encoded in the design of the apparatus of photography. Very different examples of this are provided by, for example, Snyder and Allen (1982) and Slater (1991). The very existence of the rectangular frame of the camera viewfinder and its picture plane was designed into cameras at an early stage in the history of photography. The round lens of a camera creates a circular image which shades off into obscurity at its circumference. Some two hundred years before the first successful chemical fixing of the camera image, 'the portable camera obscura of the early nineteenth century was fitted with a square or rectangular ground glass which showed only the central part of the image made by the lens' (Snyder and Allen, 1982: 68–9). This, as they point out, was the outcome of adjusting the camera image to meet the requirements of 'traditional art', the rectangular easel painting. This is a good example of the way in which a convention exists while its historical origins are forgotten. In considering the snapshot cameras of the mid-twentieth century, Don Slater (1991) sees that the small icons that help the snapshooter set the camera's focal length for a particular kind of subject matter – a portrait, a family group, a landscape – already anticipate the conventions by which such genres are recognized and need to be produced. We will start our own hunt for photographic

Figure 4.4 Robert Mapplethorpe. 'Portrait of Clifton', 1981.

conventions a little further on in the process, in the basic decisions that a photographer takes as she or he deploys their equipment (see Chapters 3 and 9).

First, however, we need to take care not to be misunderstood, as in what follows it could appear that we are imputing too much explicit intellectual effort to the photographer as they mobilize conventions. As for the fifteenth-century woodcut printer and his 'audience', conventions exist which are both used by photographers and understood by contemporary viewers of photographs. This is not to say that photographers consciously choose the conventions that they will use in making a picture. Some may of course, but we are not making the ludicrous suggestion that they hold seminars on semiotics in order to carry out a commission (although it may be worth remarking how close creative directors in advertising, whose job includes briefing photographers, come to doing this). In general, the use of conventions by photographers is a matter of assimilated 'know-how', a trained sense of 'this is how to do it' gained 'on the job' and by observing what does and does not 'work' in concrete

situations. Similarly, in looking at a photograph and finding meaning in it, we do not need to refer to a dictionary of conventions – we don't look them up. Unlike the woodcutter's 'now unfamiliar' diagrammatic representation of a river flowing, photographic conventions are very familiar to most of us: they fall below the threshold of conscious attention. They are nevertheless there.

It is the very degree to which sets of conventions have been assimilated, within a culture, as the way to do something, that guarantees their very naturalness rather than their evident conventionality. With regard to photographs in particular, the fact that they are also produced through mechanical and chemical processes tends to persuade us that they are not the outcome of skill in handling a 'language' but are automatic, and immediate, traces or reflections of what they depict (see Chapters 7 and 9).

The portrait by Robert Mapplethorpe in Figure 4.4 could seem to be without convention. Both its extreme simplicity (not much scope for artifice, arrangement or choice here) and its impact (a startled gaze which startles the viewer) is surely the result of something more like spontaneity or passion than a rule-governed activity or 'a socially agreed way of doing something'. In fact, within its simplicity, there is a considerable complexity of conventional devices and by identifying them we can go a long way toward accounting for some of its drama. The conventional operations that we would draw attention to are the following: framing, gaze, lighting, context, camera position.

First, the frame (itself, as we saw above, a device which has dropped well below visibility as the convention that it is): consider how tight it is set around the man's face. It excludes any signifying context except that of the deep black background. Anything that might locate, pin down, domesticate, classify, or otherwise offer us clues as to who this person is or what he does, is ruled out.

Second, the gaze: the man looks directly at us, wide eyed. In fact, what he looks at directly is the camera. Mapplethorpe has not had him look away to right or left, up or down, not even slightly. It is in looking at the camera that he appears to be looking at us. This is a convention known to portrait painters (who used linear perspective and ways of highlighting the eye, rather than a camera to achieve this) and film-makers who (except in special circumstances) strictly avoid the convention in order not to break the illusion that we are looking in on another world without ourselves being seen.

Third, the camera position places us completely on a level with the man. We are, in terms of frame, gaze and camera position 'face to face'. Strictly speaking it is us in our 'viewing position' (not our real location in the world) who are face to face with a man depicted in this way (which, of course, may not be how we would see his face, wherever it is, in the real world, at work, in a shop, a nightclub, whatever) (see Chapter 7).

Do we not also feel physically close to him? All of the conventional factors that we have been considering so far contribute to this sense of physical proximity. His head fills our field of vision as it is represented by the photograph and 'he' arrestingly answers, locks on, as it where, to our gaze. Lastly, the dark background and the arranged lighting of the head may contribute to this sense of proximity.

Here is a case of signification arising from the image's materiality. We can see the dark background as either measureless depth or flat surface, the material surface

of the picture itself. Seen in reproduction in this book we will tend to 'see through' the page to the image of an image – a poorly reproduced photograph. Seen as a framed 'fine print' in a photographic gallery we would be aware of the texture, lustre and grain of the black areas of the photograph as a material surface – as 'stuff' rather than depicted space. Two other factors that we have already met are at work here: the location of the image and the way we attend to it or the socially appropriate mode of looking. The very size of the photograph and the rituals of looking at photographs in galleries are likely to distance us from or bring us close to the actual object. The scale of the image also positions us in relationship to it. The way in which the man's head is lit (there is no natural light here, it is imported and arranged by the photographer), means that we 'read' the head as being in front of the already close black surface. It emerges from the black background or ground.

As we worked our way through the conventions that are at play in this image we saw, as they operated together, a photographic code. A set of signs that, taken together, means something to us. However, how we might express that meaning in spoken or written language is another matter. There are two reasons for this. One is a general matter of what and how images 'mean' and the second is particular to the kind of genre of art photography that Robert Mapplethorpe makes. In general, it can be very difficult to spell out the meanings of pictures in verbal or written language, which after all is another code. Some kind of translation is bound to take place either way but in this case from image to word. As John Berger (1972) has observed, language can never get on a level with images. Secondly, as a photographer working as an independent artist, Mapplethorpe is not charged with sending simple, clear messages or communicating unambiguous information to us. In fact, as a white gay photographer who frequently photographed naked black men his work is shot through with ambiguity and his interest in or desire to do this has provoked much debate (see Mercer, 1994: 171ff.).

Social conventions

Before we look further at the operation of photographic conventions and codes, we should recognize that photographs also work by utilizing or borrowing (by re-presenting them) many of the visual codes that are employed in 'lived' rather than textual forms of communication.

The mimetic capacity of a photograph, the way in which the indexical marks which its surface carries can resemble the look of objects and things in the real world, means that within a photograph certain things may be depicted or represented (through photographic conventions) which are themselves conventions in their own right. These are conventions that we employ in the wider social world, in our everyday lives and its sub-cultures. The photograph was described by Roland Barthes (1977: 17) as being a 'message without a code'. By this he meant something close to Susan Sontag's (1978) description of the photograph as a 'trace', a kind of direct print off the 'real' without any code (break-down into units) intervening. It is, for us, much harder to see what the equivalent of the woodcutter's conventions are in a photograph,

Figure 4.5 David Hampshire. Photograph of schoolboys, circa 1986.

although in the above example we have, hopefully, begun to do so. However, the other side of the coin, as it were, of this mimetic capacity of photography to be a trace or an imprint of the real is that it can borrow and carry all of the sign systems and codes (of dress, style, architecture, objects, body language, etc.) which, together with speech and the written word, sound and smell, make the lived world meaningful.

In the photograph in Figure 4.5 we can see how this is so. We are now using the other, more sociological, concept of convention. Much of the charge of this picture comes from the dress conventions of the boys who are represented in it. In a real sense, the photographer is using photographic codes to frame and point to this other set of signs that are used in everyday life. Consider the boy on the left of the frame. He is subverting a dress code and by doing so he is signalling his distance from the meanings of 'respectable', conventional, male dress codes.

A tie is an item of dress that is designed so as to hang between the collar of a shirt and the waist after it has been wrapped around its wearer's neck and tied in a certain way at the front, so that its knot sits neatly between the two wings of a shirt collar. The boy in the picture has not failed to achieve these conventional requirements of tie-wearing – he has deliberately used his tie to flout them. He has, literally, made it do something else. He has consumed the whole length of the tie in the knot and contrived to position it some inches away from its conventional place. The meaning of doing this will be apparent to others who also wish to resist the conventional uniformity encouraged by the institution of the school. Symbolically, at least, he is signifying his sense of exclusion from the 'community' of the school and his inclusion or membership of 'the lads'. He is marking out a difference. Clearly, the success of his

semiotic work depends upon knowing first that there is a conventional way to wear ties. The boy in the centre of the picture has done something similar by turning his tailored and lapelled jacket into a kind of all-enveloping tunic. If we catch echoes of generic movie images of the rebel caught in the rain or cold, we are probably not far from identifying one of the sources for this particular convention.

Power and photographic conventions

Figure 4.6 New Year's Day, Korem camp, Wollo province, Ethiopia, 1985.

Figure 4.7 Mike Goldwater. Drought migrant, Zalazele transit centre, Tigray, 1983.

We now turn our attention to some photographs (Figures 4.6, 4.7, 4.8 and 4.9) where, given the institutions for which they were made (newspapers and magazines), we can assume some intention to communicate information was of a high priority. These are images which belong to the genre of photojournalism, images made specifically to report on events.

Like the Mapplethorpe portrait, but for different reasons, such photographs are also characteristically marked by their lack of apparent artifice or display of pictorial convention. Indeed, sometimes referred to as 'straight photography' to distinguish it from the elaborate arrangement, setting up, lighting and theatricality of other kinds of photography (advertising, fashion, art), the very invisibility of convention seems to speak instead of photography's power to provide direct evidence of events.

The credits tell us that the photographs were taken in Africa (Ethiopia and Sudan) during periods of famine in the 1980s. The original credits also indicate that the photographers who made these photographs were working for picture agencies (Magnum and Bisson/Collectif), probably on a freelance basis, and hoping to place their work with newspapers, magazines or, possibly, famine relief charities.

These photographs were reproduced as part of a special 1985 issue of the photographic journal *Ten: 8* which examined the politics of famine relief. It explored the part that photography played in constructing a Eurocentric view of Africa and its peoples as economically and technologically weak, dependent victims of natural disaster. The accompanying text argues the case that photojournalists foster this view and that, together with the demands upon aid agencies to raise money, a view of Africa and Africans

is constructed which renders their normal self-sufficiency and culture invisible. At the same time the manner in which famine is represented ignores the role of capitalism and the history of imperialism in bringing about a situation whereby African economies are crippled by long-term debt repayments, the use of fertile soil to grow cash crops for export and dependency on short-term emergency aid.

In the text which accompanies the reproduction of these photographs in *Ten: 8,* some research is cited which indicates what ideas and images of the 'Third World' and its peoples a group of London school pupils gained from television and photo-reportage. They list poverty, babies dying, monsoons, disease, drought, refugees, flies, death, dirty water, beggars, malnutrition, bald children, large families, insects, poor clothing, bad teeth, kids with pot bellies, mud huts and injections (Simpson, 1985: 23).

These are all important factors which bear upon matters such as the tasks and commissions which the photographers are given, the purposes of the agencies that they work for, the 'news values' that they are expected to provide and the selection and editing of images by editorial staff for publication (see the section above, 'Context of production').

However, in this section we wish to concentrate upon how meaning is encoded in particular photographs. The point is to see what ideological weight conventions have, especially when they operate as parts of a complex photographic code. For the photographer who wishes to avoid producing yet another image which compounds the restricted perceptions of Africa noted above, there will be a struggle to encode different meanings in a photograph, something that begins with the choice to deploy conventions in a single act of image making. We can see this in the two images reproduced in Figures 4.6 and 4.7.

Both images represent people in obvious distress. The main signs of this distress are facial expression, the gesture of hands, bodily position and stance. We noted above that these were not, strictly speaking, photographic conventions but more broadly social and cultural ones which photographs 'cite'. They are part of the human body's expressivity. Our ability to read the signs through which bodily and mental states are expressed is a social not a photographic skill. The photographer expertly borrows these signs and relies upon our abilities, learnt through our lived experience, to read them. Often to a high degree these signs are indexical, the class of signs famously identified by C.S. Peirce where the material sign (the signifier) is caused by what it means (the signified). The usual examples in semiotic primers are the footprint = foot, smoke = fire and knock at door = presence. They are different because they are less arbitrary and symbolic than signs like 'dog' or 'chien' are for the animal it signifies. In these latter cases, these ink marks on paper are not caused by dogs having passed this way.

In Figure 4.6 there is a certain strain in the musculature of the man's face, in his open mouth and furrowed brow, which we can recognize as meaning something in the sphere of pain and hopelessness. Likewise, in 'Drought migrant' (Figure 4.7), the woman's eyes are heavy-lidded and unfocused, while she 'holds' her head – they signify something in the sphere of exhaustion and nervous distraction. It is hard to be precise, but we would surely agree on what they do not signify and on the spectrum of conditions and feelings where the meanings lie. A photograph trades in mimesis,

in establishing perceivable and meaningful similarities between one thing (a human face) and another (a set of tones on a paper surface).

There are, of course, varying degrees of such direct, symptomatic indexicality in human and bodily expressions. Consider the 'coded' smile which is not a direct expression of pleasure but a knowing and ironic response to disappointment or sadness. However, when such signs are themselves represented in a photograph, they are far from natural. Consider that before and after the moment of the photographic exposure that produced these images the subject's expression and position might have been different and less culturally or symbolically expressive of distress. First, it is likely that the photographer took a number of exposures and later chose (edited) a contact strip of her or his film to choose the image in which the signs of distress (of whatever order) were most evident. (Or selections may have been made by a picture editor, anxious to reinforce particular inflections of the famine story.) Second, there is no direct equivalence between a human face seen in a photograph and in other lived situations, something that was pointed out in discussing the Mapplethorpe portrait.

We will now consider the material qualities of some particular photographs and how they work to add meaning to these social codes and, as they do so, edge us toward recognizing how the photograph is a complex construct of signs.

First, we consider the edges or boundaries of the pictures: the frame. The framing of the 'straightest' picture is something that must be decided upon both at the time of offering up the camera's lens to the scene and later when making a print in an enlarger (or, in the case of digitized pictures, in a computer image manipulation programme), or possibly when digitally or physically cropping the print. In 'New Year's Day' (Figure 4.6) the frame is set wide: over two-thirds of the picture area represents a surface which we read as a baked and cracked plain of earth, some far-distant figures, a line of low hills behind them, a strip of almost cloudless sky. The setting of the frame in this way with the figure of the kneeling man, slightly off-centre, is the first means by which he is located and isolated in this barren space. If we imagine tightening the frame and shifting it to our left, no doubt to include a second or more figures in the picture, this image of isolation disappears.

Second, we consider the depth of field, a term which refers to how much of the scene is in sharp focus and, depending upon available light and speed of film, is a factor within the photographer's control. By choosing a combination of shutter speed and aperture (or allowing an automatic camera to set them) depth of field can be shallow or deep, restricting or amplifying the information we are given. The depth of field in this image is considerable. We see the cracked earth on which the man sits, the texture of his worn garments and the delineation of the tiny distant figures and hills. This choice of depth of field (or at least the choice not to limit it) reinforces the sense of the man's isolation, first established by the frame.

Third, we consider the quality of the light that makes the man visible and the photograph possible. Clearly this is natural ambient light (the midday sun?) which is not directly within the photographer's control. However, it is utilized by the photographer and the manner in which strong light with a high source, directly above the subject, describes surfaces in terms of stark contrasts is an important factor here. The deep shadow marking the man's eye sockets and the sharp delineation of his collar

bone and upper ribs are given emphasis by the photographer's choice to make the exposure at a place and a time when the light is of this kind. Compare this with 'Drought migrant' (Figure 4.7) where the light is more diffuse.

The focus and the light are also reinforced by the fine grain and optical resolution of the photograph. The skin of the man's head, veins standing proud on his temple, the surface of his neck and chest, the rough texture of his clothes and the cracked earth are all very apparent to us. Through these optical means our tactile sense is engaged.

Fourth, we can note that the frame or moment chosen by the photographer has the man looking upwards and out of the frame to his right. He looks up at something or someone who is invisible to us. A number of factors that we have already considered work together with this gaze (the facial expression, the delineation of the face and body, the isolation in space) to make this an image of tragic supplication. Such a gaze also adds a narrative element to the picture: something is happening outside of the space and the moment of the photograph to which it nevertheless alludes (see Chapter 7). The camera's point of view (the place from which we look) is high. He kneels; 'we' stand.

Turning now to 'Drought migrant' (Figure 4.7) we can see how each of these factors plays a different role. The face and upper body of the woman occupies over half of the framed picture area. We are positioned on a level with her. She is shot in close up and, as with the Mapplethorpe photograph, codes of space and personal proximity are put in play. Yet, markedly different from either the Mapplethorpe or the previous picture of the man on the parched plain, her eyes do not engage ours or actively direct our attention elsewhere. They look forward and out of the picture space towards the space we occupy as viewers, but in a 'blank', unfocused way that does not directly answer our own gaze and we can read as a symptom of exhaustion. The light in this photograph is less harsh and revealing of contrasts, softer and more diffuse, than that in 'New Year's Day' (Figure 4.6). The depth of field is shallow and we cannot read what is behind her or where she is, except to see a blurred image of a second woman whose gesture echoes her own.

Overall, even though we have again a single main subject in a landscape format, we can conclude that this woman is not positioned and represented as an isolated victim seeking or imploring help, physical state unflinchingly delineated, as is the man in 'New Year's Day'. The softness of light and grain, the interiority of the women's gaze together with the rhetorical quality of the way her hands are included in the frame and cradle her head, and a choreographed quality in the way this gesture is echoed in the second figure, approaches an aestheticization of the horror of the woman's situation.

Finally, we turn to two other images (Figures 4.8 and 4.9) from the same edition of the magazine. These enable us to introduce some new points about photographic codes and the 'positioning' of the viewer. They are also useful because in comparing this new pair with the two images of 'famine' we have so far been discussing, we are alerted to the relative similarity of those two images rather than their differences, which has been the object of our analysis so far.

'USAid' (Figure 4.8) introduces the element of juxtaposition within the frame. The depth of field ensures that we read the letters USAID on the side of a Range Rover

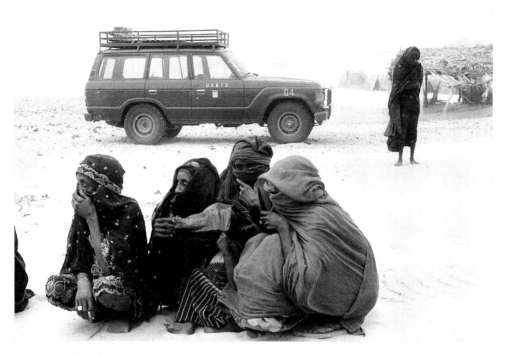

Figure 4.8 Chris Steele-Perkins. USAid, Sudan, 1985.

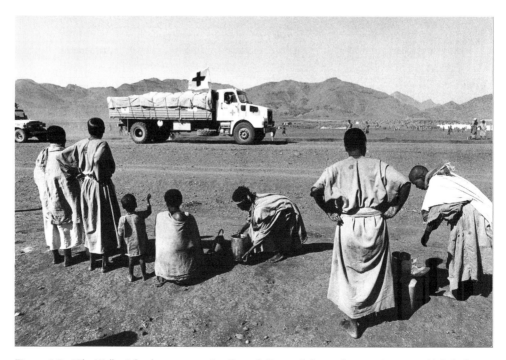

Figure 4.9 Mike Wells. A food convoy passing through Korem Refugee Camp on its way to Makele Camp in Tigray, February 1985.

positioned on the picture plane close to a group of women huddled in the foreground. For the European–American viewer the 'ethnic' dress and swathed faces of the women are played off against an icon of the West's advanced automobile technology. At first sight, like the man in 'New Year's Day' (Figure 4.6), we see that the attention of the group of women is directed towards another event taking place beyond the frame, until we notice that the third woman from the left is looking across the direction of the others' gazes and directly at the camera. Unlike the explicit and direct meeting of the camera's/viewer's gaze in the Mapplethorpe image (which makes no pretension to be a documentary record), we have here a rupturing of the documentary rhetoric. Our position as voyeurs (seeing but not seen) and the power of the camera to scrutinize (without its operation itself being scrutinized) is revealed. 'We' are seen and our gaze is returned. So in this image the photographer is, in a sense, caught in the act of constructing, through juxtaposition, a statement about what is before him.

In 'A food convey' (Figure 4.9), for the first time in this brief analysis, the camera shares the viewpoint and perspective of the subjects in the photograph. We stand with and behind the group who attend to their water pots and as the child raises its hand at the passing Red Cross convoy. If we return to think about the image of the 'redneck' in the Marlboro advertisement with which we began this chapter, which similarly 'invites' us to look with the depicted subject(s), we can begin to see how the more technical proposition of a 'viewing position' opens up into the fuller concept of a 'subject position'. Who are we, in each case? Who looks like this, with others, and at what?

LOOKING: RECOGNITION AND IDENTITY

Who is the viewer and how are they placed to look? Being 'placed', part of having an identity, is to some extent given by the form of the image itself. In short, all or most images in the Western pictorial tradition (and this includes most photographic images where the camera and its lenses have become key mechanisms in furthering and elaborating this tradition) are designed or structured so as to 'tell' the viewer where they are. As Bill Nichols has argued: 'Renaissance painters fabricated textual systems approximating the cues relating to normal perception better than any other strategy until the emergence of photography' (Nichols, 1981: 52).

As we have already noted (see p. 73), camera technology was developed and adjusted in order to take on perspectival conventions already established within Western art. Nichols goes on to argue that just as the painting stands in for that which it represents, so perspective, organized in relation to a singular imaginary point of origin, stands in for the emphasis on the individual concomitant with the emergence in the West of entrepreneurial capitalism. Thus the viewing position constructed via the camera cannot be seen as ideologically neutral. Rather, particular value systems, organized around individualism, inform our look.

That this viewing position is voyeuristic has become something of a preoccupation within cultural studies. As we have already remarked, in the Mapplethorpe portrait the man viewed seems to look back at us. This is relatively unusual. More commonly,

we look at images of people who appear unaware of the presence of the camera and – by extension – the possibility of becoming the object of someone else's look. Thus, it has been argued, the viewer exercises a controlling gaze. This notion of the voyeuristic gaze has been used to describe the way in which tourists look at the non-Western world as well as the way men often look at women (see Chapter 3).

In her well-known article on narrative cinema and visual pleasure, first published in 1975, Laura Mulvey drew upon Freud's emphasis upon scopophilia as a primary human instinct and his ensuing discussion of voyeurism within her analysis of the processes and pleasures of popular cinema spectatorship. She argued that the (male) spectator voyeuristically gratifies his erotogenic impulses through his controlling look, which is mediated through the look of the camera and through the look of male characters within the world of the film, at the female figure on screen. The argument is complex but, in brief, she concluded that pleasure in popular narrative cinema emerges from the fetishization of the female figure as an object of desire. Although subsequently criticized for its narrow concern with the male heterosexual spectator, this essay was ground-breaking at the time as it was an early attempt to articulate psychoanalysis and feminism in order to analyse visual pleasure.

Victor Burgin took up this model in relation to looking at photographs:

> Following recent work in film theory, and adopting its terminology, we may identify four basic types of look in the photograph: the look of the camera as it photographs the 'pro-photographic' event; the look of the viewer as he or she looks at the photograph; the 'intra-diegetic' looks exchanged between people (actors) depicted in the photograph (and/or looks from actors towards objects); and the look the actor may direct to the camera. (Burgin, 1982: 148)

'An oblique glance' (Figure 4.2) offers an exemplary opportunity to demonstrate and discuss the mobilization of the look within photography. The camera occupies the essentially voyeuristic position of being hidden in the shop out of the sight of passers-by, thus constructing a voyeuristic position for the viewer of the photograph whose 'catching out' of the couple cannot be acknowledged since they have no idea of the presence of the candid camera. Since the camera is not acknowledged, what preoccupies us here, and, indeed, offers the primary source of interest and amusement, is the exchange of looks within the photograph. To be more precise, it is a traversing of looks, rather than an exchange, since the woman is contemplating, and appears to be speaking about, an image which we cannot see whilst the man glances across her to contemplate the fetishized nakedness of the woman depicted in the ornately framed painting. The humour lies in this traverse, in the neat observation of a subversive moment which is heightened through the presence of the boys in the background outside the shop across the road (perhaps engaged in some mischievous activity) – in other words, the ordinariness of the setting.

As Mary Ann Doane has argued, this image appears to centre upon the woman looking, yet what makes it interesting in terms of the psychoanalytic is the scopophilic gaze of the man placed half out of the frame (Doane, 1991: 28ff.). His gaze effectively encases and negates hers, not only because the object of her look cannot be seen and shared by us but also because the geometry of the image is defined by the male axis

of vision across from one edge of the image to the other. Her gaze centres on an image invisible to us and has no part to play within the triangle of looks which offers complicity between the man, the nude and the viewer and thus animates the image. Indeed, the woman, despite being central within the picture, functions as the butt of the joke which is what the picture is actually about. This joke confirms women's place as object of the look since the key female presence is not that of the woman within the couple but that of the nude in the painting. This photograph engages the viewer in complicity with the man in ways which, as with the photograph of the schoolboys discussed earlier, articulate recognition of and, possibly, identification with a certain subversiveness. In this instance, however, the position of identification is distinctly uncomfortable for the female viewer since it is founded on the objectification of the naked woman, in phallocentric understandings of desire.

The bringing of psychoanalysis to bear on the image has been influential. As noted earlier, Mulvey (1975) drew upon Freud's discussion of scopophilia, the instinct to look, and voyeurism, the desire to exercise a controlling gaze, in order to discuss the positioning of the female figure in popular cinema as the passive bearer or object of the male gaze. For Freud woman was 'other' and femininity was a mysterious riddle. As he famously remarked about women, 'you are yourselves the problem' (Freud, 1933: 146). Mulvey drew upon psychoanalysis to investigate ways in which, in narrative film, pleasure in looking was constructed around the active male look. Despite criticism for focusing on the male gaze and heterosexual looking/desire, her essay made a key contribution within Visual Cultural Studies as it introduced debates about the pleasures of looking at images which articulated questions of social power – in this instance, patriarchy – with questions of sexuality and the erotogenic imaginary.

Within Visual Cultural Studies such debates broadened initially to take account of the female gaze, of homosexual looking and of what John Urry has termed 'the tourist gaze' (Urry, 1990). As Patricia Holland has remarked in relation to ethnic otherness:

> The coming of photography gave rise to a new set of dilemmas around the production of the exotic. On the one hand it displayed images of hitherto unknown and remarkable places and people, but at the same time it had to be recognised that these were *real* places and people. The veneer of exoticism may be confirmed or challenged by the photograph itself. (Holland, 1997: 113)

Thus broader parameters have been adopted: analysis of the gaze now considers a complexity of social positions and power relations, and also takes into account the implications of looking *from* positions defined as 'other'.

More recently issues pertaining to the fluidity of identity have been brought into play. Here, psychoanalytically informed questions relating to identity and identi-fication processes influence sociologically determined questions associated with cultural self-location. Following Laplanche and Pontalis, we can take identification as a 'psychological process whereby the subject assimilates an aspect, property or attribute of the other and is transformed, wholly or partially, after the model the other provides' (Laplanche and Pontalis, 1988: 205). They add that 'it is by means of a series of identifications that the personality is constituted and specified'. This obviously

draws upon Freud, but it can take us into discussions of the power of representation, and of identification processes within societies acknowledged as multi-cultural ethnically, and also in terms such as class or region. As Bailey and Hall have argued:

> Post-structuralist thinking opposes the notion that a person is born with a fixed identity – that all black people, for example, have an essential, underlying black identity which is the same and unchanging. It suggests instead that identities are floating, that meaning is not fixed and universally true at all times for all people, and that the subject is constructed through the unconscious in desire, fantasy and memory. This theory helps explain why for example an individual might shift from feeling black in one way when they are young, to black in another way when they are older – and not only black but male/female, and not only black but gay/heterosexual, and so on. (Bailey and Hall, 1992: 20)

They add that 'identities are positional in relation to the discourses around us. That is why the notion of representation is so important – identity can only be articulated as a set of representations' (1992: 21). Here, first, identity is seen as unfixed and, second, it is conceptualized as complexly and ambiguously caught up within identification processes.

Returning to the pictures of African people disempowered economically and subjected to famine (Figures 4.6 to 4.9), how are we positioned as viewers of these pictures? Here many of us are clearly *not* like the people pictured. Our position is as virtual tourist, Western outsider, as onlooker. However, ambiguities do enter in. We may identify at some level as women, or in terms of ethnicity, not with the plight of the people depicted so much as in a sort of universal humanitarian way. This identification is in accord with the rhetoric of these images which invite compassion, and are broadly recognizable as the type of pictures used by aid agencies and charities for fund-raising. Fundamental within this is the reassurance of otherness and of our safer social and political location.

By contrast, if we return to the Mapplethorpe portrait, our sense of self may be more ambiguously caught up within a set of slippages associated with sexuality and, from a white point of view, fascination with the ethnic other (which seems to have motivated a number of Mapplethorpe's portraits and has been one of the key sources of offence at, and attempts to censor, his work). Yet a similar complexity is associated with a recent advertisement for Pirelli tyres (Figure 4.10). Pirelli are known for producing calenders featuring naked women as pin-ups, which, in the 1970s, attracted disapprobation from feminists concerned with media representations of women. This image of Carl Lewis, the male athlete, poised as if to sprint but wearing red stilettos (which would prevent him from running anywhere) references the fetishization of the pin-up, deliberately playing upon ambiguities in gender, ethnicity and sexuality. As an image of a black 'hero' it challenges and disorients assumptions. We might fantasize ourselves as a successful athlete, and thus in some way identify with Carl Lewis, but the ambiguity of this image probably stops us short in our tracks. In discussing the spectacle of the other, Stuart Hall comments that this image works through acknowledging difference: 'The conventional identification of Lewis with black male athletes and with a sort of "super-masculinity" is disturbed and undercut

by the invocation of his "femininity"' – and what marks this is the signifier of the red shoes' (Hall, 1997: 233). The advert arrests attention through playing with conventional signifiers and stereotypes, confident in our reading competencies, that is, in our ability to unpick and enjoy the range of intertextual references mobilized.

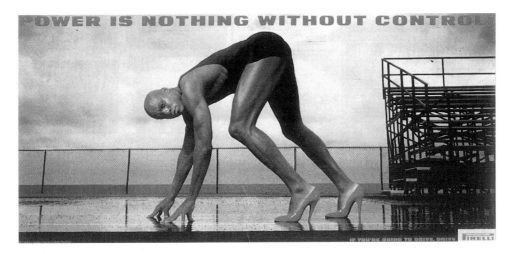

Figure 4.10 Carl Lewis photograph for a Pirelli advertisement.

So far all the pictures we have discussed have figured people. Finally, in Figure 4.11, we consider a landscape empty of people but replete with cultural references. Here a photograph of a biscuit cutter, in the shape of a sheep, is placed on top of a pile of hewn stone in the foreground of a moorland landscape. It has been constructed primarily as a gallery image and, as with all images, relies upon the viewer bringing a set of previous knowledges or competencies into play. It is one of a series in which domestic romanticization of the rural is wryly noted through the photographing of a toy or kitchen utensil in the location which it references. This work is culturally specific, relying as it does on familiarity with British land, with landscape aesthetics and with what we might term the 'Laura Ashley – National Trust' invocation of the pastoral. The stone walls imply that this is moorland, rather than central England farmland.

As with all photographs it is productive to discuss this image in immanent terms, taking account of framing, composition, tonal contrast and accordance with the photographic convention of representing land through translating views into black and white landscapes. In formal terms, it complies with the landscape aesthetic of horizontal divide as a one-third:two-third proportion; the land rolls away downwards before rising into the distance; the stone wall is foregrounded through sharp photographic focus which we decode as emphasizing its significance within the picture. The camera has been placed to underscore the placing of the 'sheep' in this position, overviewing the land, exercising a territorial gaze. Irony resides in recognizing the incongruity of placing a biscuit cutter to stand in for the relation of actual sheep to

Figure 4.11 Sean Bonnell. Chalk Down, from the series Groundings, 1996.

the moorlands which are their pastures and which, in turn, are grasslands kept from overgrowth through the grazing of sheep, goats and ponies.

From the point of view of the viewer there is yet more to be said. The wall on which the sheep stands represents a boundary or obstacle beyond which we are not supposed to step. We are excluded from the empty, expansive hillsides. Arguably, we are reminded of our place as observer, rather than as roamer. For those of us who draw rural England into our sense of national identity, there is also reassurance of something which may seem essentially British. Here we might contemplate the priority allocated to looking, to opticality, implicit in the photograph as a visual medium and, in this instance, in the photographing of land as landscape. The image may conjure up affective memories of other senses heightened in actual experience of the rural: sound, smell, touch.

So, as we now see, 'viewing position' is one component of a more complex concept – a 'subject position' (see Chapter 9). The simplest examples include those images which place us in a privileged position to see things clearly or synoptically (some argue 'panoptically'). Others cast us as voyeurs, hidden from the view of those depicted ('others') on whose bodies or actions we gaze from our occluded position. Yet other images belittle us, overawing us with their scale, relative physical placing and the perspectival rendering of the position of those who look down upon us. This particularly relates to certain settings: church, art gallery and, as we have seen in the

case of Marlboro, billboards. Many images centre us in a complex world laid out for our eye in ways that would be impossible in reality. Issues of proximity, intimacy and distance are important here. However, beyond placing us, images also tell us who we are in other ways; they offer us an identity. This is a transient sense of identity consequent upon looking at the image, engaging with and enjoying the messages and meanings it then gives to us.

CONCLUSION

As Annette Kuhn has succinctly commented:

> In general, photographs connote truth and authenticity when what is 'seen' by the camera eye appears to be an adequate stand-in for what is seen by the human eye. Photographs are coded, but usually so as to appear uncoded. The truth/authenticity potential of photography is tied in with the idea that seeing is believing. Photography draws on an ideology of the visible as evidence. (Kuhn, 1985: 27)

Nevertheless, photographs are often treated as if they were a source of objective and disinterested facts, rather than as complexly coded cultural artefacts. Roland Barthes (1984) draws our attention to the fleeting nature of the moment captured in the photograph and the extent to which contemporary experience, along with limited knowledge of the specific context within which – and purpose for which – the photograph was taken, inform ways of seeing and introduce slippages of meaning into any view of the image as witness. Photography contributes to the construction of history; it is not a passive bystander. When photographs are presented as 'evidence' of past events and circumstances, a set of assumptions about their accuracy as documents is being made. Such assumptions are usually acknowledged through statements of provenance: dates, sources, and so on. But this is to ignore wider questions about photographs concerning their status and processes of interpretation. As we have already noted, usefully, Susan Sontag (1978) uses the term 'trace' to express the caution with which the analyst needs to think about the relation of the photograph to the material world. As Allan Sekula remarks: 'Ultimately, then, when photographs are uncritically presented as historical documents, they are transformed into aesthetic objects. Accordingly, the pretence to historical understanding remains although that understanding has been replaced by aesthetic experience' (Sekula, 1991: 123).

As this implies, the original reasons for making an image, and the constraints operating within the context of its making, may disappear only to be replaced by new and substitute references and expectations. Furthermore, whatever an image depicts or shows us, the material means and medium employed to do so have a bearing upon which qualities of the depicted thing or event are foregrounded. For instance, our responses are influenced by the use of glossy paper as against cheaper, matt, absorbent paper or by the differences brought about by the use of high or low resolution VDUs when considering images downloaded from a website or stored on CD-ROM. Finally, it is not possible to separate out 'what is said' from 'how it is said'. To recognize this is not necessarily to go as far as Marshall McLuhan's edict that 'the medium is the

message' but it is to recognize a degree of sense in his insight. Roland Barthes used the term 'the rhetoric of the image' to point to the way in which seductive or persuasive means are employed to make an argument or to convince us to see things a certain way.

The photographic image is, then, a complex and curious object. As we have shown, the methodological eclecticism of Cultural Studies allows the analyst to attend to the many moments within the cycle of production, circulation and consumption of the image through which meanings accumulate, slip and shift. This is achieved through holding in play diverse approaches to the image which in their interaction acknowledge this complexity. This is simultaneously its strength and a point of criticism.[5] Indeed, in some ways Cultural Studies may seem to be a rather messy field, lacking precise boundaries and unconstrained by any single set of disciplinary protocols. But its ability to articulate a range of systematic methods of analysis in order to complexly address questions of form, production, reception and meaning while taking account of political issues, institutions and ideological discourses makes it comprehensive, significant and fascinating as a field of operation. The refusal to be prescriptive about method but rather to point to a variety of methods, and also to encourage analysts to bring into play their own experience, further underpins the strength of Cultural Studies.

NOTES

1 However, for the contrary argument, that Cultural Studies should be or is a discipline, see Bennett, T. (1998).

2 Given that historically men have been more active than women as photographers, and given the criteria mentioned above, together with the copyright availability of examples known to us, what we have constructed is a sequence mainly of photographs of men by men. A number are also of black African people, photographed by white photojournalists and now commented upon by white intellectuals. Does this matter? Cultural Studies (sometimes referred to as 'victim studies') is frequently charged with an obsession with political correctness (PC). We would say it does matter but the answer is not to add a PC 'quota' of images. The point is to be aware, reflexively, of how the work we are doing (the academic exemplification and exegesis of a kind of method) and the conditions in which we are doing it mean that some things have been rendered invisible and others have not been foregrounded.

3 News values in Media Studies refers to particular dominant agendas within news reporting associated with subject-matter, urgency, assumptions about the appropriate style of treatment, and so on.

4 An instance would be Oliveri Toscani, the Benetton art director, whose name in itself now serves to confer extra interest in the campaign or product, recently exemplified in his leadership of a campaign to draw attention to tourism and its implications for the survival of Venice.

5 For instance, Victor Burgin has accused Cultural Studies of borrowing from psychoanalysis in ways which over-simplify and therefore misappropriate concepts and terminology (Burgin, 1996).

REFERENCES

Bailey, D.A. and Hall, S. (1992) 'The vertigo of displacement: shifts in black documentary practices', *Critical Decade Ten.8*, 2 (3): 14–23.

Barthes, R. (1977) 'The photographic message', in S. Heath (ed.) *Image, Music, Text*. London: Fontana.

Barthes, R. (1984) *Camera Lucida*. London: Fontana (originally published in French, 1980).

Baxandall, M. (1988) *Painting and Experience in Fifteenth Century Italy*. Oxford: Oxford University Press, 2nd edn (1st edn 1972).

Bennett, T. (1998) *Culture: A Reformer's Science*. London, Thousand Oaks, New Delhi: Sage.

Berger, J. (1972) *Ways of Seeing*. Harmondsworth: Penguin.

Burgin, V. (1982) 'Looking at photographs', in V. Burgin (ed.) *Thinking Photography*. London: Macmillan.

Burgin, V. (1996) *In/different Spaces*. Los Angeles: University of California Press.

Cartier-Bresson, H.C. (1952) *The Decisive Moment*. New York: Simon and Schuster.

Doane, M.A. (1991) 'Film and the masquerade: theorizing the female spectator', in M.A. Doane (ed.) *Femmes Fatales*. London: Routledge.

du Gay, P. (ed.) (1997) *The Production of Culture/Cultures of Production*. London: Sage and Oxford University Press.

Freud, S. (1933) 'Femininity', in *New Introductory Lectures on Psychoanlaysis*, vol. 2 of The Penguin Freud Library. Harmondsworth: Penguin.

Hall, S. (ed.) (1997) 'The spectacle of the Other', in S. Hall (ed.) *Representation: Cultural Representations and Signifying Practices*. London: Sage and Oxford University Press.

Hamilton, P. (1995) *Robert Doisneau, A Photographer's Life*. New York: Abbeville Press.

Henning, M. (1995) 'Digital encounters: mythical pasts and electronic presence', in M. Lister (ed.), *The Photographic Image in Digital Culture*. London: Routledge.

Holland, P. (1997) 'Sweet it is to scan: personal photography and popular photography', in L. Wells (ed.), *Photography: A Critical Introduction*. London: Routledge.

Kuhn, A. (1985) *The Power of the Image*. London: Routledge & Kegan Paul.

Laplanche, J. and Pontalis, J.-B. (1988) *The Language of Psycho-analysis*, trans. D. Nicholson-Smith. London: Karnac and the Institute of Psycho-Analysis (originally published 1973).

Mercer, K. (1994) 'Reading racial fetishism: the photographs of Robert Mapplethorpe', in K. Mercer (ed.) *Welcome to the Jungle*. London: Routledge.

Mirzoeff, N. (ed.) (1998) *The Visual Culture Reader*. London: Routledge.

Mulvey, L. (1975) 'Visual pleasure and narrative cinema', *Screen*, 16 (3), Autumn: 6–18.

Nichols, B. (1981) *Image and Ideology*. Bloomington, IN: University of Indiana Press.

Panofsky, E. (1955) *Meaning in the Visual Arts*. Harmondsworth: Penguin.

Rogoff, I. (1998) 'Studying visual culture', in N. Mirzoeff (ed.), *The Visual Culture Reader*. London: Routledge.

Sekula, A. (1991) 'Reading an archive', in Brian Wallis and Marcia Tucker (eds), *Blasted Allegories*. Cambridge, MA: MIT Press.

Simpson, A. (ed.) (1985) *Famine and Photojournalism, Ten: 8*, 19.

Slater, D. (1991) 'Consuming Kodak', in Jo Spence and Patricia Holland (eds), *Family Snaps: The Meanings of Domestic Photography*. London: Virago.

Snyder, J. and Allen, N.W. (1982) 'Photography, vision and representation', in T. Barrow, S. Armitage and W. Tydeman (eds), *Reading into Photography*. Alberquerque: University of New Mexico Press (first published 1975).

Sontag, S. (1978) *On Photography*. Harmondsworth: Penguin.

Urry, J. (1990) *The Tourist Gaze: Leisure and Travel in Contemporary Societies*. London: Sage.

5 Semiotics and Iconography

THEO VAN LEEUWEN

INTRODUCTION

This chapter discusses two approaches to visual analysis: the visual semiotics of Roland Barthes (1973, 1977) and iconography. These two approaches ask the same two fundamental questions: the question of representation (what do images represent and how?) and the question of the 'hidden meanings' of images (what ideas and values do the people, places and things represented in images stand for?). With respect to the images in Figure 5.1, taken from a Dutch junior high-school geography textbook (Bols et al., 1986), these questions would become: (1) Who and what are the (kinds of) people, places and things depicted in these two images, and how do we recognize them as such?; and (2) what ideas and values do we associate with these depicted people, places and things, and what is it that allows us to do so? But where Barthian visual semiotics studies only the image itself, and treats cultural meanings as a given currency which is shared by everyone who is at all acculturated to contemporary popular culture, and which can then be activated by the style and content of the image, iconography also pays attention to the context in which the image is produced and circulated, and to how and why cultural meanings and their visual expressions come about historically.

The formulation 'people, places and things' indicates that Barthian visual semiotics and iconography deal, by and large, with the individual bits and pieces within images; in other words, they concentrate on what, in the case of language, we would call 'lexis' or vocabulary. The social semiotic approach described in Chapter 7 has relatively little to say about 'visual lexis' and hence one or both of the approaches described here would form a very useful complement to it. On the other hand, Barthian semiotics and iconography do not have very much to say about visual 'syntax'. Although they do not stop at inventories of the meanings of the individual people, places and things in images and also put them together to show how they add up to a coherent whole, they do not usually identify specific patterns for this or use specific methods to put the meanings together. (Iconography sometimes does, but generally within the confines of a specific style, school or period.) Again, this suggests possibilities for combining social semiotics and the approaches described here. The formulation 'people, places and things' might also seem to exclude 'abstract things'. While it is true that Barthes has concentrated on figurative images, more specifically photographic images (see Groupe μ, 1992 for a structuralist approach to abstraction), and that iconography

Figure 5.1 'The Third World in Our Street' (from Bols et al., 1986).

has also emphasized figurative art, there is no reason why the methods described here cannot also be applied to 'abstract things', and I will try and show this in the course of the chapter.

Finally, this chapter should not be seen as an introduction to Barthian visual semiotics and iconography as a whole. It concentrates on the way in which 'public' images are analysed within these two approaches. It leaves aside, for instance, Barthes's later concerns with the immediate emotive impact of certain aspects of images, with the 'punctum' of the image (Barthes, 1982), or the concern of iconography with dating works of art and authenticating their authorship, and focuses on concepts and methods useful for contemporary studies of the visual representation of specific issues.

SEMIOTICS

In Barthian visual semiotics, the key idea is the layering of meaning. The first layer is the layer of *denotation*, of 'what, or who, is being depicted here?'. The second layer is the layer of *connotation*, of 'what ideas and values are expressed through what is represented, and through the way in which it is represented?'.

Denotation

For Barthes, denotation is a relatively unproblematic issue. There is no 'encoding' into some kind of language-like code which must be learnt before the message can be deciphered. Perceiving photographs is closely analogous to perceiving reality because photographs provide a point-by-point correspondence to what was in front of the camera, despite the fact that they reduce this reality in size, flatten it and, in the case of black and white, drain it of colour. In the case of drawings and painting the situation is not essentially different. Although the style of the artist provides a 'supplementary message', the content is still 'analogical to reality'. Here is how Barthes describes the denotation in one of his most often quoted examples: 'I am at the barber's and a copy of *Paris-Match* is offered me. On the cover, a young Negro in a French uniform is saluting, with his eyes uplifted, probably fixed on a fold of the tricolour. All this is the *meaning* of the picture' (1973: 116). In other words, the first layer, the denotative meaning, is here constituted by the act of recognizing who or what kind of person is depicted there, what he is doing, and so on.

Barthes realizes of course that we can only recognize what we already know. Describing a particular advertisement for pasta, he writes: 'We need to know what a tomato, a string-bag, a packet of pasta are, but this is a matter of almost anthropological knowledge. This message corresponds, as it were, to the letter of the image, and we can all agree to call it the literal message, as opposed to the symbolic message' (1977: 36). Anyone who has tried to describe images in this way knows that such knowledge is often lacking or existing only at a very general level. We may recognize a uniform as a uniform without knowing what kind of uniform it is, or a tool as a tool without having

the faintest idea what it is for. Normally such a lack of knowledge is not a problem. We are not even aware of it until we have to describe what we see. We have mentally put it into the category of things about which we do not need any detailed knowledge. Clearly images can be perceived at different levels of generality, depending on the context, depending on who the image is for, and what its purpose is. In describing denotative meaning it may therefore be desirable to introduce a little more context than Barthes did, to set a plausible level of generality for the reading. In the case of Figure 5.1 the text seeks to describe 'others' for an 'us' (remember the title of the chapter, 'The Third World in Our Street'). This 'us' is Dutch teenagers in a high-school context in the second half of the 1980s. In this context the women on the left are 'immigrants' or, as the Dutch call them, *allochtonen*, 'non-indigenous' people. Whether they are Moroccan or Turkish is not relevant. Nor is it relevant that the three women are wearing different kinds of headscarves and that they are wearing them in different ways and that this perhaps carries meanings for people able to recognize different kinds of headscarves and different ways of wearing them. On the other hand, the boy on the right will be recognized as a Surinamer (even if he is not) by Dutch school children.

Is denotation entirely up to the beholder? Not necessarily. This too depends on the context. There are contexts (for example, certain forms of modern art) where a multiplicity of readings is allowed or even encouraged. But there are other contexts where the producers of the text have an interest in trying to get a particular message across to a particular audience, and in such cases there will be signs to point us towards the preferred level of generality. Even if I were a Turkish student of the Dutch school and if one of the three women in Figure 5.1 were my sister or my aunt, I would still also see that here she is depicted as a typical 'allochtoon'. Taking such pointers into account could help overcome some of the problems involved in a Barthian description of visual denotation. I will list four. They can of course occur in various combinations:

Categorization

Captions can indicate the preferred level of generality. But even in the absence of a caption people can be visually represented as a specific individual (my sister, or my aunt) or a social type ('an immigrant woman'). Typification comes about through the use of visual stereotypes, which may either be cultural attributes (objects, dress, hairstyle, etc.) or physiognomic attributes. The more these stereotypes overshadow a person's individual features (or the individual features of an object or a landscape), the more that person (or object, or landscape) is represented as a type.

Headwear is a commonly used cultural attribute, or as Barthes calls it 'object sign' (think of the French beret, the workman's cap, etc.) and in Figure 5.1 the head-scarves are clearly more salient than the women's individual features. The hairstyle of the boy on the right also stereotypes him to a degree, but less so, because it does not dominate the picture to the same degree. Again, the glamorous people in fashion magazines and advertisements can often disappear as individuals behind the hairstyles and the make-up that signify them as desirable social types. On the other hand, it is also possible to de-emphasize such cultural attributes. John Berger (1972: 111–12) compares

Rembrandt's early 'Self-portrait with Saskia' to a much later self-portrait. In the former the attributes of Rembrandt's new-found wealth and status are prominently displayed. In the latter all the light falls on Rembrandt's aged face, and everything else is reduced to a dark, shadowy outline.

Traditions of representation can also create *physiognomic* stereotypes. To the degree that these are exaggerated or otherwise made prominent in the representation (for example, by selecting a person or a picture of a person in whom they are prominent), the person depicted will be represented as a 'type' rather than as an individual. It can be argued that the pointed contrast between the blonde girl and the black boy stereotypes both the girl as typically Dutch and the boy as a typical second-generation Suriname immigrant.

Groups vs. individuals

Depicting people in groups rather than as individuals can have a similar effect, especially if similarity is enhanced by similar poses or synchronized action. The three women in Figure 5.1 not only look similar but also all walk in the same direction and are angled towards the viewer in more or less the same way. This reinforces the 'they're all the same effect' that constitutes generalization. Elsewhere (van Leeuwen, in press) I have pointed out how in press photographs of the Gulf War allied soldiers were usually depicted as individuals, doing things like defusing bombs, writing letters home, and so on, and Iraqi soldiers as groups involved in synchronized actions like aiming guns and surrendering.

Distancing

Showing people from a distance (in a 'long shot') can also decrease their individuality and make them more into types, because from a distance we will be less able to discern their individual features. Figure 5.1 is again an example of this. The 'immigrant women' on the left are distant, the young people on the right closer, with obvious effects on the degree to which they can be seen as unique individuals.

Surrounding text

As already mentioned, the surrounding text (or adjacent pictures) can also provide pointers. Captions can give the name of depicted people, or describe them as types. But pictures and words may also contradict each other in this respect. The picture of a named individual may illustrate a generalizing text, for example. British documentaries made in the 1930s often showed highly generic shots of workers while a voice-over commentary would somewhat patronizingly call them by their first names.

Connotation

The second layer of meaning is *connotation*, the layer of the broader concepts, ideas and values which the represented people, places and things 'stand for', 'are signs of'. The key idea is that the denotative meaning is already established, that we have, for

instance, already identified the three women as '*allochtoon*'. On this already established layer of recognition/interpretation a second meaning is then superimposed, the connotation. It can come about either through the cultural associations which cling to the represented people, places and things, or through specific 'connotators', specific aspects of the way in which they are represented, for example specific photographic techniques. In *Mythologies* (1973) Barthes concentrated on the former. In his essays on photography in *Image, Music, Text* (1977) he added the latter.

We already discussed the denotative meanings of Barthes's saluting African soldier. Here is the whole quote, showing how his reading moves from denotation to connotation:

> I am at the barber's and a copy of *Paris-Match* is offered me. On the cover, a young Negro in a French uniform is saluting, with his eyes uplifted, probably fixed on a fold of the tricolour. All this is the *meaning* of the picture. But, whether naively or not, I see very well what it signifies to me: that France is a great Empire, that all her sons, without any colour discrimination, faithfully serve under her flag, and that there is no better answer to the detractors of an alleged colonialism than the zeal shown by this Negro in serving his so-called oppressors. I am therefore again faced with a greater semiological system: there is a signifier, itself already formed with a previous system (a black soldier is giving the French salute); and there is a signified (it is here a purposeful mixture of Frenchness and militariness). (1973: 116)

Such connotative meanings – in *Mythologies* (1973) Barthes called them 'myths' – are first of all very broad and diffuse concepts which condense everything associated with the represented people, places or things into a single entity (hence Barthes's use of terms like 'Frenchness' and 'militariness' to indicate these meanings). Secondly, they are ideological meanings, serving to legitimate the status quo and the interests of those whose power is invested in it (in this case French colonialism and military role in Africa) – it should be remembered that *Mythologies*, though translated into English only in 1973, dates from 1957. Photographs are particularly good vehicles for such meanings, because they naturalize them. They can be thought of as just 'finding' these meanings on the street, as it were, rather than 'constructing' them. And they can also be thought of as not quite 'spelling out' their message, not saying it 'in so many words', so that that message can be construed as 'read into it' by the viewer, rather than as communicated by a powerful social institution (see Chapter 4).

Two elements of the content of images are singled out as especially frequent carriers of connotation, poses and objects. There is, says Barthes, an unwritten 'dictionary' of poses which is known to everyone who is at all exposed to the mass media, and whose 'entries' again have the kind of broad and ideologically coloured meanings that are typical of connotation:

> Consider a press photograph of President Kennedy widely distributed at the time of the 1960 election: a half-length profile shot, eyes looking upwards, hands joined together. Here it is the very pose of the subject which prepares the raising of the signifieds of connotation: youthfulness, spirituality, purity. The photograph clearly only signifies because of the existence of a store of stereotyped attitudes which form ready-made elements of signification (eyes raised heavenwards, hands clasped). (1977: 22)

At this point we should mention Goffman's exemplary account of gendered poses and their meanings (1979), which comes close to realizing Barthes's imagined 'lexicon', albeit for a restricted (but important) domain of meaning. Objects are equally significant:

> Special importance must be accorded to what could be called the posing of objects, where the meaning comes from the objects photographed . . . The interest lies in the fact that the objects are accepted inducers of ideas (book case = intellectual) or, in a more obscure way, veritable symbols (the door to the gas chamber for Chessman's execution with its reference to the funeral gates of ancient mythologies). Such objects constitute excellent elements of signification: on the one hand they are discontinuous and complete in themselves . . . while on the other they refer to clear familiar signifieds. They are thus the elements of a veritable lexicon. (1977: 23)

These examples analyse specific parts of images and are seen as 'discontinuous' individual 'dictionary entries', but Barthes also reads them together in a 'discursive reading of object-signs' (1977: 24). In this case, which he calls 'syntax', 'the signifier of connotation is no longer to be found at the level of any one of the fragments of the sequence but at that . . . of the concatenation' (ibid.). Here is an example of such a 'discursive reading':

> Here, for example, is a 'composition' of objects: a window opening on to vineyards and tiled roofs; in front of the window a photograph album, a magnifying glass, a vase of flowers. Consequently we are in the country, south of the Loire (vines and tiles), in a bourgeois home (flowers on the table) whose owner, advanced in years (the magnifying glass), is reliving his memories (the photograph album) – François Mauriac in Malagar (photo in *Paris-Match*). The connotation which somehow 'emerges' from all these signifying units which are nevertheless 'captured' as though the scene were immediate and spontaneous, that is to say, without signification. The text renders the connotation explicit, developing the theme of Mauriac's ties with the land. (1977: 23)

In this example the 'object-signs' are clearly denotative. The recognition of a place ('the country, south of the Loire') through specific attributes ('vines and tiles') is entirely similar to the recognition of a French soldier by his uniform, or an 'immigrant woman' by her headscarf. It is their concatenation which connotes 'myths' of the French countryside.

Connotation can also come about through the style of artwork or the techniques of photography, such as 'framing, distance, lighting, focus, speed' (1977: 44). Barthes calls this '*photogenia*' (1977: 23): 'An inventory needs to be made of these techniques, but only insofar as each of them has a corresponding signified of connotation sufficiently constant to allow its incorporation in a cultural lexicon of technical "effects".'

Several of the analytical categories discussed in Chapters 2 and 6 would fall under this heading, in particular 'social distance', 'point of view' and 'modality'.

We can now attempt to apply this analysis more fully to Figure 5.1, looking first at the 'object-signs' in Table 5.1. Then we can look at the 'photogenia' connotators in Table 5.2. Looking now at 'syntax', and putting together the 'object-signs' and the connotators, we get something like the following story. The first generation immigrants

(the three women) do not adapt to 'our' culture. They walk through a typical Dutch street (bicycles), where Dutch women's fashion is on sale for everyone (the shop behind the women), but nevertheless persist with their own ways (headscarves). Thus it is through their own fault that they do not integrate and remain distant (long shot) and detached (profile) from 'us' *autochtone* ('indigenous') Dutch. By contrast the younger generation of immigrants (the black man) adapt to our culture and even influence it as 'ethnic' culture transforms into consumer culture, including youth music and fashion (the plaited African hairstyle with beads). This makes love relationships possible (the man's arm around the woman's shoulder) between *autochtoon* (the woman) and *allochtoon* (the man) and may even hold out the promise of marriage (the ring).

Table 5.1 Denotative signifier and signified in Figure 5.1.

Denotative signifier	Denotative signified
Headscarves	Immigrant women
Bicycles	Dutch street
Dresses in shop window	Store with fashionable dresses
Black skin plus Afro hairstyle	Second-generation Surinamer
Blonde hair and white skin	Dutch girl
Rings	Betrothal and marriage
Awning and corner of chair	Café

Table 5.2 Connotator and connotation in Figure 5.1.

Connotator	Connotation
Angle: profile (3 women)	Detachment
semi-profile (couple)	Somewhat greater involvement
Framing: long shot (3 women)	Socially distant from the viewer
closer shot (couple)	Socially closer to the viewer

This visual 'story' appeared in a school textbook in a time when the 'asylum seekers' question became crucial in The Netherlands, and in which legitimations for the curtailing of immigration and the expulsion of refugees were construed and promulgated by the government and the media – and evidently also by the education publishing industry. It is surely no less an ideological message than that of Barthes's saluting African soldier.

Although I have given a qualitative analysis of a single picture, it is possible to use the concepts introduced here quantitatively (see also Chapter 2). The chapter from which Figure 5.1 was taken is called 'The Third World in Our Street' and depicts many 'non-indigenous' Netherlanders. In Table 5.3 I tabulate how one of the 'photogenia' connotators was used in the geography textbook as a whole (VCS stands for 'very close shot', MCS for 'medium close shot', MS for 'medium shot', LS for 'long shot' and

VLS for 'very long shot'). Similar tabulations could be made for other ('object-sign' or 'photogenia') connotators.

The table shows that pictures of 'non-indigenous' people far outnumber pictures of 'indigenous' people: after all, they are 'the problem'. 'Indigenous' people we know already. No need to show them. The main indigenous people included are the girl from Figure 5.1, a television reporter and a teacher. Non-indigenous people are mostly seen from some distance, though strip cartoons also show non-indigenous people in close up – but, then, cartoon drawings can create distance in other ways, for instance through stereotypical modes of depiction.

Table 5.3 Use of 'photogenia' connotators in a chapter on 'Netherlanders'.

	Drawings		Photographs	
	Non-indigenous	Indigenous	Non-indigenous	Indigenous
VCS–MCS	3	2	1	
MS–LS	13	2	6	1
VLS	10		11	

ICONOGRAPHY

Iconography distinguishes three layers of pictorial meaning: representational meaning, iconographical symbolism and iconological symbolism.

The idea of '*representational meaning*' is close to that of 'denotation'. Panofsky speaks of it as the 'primary or natural subject matter' (1970: 53) and describes it as the recognition of what is represented on the basis of our practical experience, taking into account the stylistic conventions and the technical transformations involved in the representation – for example, the fact that in medieval paintings 'human beings, animals and inanimate objects seem to hang loose in space in violation of the law of gravity, without thereby pretending to be apparitions' (Panofsky, 1970: 60), or the fact that in photography the three-dimensional world is reduced and flattened. The key idea is to see this kind of recognition as separate from the understanding of the conventional meanings that may be associated with what is represented. As an example he uses a gesture of greeting: a given viewer might recognize a picture as representing a man lifting his hat, but not know that lifting your hat is a conventional form of greeting. In the analysis of contemporary images this may seem an unnecessary complication, but in studying art works from the past it is not: faces may no longer be recognized, objects, gestures and activities may have become obsolete and establishing which of the people, places and things in a picture are iconographically significant (or, rather, were at the time of its production) may require quite a bit of research.

Iconographical symbolism. At this level, the 'object-signs', to use Barthes's term, not only denote a particular person, thing or place, but also the ideas or concepts attached to it. Panofsky glosses it as 'secondary or conventional subject matter' and explains it as follows:

> [Iconographical symbolism] is apprehended by realising that a male figure with a knife represents St Bartholomew, that a female figure with a peach in her hand is a personification of veracity, . . . or that two figures fighting each other in a certain way represent the Combat of Vice and Virtue. In doing this we connect artistic motifs and combinations of artistic motifs (compositions) with themes or concepts. (1970: 54)

Elsewhere Panofsky notes that such iconographical symbolism also exists in twentieth-century popular art:

> There arose, identifiable by standardised appearance, behaviour and attributes, the well-remembered types of the Vamp and the Straight Girl (perhaps the most convincing modern equivalents of the Medieval personifications of the Vices and Virtues), the Family Man and the Villain, the latter marked by a black moustache and a walking stick. (Quoted in Wollen, 1972: 146)

The conventions of the past are more easily recognized as conventions than those of the present, but I hope that the remainder of this chapter will show the value of studying contemporary images with the tools of iconographical analysis.

Iconological symbolism is what, in another context, would be called ideological meaning. To analyse it is, in Panofsky's words, to 'ascertain those underlying principles which reveal the basic attitude of a nation, a period, a class, a religious or philosophical persuasion' (1970: 55):

> When we try to understand [Da Vinci's Last Supper] as a document of Leonardo's personality, or of the civilisation of the Italian High Renaissance, or of a peculiar religious attitude, we deal with the work of art as a symptom of something else which expresses itself in a countless variety of other symptoms, and we interpret its compositional and iconographic features as more particularised evidence of this 'something else'. The discovery and interpretation of these 'symbolical' values (which are often unknown to the artist himself and may even emphatically differ from what he consciously intended to express) is the object of 'iconology', as opposed to 'iconography'. (1970: 56)

There is thus a clear move here from identifying generally accepted conventions (which the artist would also be aware of) to an interpretation of which the artist may not be aware and which may not be generally accepted, but which is nevertheless an indispensable part of the analysis: '[The work of art] must also be understood as carrying a more-than-visual meaning' (1970: 205).

Unlike Barthian visual semiotics, iconography uses both textual analysis and contextual research. With respect to art works of the past it is not possible to appeal to a shared knowledge of what 'object-signs' stand for (Barthes's 'accepted inducers of ideas'), and so iconography also uses intertextual comparison and documentary research to support its interpretations. Iconographers will 'find out as much as they possibly can of the circumstances under which the objects of their studies were created', 'collect and verify all the available factual information', 'read books on theology and mythology in order to identify the subject matter', and 'observe the interplay between the influences of literary sources and the effect of self-dependent

representational traditions to establish a history of iconographic formulae or "types'" (Panofsky, 1970: 41). Using this approach in studying the contemporary visual representation of significant issues can bring to light the origins of certain conventions and undo the ideologically convenient effects of what Bourdieu has called 'genesis amnesia'.

In this chapter I use a contemporary study of visual racism as an example: Nederveen Pieterse's *White on Black* (1992). The book resulted from an exhibition held in Amsterdam in 1989, and subsequently in several other European capitals. This exhibition was based on a collection of visual materials (prints, drawings, magazines, books, posters, packaging, etc.) put together by Rufus Collins, an Afro-American theatre director working in Amsterdam who had been astonished at the continued existence of demeaning caricatures of black peoples which in the USA would have been proscribed long ago. Nederveen Pieterse's research on the collection, which used the iconographical approach, formed the basis of the exhibition, and later of the book. Drawing on it here will hopefully demonstrate the relevance of iconography for contemporary studies of visual representation.

It is sometimes argued that iconography favours the 'original meaning' of art works from the past when these art works might mean something quite different today. This is of course true. What today's tourists get out of medieval and Renaissance paintings differs from what the artists' contemporaries saw in them. Panofsky comments that the 'patina of age' of art works is an important part of their contemporary meaning, even though this was obviously not intended by the artists (1970: 38). And he realizes that the 're-creative experience of art' depends on the 'cultural equipment of the beholder' (1970: 40). Different readings will occur. And they will be set in the context of different hegemonic or counter-hegemonic social institutions (tourism, education, political movements, etc.) and serve different interests. Readings such as those produced by Nederveen Pieterse are critical readings, set in the context of the anti-racism movement, and hence strongly contested by many. Nederveen Pieterse shows, for instance, how the iconography of the 'golliwog' doll came about in the heyday of imperialism and colonialism, when black people in the USA and Britain were routinely the subject of racist mockery (and worse), and also how, when the National Committee on Racism in Children's Books started a campaign branding the golliwog as racist in the 1980s, the majority of the press came out in favour of the golliwog and reproached black people for their 'oversensitivity'. In 1998 the cover of the *Guardian's* weekly 'Guide' (11 April 1998) magazine featured a golliwog, to highlight a programme in which the detractors of the golliwog were depicted as examples of outdated 'political correctness'. In such a context it is good to remember where the symbol comes from.

Representational meaning

How does iconography establish that a particular image represents a particular (kind of) person (or object, or place)? Following Hermeren (1969), to whose work this chapter is much indebted, we can distinguish five types of answer to this question in the work of art historians.

The title indicates who or what is represented

One possibility is that the work itself includes a written title, or some other kind of inscription or caption. This title then indicates who or what is represented. Arguments like the following are common in the work of art historians: 'A miniature of Davalos with authentic contemporary inscription in the collection of Duke Ferdinand of Tirol proves that we are really confronted with a portrait of this field marshal' (Ingvar Bergström, quoted in Hermeren, 1969: 47).

Many of the pictures in Nederveen Pieterse's book fall into this category. For instance, a 1947 advertisement for Chesterfield cigarettes showed the boxer Joe Louis, as well as his signature, underneath the words 'Chesterfield, the Champ of Cigarettes' (1992: 149). A 1930s poster for the Dutch Musicians' Union featured the slogan 'Do not become a musician. Dying occupation for Netherlanders' and showed a Jewish and a black musician as well as the horn of a gramophone. The label '*buitenlander*' ('foreigner') was superimposed over the face of the black musician. As also indicated in Nederveen Pieterse's captions, the boxer was represented as a specific individual and the musician as a type.

The identification of who or what is represented may also be done on the basis of personal experience

In the case of art works from the past this is obviously restricted to objects, buildings and landscapes which have survived relatively unchanged. And even then, we cannot always be sure that our recognition is at the appropriate level of generality. We may recognize a specific person when a generalized 'type' was meant to be recognized.

Identification on the basis of background research

As we have already seen, iconographers often undertake contextual research to establish who or what was portrayed. But this again may cause the identification to be made at an inappropriate level of generality. Hermeren quotes the case of a Rembrandt drawing called 'Girl sleeping'. There is, apparently, good evidence that Rembrandt's second wife was the sitter for the portrait. But the similarity between the portrait and Hendrickje is only slight, judging by other portraits. As also suggested by the title, it must have been Rembrandt's intention to portray a 'type', rather than a specific person.

Sometimes both the type and the person are meant to be recognizable. Edgar Wind (1937: 138), for instance, discusses the 'Bust of Commodus as Hercules' as follows: 'The Roman Emperor Commodus had his portrait sculptured with lifelike accuracy, yet he surrounded his head with the skin of a lion and held a heavy club in his hand. Being thus vested with the emblems of Hercules, he presented himself as possessed of his virtues.'

A similar kind of double identification occurs in Figure 5.2, where General Aguinaldo (1869–1964), leader of the Philippine resistance to American colonialism, is represented as a black dancing girl (and Uncle Sam as a white old lady). The dancing girl, like the black minstrel, was an iconographical symbol of black people as childlike, irresponsible and happy-go-lucky, as a simple 'child of nature, and one of the most interesting, selfless and happiest of creatures' (from a late nineteenth-century American 'advertising card', cf. Nederveen Pieterse, 1992: 137). As Nederveen

Pieterse points out, the cartoon is an instance of 'niggering', the comparison of colonized peoples with the American minorities (black people and Native Americans). 'The American press regularly represented Filipinos and other peoples as blacks', he writes, which shows that 'it is not ethnicity, or "race", that governs the imagery and discourse, but rather, the nature of the political relationship between peoples' (1992: 217). The hairstyle of the dancing girl remains a potent symbol, for instance in contemporary advertising (Figure 5.3) and more generally in fashion, where it is perhaps an example of what Halliday has called 'anti-language', the proud use of demeaning epithets ('blacks' used to be a derogatory term) and marks of identification.

Figure 5.2 General Emilio Aguinaldo represented as a black dancing girl. Cartoon by Victor Gillam in *Harper's Weekly*, 1899.

The contemporary star system means that actors are often to be identified both as themselves and as their characters. This also extends to advertisements, for example a Dutch advertisement showing 'the black actor Donald Jones offering a variety of types of coffee' (Nederveen Pieterse, 1992: 194) and adopting the stereotyped sub-servient posture and smile of the 'black servant'. As Nederveen Pieterse comments: 'Over the years the role of blacks in the advertising and packaging of cocoa, chocolate and coffee has hardly changed. As tropical products these things seem to be permanently associated with the colour black and with black labour' (1992: 194).

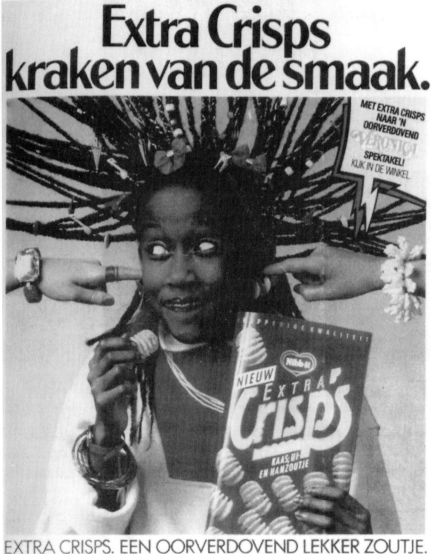

Figure 5.3 Advertisement for a Dutch brand of crisps (The Netherlands, 1987).

Identity established through reference to other pictures

The identity of a people, places or things can also be established on the basis of visual intertextuality, of their similarity to people, places or things in other pictures. An example from Panofsky:

> There is little doubt that the youthful figure which . . . 'attracts the eyes of the beholder' in the Columbian altarpiece is the same person who appears in Roger's portrait of Charles the Bold. . . . The aggressive, somewhat prognathous mouth with its watchfully pinched corners, the large, impatient eyes, the sombre eyebrows and, most important, the long, unruly hair recur in both pictures; to judge from the many other portraits of personages belonging to the entourage of Philip the Good, it would seem that at this most formal of all courts no one but the Crown Prince could afford to wear his hair as though there were no scissors and combs. (1953: 286)

In the contemporary media, with its plethora of photographic images of the famous and infamous, this type of recognition is of course very common. No 'title' is needed for the recognition of runner Nellie Cooman in an advertisement (see Figure 5.8 on page 113), although with time such visual recognizability will fade, as perhaps is already the case of Joe Louis cited above. The situation becomes a little more complex when we also include the recognition of 'types'. Nederveen Pieterse (1992: 131) sums up the following characteristics of the type of the 'black servant' (many of them of course also have iconographical significance):

> the smile expressing availability;
>
> the servant depicted as smaller, lower or in the background;
>
> a slight stoop in posture which makes his body seem shorter or smaller and which suggests subjection;
>
> a bend in the knees which, as in reverence, expresses subjection;
>
> watching the eyes of the person being served – a look which does not have to be reciprocated; on the contrary, the person served usually looks past the servant;
>
> a physical distance between the servant and served which denotes social distance and status difference.

Identification on the basis of verbal descriptions

Fictitious people, places and things may be identified on the basis of verbal inter-textuality, of descriptions in mythological or other literature – on condition that the description is applicable to the representation and can be considered to have been familiar to the artist and/or patron of the work. Thus St Joseph was portrayed not on the basis of a physical stereotype (as often in the case of Christ), but on the basis of the attributes of his trade, a description clearly based on what is written about him in the Gospels. 'The figure of Joseph appears in a wing beside the Annunciation as an artisan who fashions mousetraps' (Schapiro, 1945: 182).

Modern types, for instance racial stereotypes, may be fictitious in another sense and have their origin in other kinds of literature. Nederveen Pieterse shows how the physiognomic stereotyping of black people was still entirely absent from portrayals of black people by Rubens, van der Weyden, Rembrandt and others. Before these

stereotypes could enter into circulation they had to be constructed as meaningful signs, for instance in scientific writings such as those of Georges Cuvier (1769–1832), the Swiss scientist regarded as the founder of paleontology:

> The Negro Race is confined to the south of mount Atlas; it is marked by a black complexion, crisped or woolly hair, compressed cranium, and a flat nose. The projection of the lower parts of the face, and the thick lips, evidently approximate it to the monkey tribe; the hordes of which it consists have always remained in the most complete state of utter barbarism. (Quoted in Nederveen Pieterse, 1992: 42)

Such writing connected specific meanings to specific facial features (features which are of course not at all specific to black people). They were to be echoed in countless other places (cf., for example, Ineke Mok's 1999 study of racism in Dutch geography textbooks between 1876 and 1992).

Iconographical symbolism

A first distinction which needs to be made here is that between abstract symbols (abstract shapes with symbolic values, for example the cross), and figurative symbols (represented people, places or things with symbolic value). Abstract symbols were common in the Middle Ages. The haloes which indicated sainthood, for instance, had several variants. There were haloes with a cross (reserved for Christ), triangular haloes (reserved for God) and square haloes (reserved for donors who wanted to be depicted among the saints). In the age of the logo, abstract symbols may yet again become increasingly important.

Figurative symbols are often seen as natural by contemporaries, as operating on the basis of transparent analogies with the natural world, rather than on the basis of conventions. In hindsight they may turn out to have been based on conventional ideas about nature, rather than on nature itself. In the Middle Ages Christ was often depicted as a lion. This seemed a perfectly natural symbol for the resurrection as it was believed that lions kill their cubs after birth and then revive them after three days. Scientific as well as popular racism may appeal to such analogies with the animal world. In late nineteenth-century America black people were called 'coons' because raccoons have large white eyes in a dark snout and are known as sly night creatures. 'Coon songs' popularized the analogy. Their sheet music covers were 'aggressively racist, showing black people with lips like watermelons, eyes like saucers, wild curly hair and elongated bodies' (Nederveen Pieterse, 1992: 135).

I will now turn to the textual and contextual arguments used in iconography for justifying the symbolic interpretations of represented people, places and things. The textual arguments identify visual 'pointers' which tell the viewers that a given motif should be interpreted symbolically. Following Hermeren (1969), four kinds can be distinguished:

1 The symbolic motif is represented with more than normal care and detail compared to similar works, or it is given an especially conspicuous place in the

composition, or made extra conspicuous by lighting, contrasts in tone or colour, etc.
2 Someone in the picture points at the symbolic motif with an expressive gesture.
3 The symbolic motif seems out of place in the composition.
4 The presence of the symbolic motif somehow contravenes the laws of nature.

Here is an example of the third argument:

> It seems strange that Jan van Eyck as well as Ghirlandaio should be so anxious to stress St Jerome's liking for apples. In fact, the fruit looks out of place in the saint's study and this suggests that a symbolic interpretation is called for, or at least likely. (Ingvar Bergström, quoted in Hermeren, 1969: 84)

And here is an example of the fourth argument, Jan van Eyck's Madonna in a Church, as interpreted by Panofsky:

> It seems to have escaped notice however, that in this painting by a master so renowned for his naturalism . . . the sun shines from the North. There is in all Christendom no Gothic church having a full-fledged cathedral choir with radiating chapels that would face the West and not the East. And if it is hazardous to accuse the most observant of painters – and also one of the most erudite – of a mistake in scale, it would be almost sacrilege to accuse him of a mistake as to the simplest law of nature and the most familiar of ecclesiastical customs. If he decided to reverse the laws of nature, he must have had a reason for doing so. And this reason is, simply, that the light he depicted was not intended by him to be the light of nature but the supernatural or 'super-essential' light which illumes the City of God, the Light Divine disguised as the light of day. With Jan van Eyck this light, though independent of the laws of astronomy, was subject to the laws of symbolism. (1953: 147)

Just to make sure, Jan van Eyck also included an inscription (cf. Panofsky, 1953: 148):'The Virgin Mary . . . is more beautiful than the sun and above the whole order of the stars. Being compared with the [natural] light, she is found before it. She is the brightness of eternal light and the flawless mirror of God's majesty.'

Contextual arguments for symbolic interpretations are of three kinds:

1 The symbolic motif occurs often in an artist's oeuvre (or in a certain kind of art) without any obvious historical or natural explanation.
2 The symbolic motif is, to use Barthes's words, 'an accepted inducer of ideas', a commonly used symbol (in a given period and/or kind of art).
3 There is documentary evidence that the artist intended the motif as a symbol, or, more generally, that he or she was interested in symbolic traditions.

Iconographers are aware of the fact that symbolic meanings may be intended to be understood only by a restricted audience of cognoscenti, or even be private. In such cases 'allude' and 'suggest' may be more appropriate terms than 'symbolize', as in this quote from Edgar Wind: 'The allusions [to the four elements in Raphael's 'Stanza della Segnatura' are extremely remote and reveal the playfulness of a humanist mind which rejoices in making itself understood only to a select and erudite circle' (1938: 76).

A key distinction in the work of Panofsky is the distinction between *open symbolism* and *disguised symbolism*. This distinction comes about with the rise of pictorial naturalism in the Renaissance. A motif is an open symbol of something when it is not represented naturalistically or when there is no naturalistic excuse for its presence in the image. It is a disguised symbol when it is represented naturalistically and when there can be both a naturalistic and a symbolic explanation for its presence in the image. In medieval painting, Panofsky explains, 'objects accepted and plainly recognisable as symbols could mingle with real buildings, plants or implements on the same level of reality – or, rather, unreality' (1953: 140). When painters wanted to represent the prophets of the Old Testament as witnesses to the Crucifixion, they simply placed them beneath the Cross and identified them with suitable attributes and scrolls. Later painters began to find such anachronisms unrealistic and disguised the prophets as statues. Again, in Grivelli's 'Madonna and Child enthroned with donor' (Figure 5.4), the Christ Child holds up a rather large apple in a gesture which is clearly meant to display the apple to the viewer, rather than to represent the preliminaries to eating it, and fruit also decorates the throne on which they sit. The more inconspicuous apple in Jan van Eyck's 'St Jerome in his study' (Figure 5.5) could either be interpreted naturalistically (perhaps St Jerome liked apples) or as a symbol of 'original sin' (cf. the story of Adam and Eve), as was done, for instance, by Ingvar Bergström:

> This summary of the importance of the theological idea of *medicina* gives us a clue to the understanding of the apothecary's jar of 'Tyriaca' represented in Jan van Eyck's *St Jerome*, particularly when we consider it together with the apple placed on top of it. It has doubtless to be interpreted as a disguised symbol expressing the remedy against original sin, acquired sin, disease and death, which is Christ. (Quoted in Hermeren, 1969: 91)

In the case of 'disguised symbols', symbolism can be more easily denied. Deciding which motifs should be interpreted symbolically becomes more problematic and contestable, and the arguments will have to be mostly contextual, as can be seen in the following quote:

> [In the Mérode altarpiece] it is not easy to determine just which of the objects other than the pot of lilies – and of course the pious books on the Virgin's table – carry a determinable meaning. Several of them recur in an analogous context of other works, both by the Master himself and by others, and can thus be shown to conform to an established tradition. The laver and the basin have already been mentioned as an indoors substitute for the 'fountain of gardens' and 'well of living waters', one of the most frequent symbols of the Virgin's purity. The lions on the armrests of her bench bring to mind the Throne of Solomon described in I Kings X, 18 ff., with its two lions 'beside the stays' and twelve 'on the one side and on the other upon the six steps'. . . . Other features, however, such as the fireplace with its screen and the two wall brackets . . . do not so readily lend themselves to a symbolical interpretation. (Panofsky, 1953: 143)

Contemporary art may disguise symbolism in another sense. When artists draw on unconscious inspiration rather than on consciously known symbolic traditions, symbolism will be repressed on a conscious level. When critics then nevertheless give

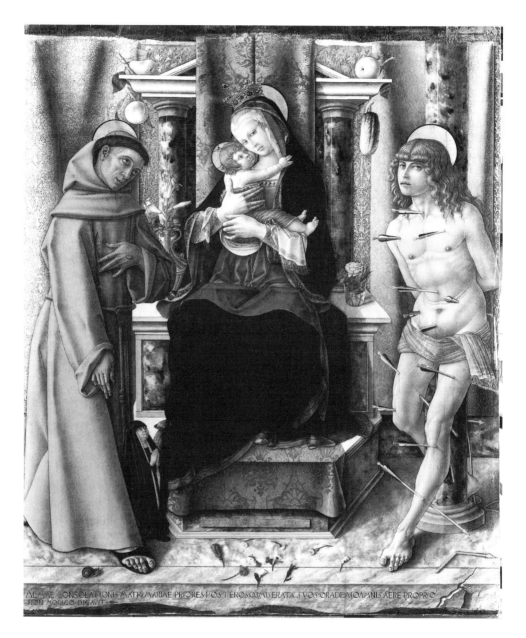

Figure 5.4 Carlo Grivelli: 'Madonna and Child enthroned with dono'.

a symbolic interpretation of such works, the artists will often contest it. In the age of post-modernism a conscious use of symbols and intertextual references seems to have become more acceptable again.

I cannot do justice to the wide range of racist iconographical symbols discussed in Nederveen Pieterse. I have already touched on the iconographical significance of racist stereotypes such as 'thick lips' and the 'projected lower part of the

Figure 5.5 Jan van Eyck: 'St Jerome in his study'.

face' and on the figure of the 'dancing girl' and her 'kinky' hairstyle (Kornelia Kinks was a familiar figure in pre-war American advertising and had a 'peaked' hair style of this kind). I will now give one further example: fruit.

In discussing the iconographical significance of fruit in white representations of black people, Nederveen Pieterse uses many of the arguments we have just discussed, for instance references to literature such as this quote from Anthony Trollope's account of the West Indies in 1858:

> [The West Indian Negro] is idle, unambitious as to worldly position, sensual and content with little. He lies under the mango-tree, and eats the luscious fruit in the sun. He sends his black urchin up for breakfast and behold the family table is spread. He pierces a cocoanut and lo! there is the beverage. He lies on the grass surrounded by oranges, bananas and pine-apples. (Quoted in Nederveen Pieterse, 1992: 199)

Or the argument that fruit was commonly used as symbolic of the 'laziness' ('irresponsibility', etc.) of black people:

> Fruit was the classic symbol of plenty, commonly used to denote the natural fertility of the tropics, and hence the 'natural laziness' of blacks. For the West Indies, pumpkins and melons were the common signifiers of tropical abundance. In American folklore blacks are beset by an uncontrollable desire for water-melons. It is one of the attributes of the child/savage image. The water-melon suggests sloth, gluttony, lack of self-control, childlike needs; additionally it may carry sexual overtones. Bananas and coconuts have also been associated with blacks. Again the connotation is tropical abundance; in addition, the banana is a classic phallic symbol. (Ibid.)

Figure 5.6 'In the good old summer time', American postcard, 1907.

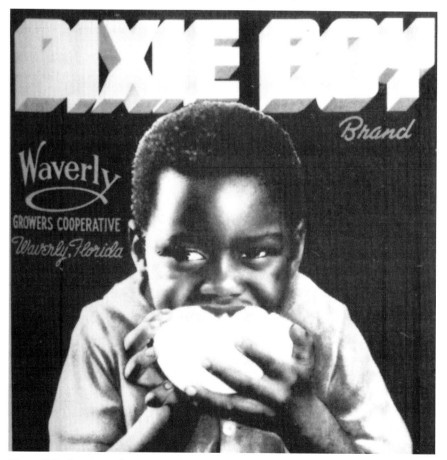

Figure 5.7 American advertisement for grapefruit, 1930s.

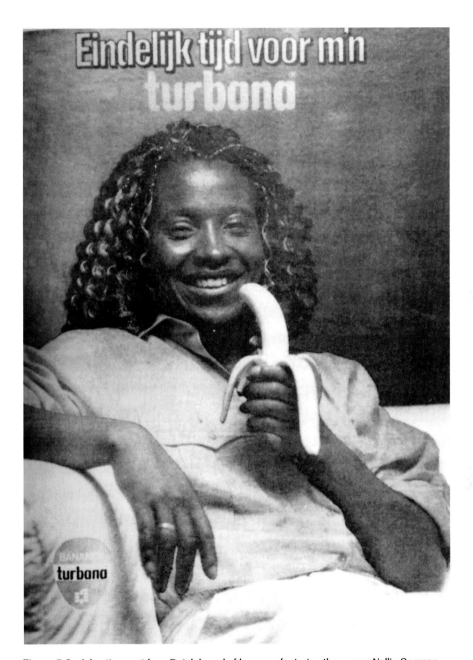

Figure 5.8 Advertisement for a Dutch brand of bananas featuring the runner Nellie Cooman, 1987.

In Figures 5.6–5.8, the deliberate 'posedness' of the people and the foregrounding of the fruit could be a further argument in favour of a symbolic interpretation.

Although I have analysed single images, it should be clear that iconographical analysis can be used, not only for revealing the history (and persistence) of such racist symbols, but also for quantitative studies, so that the approach described here could be usefully combined with that of Chapter 2.

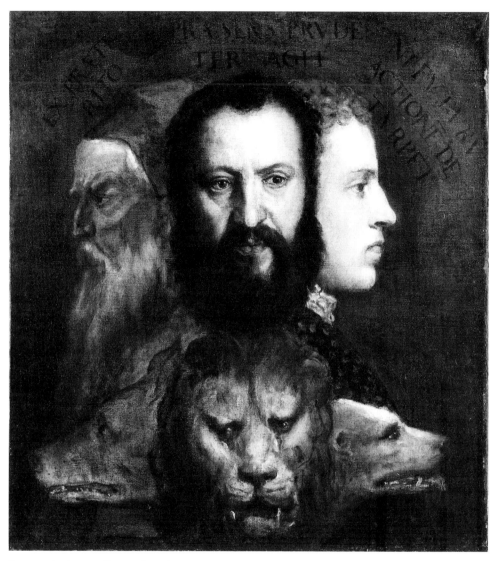

Figure 5.9 Titian: 'Allegory of Prudence' (1569).

With the exception of the lighting in Jan van Eyck's 'Madonna in a church', most of my examples have been of what Barthes would call 'object-signs'. But aspects of the way in which people, places and things are represented and compositions ('combinations of artistic motifs') can also be interpreted as iconographical symbols. As Schapiro says: 'Meaning and artistic form are not easily separated in representations; some forms that appear to be conventions of a local or period style are not only aesthetic choices but also attributes of the represented objects' (1970: 37). He argues this in the context of interpreting the use of frontal and profile in medieval manuscript illustrations representing the story of Moses at the battle with the Amalekites. In earlier pictures Moses was represented frontally (as was usually done with Christ), with his

arms extended like the arms of Christ on the Cross. Here he 'pre-figured' Christ and all that Christ stands for. Later 'he is turned in profile, and the reference to the cross is thereby blocked or weakened. Moses becomes a part of the action, like the fighting soldiers who are also shown in profile' (1970: 40).

> The earlier rendering of Moses as if turned towards us and with arms outstretched appears all the more clearly then as a specially accented form suited to the reading of the episode as a symbol . . . ; while the later profile pictures an action of which the significance is given in the simple denotation of the words of the Bible and calls for no deeper understanding as a symbol. (Schapiro, 1970: 40)

In a footnote Schapiro extends this to modern art:

> In the painting of the later 19th and early 20th century, the starkly frontal face and the pairing of frontal and profile returned as elements of the strong expressionist trend, both in portraits and narrative themes. The frontal position in subjects of sorrow, death, jealousy, anxiety, panic and despair by Munch and Ensor is a means in portraying the person in distress, self-isolating and turned away from others – he cannot 'face' the world; it is also a means of engaging the viewer's attention to the subject's face as that of another and kindred self preoccupied with its own overpowering feelings and speaking out to the viewer. (1970: 61)

Iconological symbolism

In moving from iconographical to iconological symbolism we move from identifying accepted conventional meanings to interpretation. One such kind of interpretation interprets works on the basis of the biography of the author, as 'autobiographical' on a deep, not immediately manifest level. The following example from Panofsky clearly shows this move from identifying conventional symbols to autobiographical interpretation. The work is Titian's 'Allegory of prudence' (Figure 5.9). It uses conventional symbols which were well known to Titian's contemporaries. On the level of 'representational meaning' we see, on the left, the profile of an old man facing left, in the centre a frontal portrait of a middle-aged man and on the right a profile of a younger man, facing right. The iconographical meaning of this is as follows:

> [The three faces] typify three stages of human life (youth, maturity and old age), [and] symbolise the three modes or forms of time in general; past, present and future. We are further asked to connect these three modes or forms of time with the idea of prudence, or, more specifically, with the three psychological faculties in the combined exercise of which this virtue consists: memory, which remembers, and learns from, the past, intelligence which judges of, and acts in, the present, and foresight which anticipates, and provides for, or against, the future. (Panofsky, 1970: 184)

But Panofsky goes further. He notices the resemblance of the old man to a self-portrait of Titian, and discovers that Titian, at the time he produced the painting, was engaged in collecting moneys owed to him, and managed to persuade the Venetian authorities to award his annual stipend and tax exemption to his son Orazio. He then searches for, and finds evidence that the man in the centre indeed represents Orazio,

and the younger man on the right Titian's adopted grandson Marcio Venellui, born in 1545 and hence 24 years old at the time. The painting is autobiographical. It represents an episode from Titian's life, an episode in which Titian, an old man, takes measures to provide for the future of his son and grandson.

As Panofsky comments, iconological interpretation requires 'something more than a familiarity with specific themes or concepts as transmitted through literary sources'. It requires 'a mental faculty comparable to that of the diagnostician – a faculty which I cannot describe better than by the rather discredited term "synthetic intuition", and which may be better developed in a talented layman than in an erudite scholar' (1970: 64). But iconological interpretation is also necessarily based on a certain principle of integrative interpretation, whether it is autobiographical, psycho-analytical, theological, sociological or otherwise. Here is a different example, this time not 'autobiographical' but 'philosophical': Jean Seznec's discussion of a miniature in a Copenhagen manuscript.

> These small images have much to tell us on attentive examination. They betray the conviction which had begun to assert itself in the fourteenth century that man is the prisoner of the heavenly bodies, entirely at their mercy. But resistance to this is some-times expressed as well. In one case we have the figure of a happy child, unconcernedly plucking flowers and paying no attention to the nine spheres which gravitate around him charged with their dread symbols. In their own way, these naive images raise the whole problem of necessity versus freedom of will. (Quoted in Hermeren, 1969: 127)

But, however much such interpretations rest on 'synthetic intuition', the argu-ments used to justify them are similar to those used in iconographical analysis. Again, they may either be contextual, as in the case of Panofsky's analysis of the 'Allegory of prudence' (intertextual comparison of portraits, background research into documents pertaining to Titian's life and affairs, etc.), or textual, as in the example below, which draws an analogy between the structure of a work and the structure of a particular religious/philosophical interpretation of the subject-matter:

> In [Michelangelo's] *Tomb of Julius*, however, heaven and earth are no longer separated from each other. The four gigantic figures on the platform, placed as they are between the lower zone with the Slaves and Victories and the crowning group of the two angels carrying the *bara* with the Pope, serve as an intermediary between the terrestrial and the celestial spheres. Thanks to them, the apotheosis of the Pope appears, not as a sudden and miraculous transformation, but as a gradual and almost natural rise; in other words, not as a resurrection, in the sense of the Orthodox Christian dogma, but as an ascension in the sense of the Neoplatonic philosophy. (Panofsky, quoted in Hermeren, 1969: 145)

Iconological analysis, then, draws together the iconographical symbols and stylistic features of an image or a representational tradition into a coherent interpretation which provides the 'why' behind the representations analysed. In the case of Nederveen Pieterse this 'why' is clearly sociological and political:

> The question that keeps arising is, what interests of whites are being served by these representations? This refers not only to measurable economic and political interests

but also to relations of a subtler nature in cultural, emotional and psychological spheres, and to the various ways in which these relations figure in the phenomenon of sub-ordination. The key that unlocks these images is what whites have made of blacks and why. (1992: 10)

CONCLUSION

In conclusion, then, Barthian visual semiotics and iconography are particularly useful for investigating the representational ('denotative') and symbolic ('connotative') meanings of the people, places and things (including abstract 'things') included in different kinds of images. Both methods provide explicit arguments for determining whether represented elements such as poses and objects, and elements of style such as angle, focus and lighting, can be interpreted as symbolic, and for distinguishing between conventionally accepted forms of symbolism and broader 'iconological' interpretations. The main differences between the two methods lie first of all in their objects of study – art works of the past versus media images of the present. Hopefully the use of Nederveen Pieterse's history of white peoples' representations of black people has demonstrated that iconography can usefully be applied to the analysis of contemporary images as well. Another difference between the two methods is that Barthian visual semiotics remains restricted to textual arguments, at least insofar as its explicit conceptual apparatus is concerned, whereas iconography also uses arguments based on intertextual comparison and archival background research.

Both methods recognize that symbolism may be 'open', mingling 'objects accepted and plainly recognised as symbols with real buildings, plants or implements on the same level of reality – or rather unreality', as Panofsky says (1953: 140), or 'disguised'. In Renaissance painting, the favoured object of study of iconography, increasing naturalism led to an interest in presenting symbols in the guise of reality. Barthes's favoured object of study was photography. Recognizing photographs, even documentary photographs, as (also) symbolic constructs, a quest in which Barthes was a pioneer, may well have played a small part in the decline of naturalism, along with the 'constructivist' power of the new digital technologies.

REFERENCES

Barthes, R. (1973) *Mythologies*. London: Paladin.
Barthes, R. (1977) *Image, Music, Text*. London: Fontana.
Barthes, R. (1982) *Camera Lucida*. London: Paladin.
Berger, J. (1972) *Ways of Seeing*. Harmondsworth: Penguin.
Bols, P., Houppermans, M., Krijger, C., Lentjes, W., Savelkouls, T., Terlingen, M. and Teune, P. (1986) *Werk aan de Wereld*. Malmberg: Den Bosch.
Goffman, E. (1979) *Gender Advertisements*. London: Methuen.
Groupe μ (1992) *Traité du signe visuel – Pour une rhétorique de l'image*. Paris: Seuil.
Hermeren, G. (1969) *Representation and Meaning in the Visual Arts*. Lund: Scandinavian University Books.
Mok, I. (1999) *In de ban van het ras: Aardrijkskunde tussen wetenschap en samenleving*. Amsterdam: ASCA Press.

Nederveen Pieterse, J. (1992) *White on Black: Images of Africa and Blacks in Western Popular Culture.* New Haven: Yale University Press.

Panofsky, E. (1953) *Early Netherlandish Painting.* New York: Harper and Row.

Panofsky, E. (1970) *Meaning in the Visual Arts.* Harmondsworth: Penguin.

Schapiro, M. (1945) '"Muscipula Diaboli": the symbolism of the Mérode altarpiece', *Art Bulletin,* 27: 182–7.

Schapiro, M. (1970) *Words and Pictures.* The Hague: Mouton.

van Leeuwen, T. (in press) 'Visual racism', in R. Wodak and M. Reisigl (eds), *The Semiotics of Racism.* Vienna: Passagen Verlag.

Wind, E. (1937) 'Studies in allegorical portraiture', *Journal of the Warburg and Courtauld Institutes,* 1: 138–62.

Wind, E. (1938) 'Elements in Raphael's "Stanza della Segnatura"', *Journal of the Warburg and Courtauld Institutes,* 3: 75–9.

Wollen, P. (1972) *Signs and Meaning in the Cinema.* London: Secker and Warburg.

6 A Therapeutic Perspective: the Use of Drawings in Child Psychoanalysis and Social Science

GERTRAUD DIEM-WILLE

INTRODUCTION

In this chapter I concentrate on the communicative function of drawings in child analysis and their use in social research. As the use of drawings is described in a psychoanalytical framework, I will briefly outline the psychoanalytical approach, considering pictorial images and drawings as expressions of the unconscious emotional aspects of a person. Freud's model of the mind will be presented in a simplified way, concentrating on the topographical frame of reference. In the second part of the chapter my approach will be primarily clinical: I will bring sequences of analytic sessions to describe the situation when the drawing was done and how it was interpreted. In child psychoanalysis all actions of the children, including their play and their drawings, are understood as ways of expressing their inner world and their relationship to the analyst. The relationship to the analyst is mainly influenced by the transference neuroses. In the third part of the chapter I demonstrate how a projective drawing test was adjusted for use in a qualitative social research project to understand underlying preconscious and unconscious motives.

PSYCHOANALYTIC UNDERSTANDING OF VISUAL IMAGES

Psychoanalytic theory is not coherent and unified within a single framework. It is a theory of normal and pathological mental functioning but also a theory of therapy. Freud called his overall theory of the mind his 'metapsychology' but nowadays we speak of a 'psychoanalytic psychology' (Sandler et al., 1997). Although Freud described three models of the mind – the dynamic, the economic and the topographical or structural – I will concentrate on the topographic model, because it is most relevant for understanding the importance of drawings. This frame of reference was used by Freud in 1900 in the *Interpretation of Dreams*. Freud's language is characterized by the rich and vivid use of metaphors, while clinical examples facilitate the understanding of complicated matters.

Pictures, drawings and metaphors show a person's emotional state of mind much better than verbal definitions or descriptions. In psychoanalysis we understand

visual images, daydreams, dreams, works of art, symptoms and character traits as compromise formations. These products are regarded as compromises between the instinctual wish and all forces that oppose instinctual gratification. As a compromise they represent a disguised form of gratification, but at the same time reflect the defence that had been mobilized against it. To understand Freud's concept of an inner conflict we want to describe his attempt to outline a 'topography' of the mind, with emphasis on the psychology of interrelationships and interactions, of qualitatively different areas of the apparatus. The three systems that are involved are called the conscious, preconscious and unconscious. The principal reference point to the topography is the psychological quality of the conscious, the preconscious and unconscious which are considered deeper layers. Boundaries functioning as censorship are thought to exist between these systems. Only during periods of conflicts are these boundaries sharply defined and separate entities; at periods of relative mental harmony these dividing lines must be regarded as being blurred. Freud gives us a metaphorical description on the relationship between the three systems:

> Let us . . . compare the system of the unconscious to a large entrance hall, in which the mental impulses jostle one another like separate individuals. Adjoining this entrance hall there is a second, narrower, room – a kind of drawing-room – in which consciousness . . . [also] resides. But on the threshold between these two rooms a watchman performs his function: he examines the different mental impulses, acts as a censor, and will not permit them into the drawing-room if they displease him. . . . It does not make much difference if the watchman turns away a particular impulse at the threshold itself or if he pushes it back across the threshold after it has entered the drawing-room. . . . If they have already pushed their way forward to the threshold and have been turned back by the watchman, then they are inadmissible to consciousness; we speak of them as repressed. But even the impulses which the watchman has allowed to cross the threshold are not on that account necessarily conscious as well; they can only become so if they succeed in catching the eye of consciousness. We are therefore justified in calling this second room the system of the preconscious. (Freud, 1916–17: 295–6)

Freud's shift from the affect–trauma model to the topographical model of the mind was influenced by a shift of focus on psychological thinking from the influence of the external reality to the way in which the mind deals with spontaneous inner urges and demands. The individual was seen to be, to a large degree, at the mercy of instinctual impulses (the sexual and death instinct). These impulses, arising from the depth of the mental apparatus could not always be allowed direct expression after early childhood but, to a large extent, could only show themselves indirectly in surface manifestations, from the system unconscious to the preconscious.

The unconscious system is thought of as functioning according to certain specific laws. Its contents, as long as they remain in this system, always have the quality of the unconscious. The term preconscious was introduced to refer to contents that are, descriptively speaking, unconscious, but were capable of becoming conscious if attention was directed towards them. Not all contents of the preconscious system are freely accessible to consciousness; some may only be permitted to pass in a disguised form. Equally, they may be repressed into the unconscious.

In the unconscious the 'characteristic' modes of functioning include the primary process, which is structured on different principles than logical thinking. The working of the preconscious and conscious make use of the formal modes of thinking, what we call the secondary process. The study of the analysis of dreams led Freud to recognize a type of mental functioning that was very different from thought-processes. The primary process, the mental functioning of the unconscious, flows freely and passes unhindered to express unconscious wishes (primitive hallucinations). The primary process does not recognize different times, such as past, present or future. It also has no means of expressing contradiction and negation, which means contradictory elements are quite compatible and exist side by side. Instinctual wishes are considered by Freud as following the pleasure principle and the pressure towards the satisfaction of infantile instinctual wishes, however unreasonable in the present, still persist. Memories of real events and of imagined experiences are not distinguished but are treated as if they present concrete reality. Symbols are treated as if they were a representation of a concrete thing. Instead of clarity the dream seeks to establish meaning in several chains of association, by the psychic mechanism of condensation, of what Freud called the defence mechanism of condensation. The second mechanism which is in operation is displacement, where an often apparently insignificant idea is attributed with all the psychical value, depth of meaning and intensity of another disguised one. The primary process follows the pleasure principle whereas the secondary process represents the reality principle.

The secondary process is the mode of functioning of wakeful thinking, attention, judgement, reasoning and controlled action. Its characteristics are the notion of causality, logic, a sense of time and an intolerance of ambiguity and contradictory elements. There is an aim at thought identity. 'Thinking must concern itself with the connecting paths between ideas, without being led astray by the intensity of those ideas' (Freud, 1900: 602). He continues: 'In the dream, pictures are used in consideration of repre-sentability', which can also express metaphors or sayings. Freud (1900) gave many examples of how dream-thoughts are transformed into pictures. The content of the dream can express latent dream-thoughts which would not pass the censorship of a conscious state of mind. This mental operation which transforms the raw material of the dream (unconscious wishes) was called 'dream-work'. Schleiermacher described the characteristic of being awake as thinking with concepts. 'The dream,' said Freud (1900: 602), 'thinks mainly in visual images.'

In 'imaginative' or 'creative' products, such as works of art, storytelling or drawing, instinctual wish-fulfilment may be permitted, whereas they would not otherwise be allowed access to consciousness.

INTERPRETATIONS OF DRAWINGS IN CHILD PSYCHOANALYSIS

In child analysis the play of children, the way they use materials and their freedom is understood as communication about their state of mind, their feelings in their relationship with the analyst. Drawing is a way of using the material that is provided.

The aim of analysis is to understand these inner conflicts, anxieties and wishes. Whether a child makes drawings or not, when she or he does it, and in what way, differs greatly from child to child. The special way that a child uses the material shows his relationship to the analyst. I follow here the concept of Melanie Klein (1975: 7), who wrote: 'The child expresses its phantasies, its wishes and its actual experiences in a symbolic way through play and games.' It uses an archaic, primary process, which we know from dreams. We can understand this language only if we understand it in the same way as we interpret dreams. In dreams we do not isolate single symbols. The same is true for the interpretation of drawings, where we always keep in mind the context, the situation in which they were produced. One single figure can have different meanings: for example, a doll can represent the child itself, or the baby the child wants to steal from its mother or the penis of its father, depending on the context. It is sometimes surprising how clearly a child responds to an interpretation by showing relief or increased anxiety. Klein thinks that the 'communication between the unconscious and the conscious is as yet comparatively easy, so that the way back to the unconscious is much simpler to find' (1975: 8).

In the same way as we do in therapy with adults, we assume that the relationship to the analyst is mainly influenced by transferring emotional patterns which were established in early childhood. Betty Joseph (1985) talks about the 'total transference situation', which enables the analyst to get fresh impressions of the quality of the relationship, the distortions and fragmentations. Both children and adults try to draw us into their familiar patterns of behaviour which they have experienced in earlier relationships. What happens in the session is regarded as the product of the interaction between an immediate reality and the patient's view of the reality, which is derived from their unconscious fantasies rooted in her or his history. As Feldman and Spillius commented: 'The patient's history, in other words, is in his inner world. It is through observing and experiencing the pressure to live out aspects of this unconscious internal world in the immediate transference relationship that the analyst comes to know his patient and his history' (1991: 6). It is an important ability of an analyst to feel and to recognize the pressure and what is projected on to her or him. The analyst observes how the patient reacts to an interpretation. Does he or she ignore it or show relief or anxiety, feel criticized or turn away from the topic altogether to avoid painful feelings? As Joseph found, children express their feelings straightforwardly:

> The child patient usually soon learns and in some deep way appreciates that this is a unique kind of relationship, and that the analyst can be relied on not to be drawn into reassuring, reprimanding, educating or playing, but will truly try to understand and help him face his anxieties and pain and the defensive manoeuvres that he has developed to try to cope with them. (1998: 2)

A three-year-old boy who found a comment I had made too painful took a wooden building-block and hit me on the head to get *the thought* out – he didn't want to confront himself with his feelings. Or when he was destructive because he felt the separation was too painful, and I put it into words, he was relieved and stopped. To understand and interpret these reactions is very helpful for the child who sometimes

feels understood on a deep level for the first time in his life. The equipment we provide in child psychoanalysis is as simple as the playroom itself. To enable the child to express his or her fantasy and wishes we use simple materials such as pencils, paper, glue, sellotape, crayons, scissors, wooden figures, wooden animals, and so on. The materials are kept in a locked box or drawer in order to enable the child to keep their products untouched by others and confidential. In this way the child can keep the whole history of her or his therapy in a drawer or box, and can refer to the drawings and products created earlier.

Below I offer two examples of the way drawings are dealt with in an analytic session. A detailed description of two sessions and the context of the origin of the drawings is needed in order to illustrate the dynamics of a therapeutic session, how impressions, wishes and stories are linked in a chain of associations. We see that the drawings are treated not only as products but that the context is emphasized. In the interpretations we use elements of the drawings and the way in which the drawing is presented. We do not isolate single visual elements like the words of a secret language to be deciphered like dream symbols; rather we concentrate on the context and the individuality of the patient. Certainly there are principles of representation: the most important person is drawn first – a way to express conflicts is to omit this person – and colour is used to express feelings (Abraham, 1950: 237). These principles help the analyst to be alert to 'hidden' meanings (see Chapter 7).

Rupert draws whales

First some background information. Rupert is a musically gifted eleven-year-old boy who has problems at school although he is very intelligent. He is aggressive at school and cannot adjust to the rules. He thinks he hears voices giving him orders, not allowing him to practise his violin or do his homework. His mother had been living for six years with Rupert's father, though he was married to another woman. He promised to marry Rupert's mother and urged her to get pregnant. He got divorced during the pregnancy but married another woman out of the blue. He seemed to have psychotic episodes. Rupert's mother tried to commit suicide when Rupert was six months old after she found out that Rupert's father had married somebody else. Rupert destroyed her relationship, she complains, but now he is the only important thing in her life. She has a boyfriend who is not interested in an intimate relationship with her.

When Rupert comes to the first assessment session he is brought by his mother. They are twenty minutes late. His mother urges him to apologize, which he reluctantly does, pouring out a long story. But as soon as the door to the waiting room is closed he is very shy: he stands in the middle of the room helplessly. He listens attentively when I tell him the basic rule, that he can express what comes into his mind in any way he likes and that I would try to see whether I can help him. He goes to the chest of drawers and looks into his drawer, then tries to open the others. He criticizes himself for how curious he is and walks over to the window. I tell him that his actions show me how interested he is in the other children's drawings and what problems they have and how critical he is of himself. He looks round and takes a close look at the scribbles

on the wall. I say that he might wonder what other children are doing here and what kind of problems they might have. He is relieved and says: 'That's good that they also have problems. I always thought I was the only one.' He adds that he knows that he is not supposed to write on the wall and asks whether he could use the paper and pencil on the table. I interpret this question as reflecting his disbelief and doubt as to whether he can really trust my words. He becomes very sad, and admits that promises were very seldom reliable.

Figure 6.1 Rupert's drawing.

As shown in Figure 6.1, Rupert drew short lines to form the body of the first whale in the middle; he explains while he draws it with a quick and steady hand that it represents himself. Then he draws the huge whale with the big mouth in the bottom left corner, twice correcting the shape and the mouth with the big teeth. Later he adds the two smaller whales above. When I ask him whether he could make some comments on his drawing he starts to cringe. He struggles to regain his composure and repeats my question, asking whether I meant he should tell me which whale represents which member of his family. He repeats that the first one represents himself: 'I feel like a whale. Whales have no words but communicate with songs they sing. They have a distinct and articulated communication.' The others he doesn't want to explain so he asks if he is supposed to do it. I understand that this would be too painful. He nods and looks at me gratefully. He also wants to find out whether I am as intrusive as his mother, forcing him to tell me things he is not yet ready to, or if I am giving him freedom to open up as much as he wants to. He gives me a little lecture on whales, the different kinds that exist and the special ways of living they have. Then he suddenly compares me to a dolphin, with a dolphin that can help and save lives. Suddenly he tells me a story from Roman mythology about a man who helped a lion by taking out a thorn from its paw. Later, when the same man has to fight against the lions in the Roman Circus this lion jumps at him and pulls him down, only to lick his face in gratitude. I link this story with his comparing me with a helpful dolphin. If I can be helpful for him he would spare me at the Circus later. But we are both subject to the cruel power of he who decides about life and death. At the end he has difficulties in leaving. He tries to extend the session by telling me about other drawings of whales he had done. At the same time he is very sceptical about whether anybody can help him at all.

In summary, first Rupert shows me his anxiety about coming by arriving late. As soon as the door to the waiting-room is closed he is helpless and anxious. His impulse not only to look into his drawer but also into other children's drawers breaks through and makes him feel ashamed. He jumps back and criticizes himself. We can understand his idea of drawing as a compromise. It is not emotionally as dangerous as his actions where an impulse was acted out; he can erase lines, change them, can take

his time and think in between. Again when he is invited to say something about his drawing he retreats. He also wants to find out how reliable I am. His father promised several times to visit him during the summer but he hasn't seen him since he was five years old. His mother convinced him not to post the letters he had written to his father over the years in order not to be disappointed again. How deeply hurt he is shows in his painful reaction, his sadness when I address his mistrust and doubts about me being reliable. His deep aggression is shown in the story about the man and the lion. Rupert identifies himself with the dangerous lion who would spare me. But both of us are prisoners of the Roman Emperor, representing his paranoid, hallucinatory self.

In the drawing we see how he experiences the close, threatening relationship with his intrusive mother. To express this intense conflict in words would have been very difficult at this early stage. In the picture he can express these ambivalent feelings. In the analytic process it is important not to insist on a clarification of who represents whom but to follow the free associations of the patient. It also shows the patient that he has the freedom to express himself the way he wants to so that we can understand his way of dealing with inner and outer problems.

Daphne's way of communicating by drawing

First some information about the case. The mother of a five-year-old girl, whom I call Daphne, came for a consultation about which school she should send her daughter to. It was clear that there were more serious underlying problems which she found difficult to acknowledge. She described Daphne as shy at school but having temper tantrums at home and being very jealous of her four-year-old sister. Only after Daphne's anxiety about 'going mad' was expressed during the session did her mother speak about Daphne's 'fits', when she was not herself, and her hallucinatory fever fantasies when she could not recognize her mother. This way of presenting Daphne's problems by hiding them for as long as possible shows us the intense anxiety in the family and the wish to conceal her serious problems.

During the sessions the main way for Daphne to express herself is by making drawings. At the first session she is very anxious and can only come into the consulting room holding her mother's hand. She quickly develops a ritual: coming in with her mother, sitting down on a chair by the table and doing drawings most of the time. In the first session she arranges the pencil, the ruler and the other materials in a straight line. If she uses a crayon she carefully takes one out, uses it and then puts it back making sure it is in a line. Only then can she take out another colour. This compulsive behaviour showed her unconscious wish to control her inner chaos and explosive feelings by putting the outer world in order.

The three drawings I discuss here were made in the third session. As her father was very sceptical about therapeutic help, during the second meeting we agreed with the parents to bring her four more times. This would give the parents a chance to observe at home how she reacted to the sessions. At the end of the second session it remained uncertain whether we would meet again. In the third session she seemed to

be relieved to be back and was less anxious. She came into the playing room with her mother and sat down to pick up a blue felt-tip pen.

Figure 6.2 Daphne's first drawing.

Daphne's first drawing is shown in Figure 6.2. First she makes a horizontal line covering the whole sheet of paper. In a tiring way she draws circles in the lower part under the horizontal line. After a quarter of an hour I comment how important it is for her to have my full attention, which she accepts with a faint smile. When she covers the circles with thick lines I interpret the blue circles as her intense and dangerous feelings which she wants to hide under a calm surface. She nods almost imperceptibly. So I say: 'You show me without words that you think I understood you.' Then she draws the two figures on the right, saying that this is a stage, while she adds curtains. When I ask her whether she'd like to explain to me the drawing she shakes her head to say no. When I suggest that this could be herself and me, she shakes her head in a way that I can see she agrees. I put this ambiguity into words by saying: 'Sometimes you shake your head to say no although you agree with what I just said because you want to find out whether I can see that you try to disguise it in the same way as you did in the picture.' She reacted with a friendly and cheeky 'Mhm?', while she drew two bright lights in the corners as if to tell me that something important was lit up. While she draws the central figure she tells me that this is a man. After she has drawn the fourth figure she adds other details to the middle one and comments that this is a woman. I respond by saying: 'You want to show me that sometimes you are confused about the difference between men and women.' As an answer she makes the second drawing.

Figure 6.3 Daphne's second drawing.

Daphne's second drawing (Figure 6.3) is of a large cake with five lit candles. I take this as a response to my interpretation, giving me a cake as a present. She looks at me for the first time and smiles.

Daphne then makes a third drawing (Figure 6.4). She draws a little rabbit and says that this one died, in a matter-of-fact voice. As there are only a few more minutes left I connect the death of the rabbit with her painful feelings about the immediate ending of her session. She responds by drawing a second rabbit and tells me that she was asked by friends to take care of another rabbit. I interpret it as expressing her

hope that I should take care of her. When I remind her of the end of the session she ignores it and carefully takes a brown pencil to draw three swallows and a blue sky. I acknowledge how difficult she finds it to leave and that she shows me that she knows that she will definitely come back for three more sessions. She puts her things back into her drawer and leaves.

Figure 6.4 Daphne's third drawing.

In summary, although Daphne and her parents emphasize that she doesn't want to come to her sessions she develops a strong attachment to me. The second and third week were more than five weeks apart but she behaves as if she had been here yesterday. This sequence of drawings shows how she uses them as a way to communicate with me. She uses them as a sort of private language. Her way of making drawings arouses strong feelings in me. As it is almost unbearably slow and monotonous I get tired and feel bored, a common defence to cover aggressive and frightening feelings. Observing my own reaction made me more receptive to understanding her defence of covering her anxiety behind monotony. The most dangerous questions are inserted as casual remarks to see whether I would recognize their seriousness. But if I pay attention she is very pleased and draws a sun or light to show me that we both face her anxieties. Then she gives me a cake as a present. In the remark about the dead rabbit she shows that she is cut off from her feelings: she cannot be sad or desperate. If I connect it with her pain about the ending of the session she has a comforting idea that she can come back and I could take care of her anxieties. She is delighted to be understood and tries to extend the session.

In the drawings wishes are expressed by a dramatization in the present, as in a dream where a wish for the future is expressed in the present as if it were already fulfilled. Daphne's swallows are already here even though she refers to her future sessions.

THE USE OF A PROJECTIVE DRAWING TEST IN SOCIAL SCIENCE RESEARCH

My experience of using drawings to access deep emotional conflicts made me think of using this method in social research in addition to narrative interviews. I wanted to see whether drawings in a projective test would bring additional data to understand the inner world and the emotional experiences in early childhood. Below I discuss two examples of the application of this psychoanalytic method in a social science research project.

The study focused on identifying gender-linked patterns in identity formation among successful contemporary career men and women (Diem-Wille, 1996a, 1996b). It was based on data gathered from interviews with a small sample of top managers and university professors. As I was not only interested in demographic data such as

birth order and parental influence but in their psychic inner reality, I used a projective drawing test ('the enchanted family', developed by Kos and Biermann, 1973). This projective test was developed for the assessment of the quality of attachment of children to their parents. It was modified in order to be used with adults. The aim of the projective drawing test is to visualize the dynamics in the family of origin. In narrative interviews we mainly hear the conscious self-perception of the interviewee. The unconscious conflicts in relationship to the parents, for instance, are often not shown in the content of the narrative but more in the way the person talks: their omissions, self-interruptions, or sudden changes of topic. In emphasizing the inner reality it would not be enough to know that there were conflicts with the parents; more explicit data about the quality of the relationship were needed.

In a psychoanalytic model of personality we understand that alongside the conscious realm, which is considered in sociological surveys, lies the realm of the unconscious, which influences behaviour. Figuratively speaking, the conscious represents the tip of the iceberg, while the unconscious represents the much larger submerged part of the iceberg. Feelings towards other people are not one-dimensional when seen from the psychoanalytical point of view. This is particularly the case in close relationships where love and affection are present, as well as contradictory emotions such as aggression, jealousy and hate. An important contribution, made by Freud, is the suggestion that every adult also 'contains' a child that, in part, controls and influences behaviour. This child part is censored by the adult part, so it mainly appears during dreams and in ways that are beyond the control of the adult part, in 'Freudian slips' and unintended actions (like forgetting something).

If we are to understand how successful career women and men relate to challenge, and what determines their ambition, it is not enough to observe external appearances or to examine their personal qualities in the light of a one-dimensional approach. A psychoanalytic approach differs from sociological examinations which focus on external reality, concentrate on stability and change in social systems, and stress the inter-relationship of social sub-systems in which an individual's fate is seen as an element of the whole. In a psychoanalytic study it is important to gain access to both conscious and unconscious aspects of emotional developments.

In changing the emphasis of the inner reality, my intention is not to play down the importance of these external factors. Quite the opposite. External conditions, such as family background and personal abilities, play a major role. My goal, however, is to show how these external conditions can be influenced by the inner reality. Thus, in a particular family, one brother can become a top manager while the other finds great difficulties in earning a living at all. Children can see the same people, for example their parents, very differently, and parents can also develop different relationships with each child. How an individual perceives outer reality cannot be judged from the outside. The drawing of the family of origin should give the interviewee a medium for expressing their ambivalent relationships with each member of the family, their inner pictures and perceptions of significant family members. I argue that it is not the objective qualities of the father or mother that are important for a child's development, but the image of the father constructed by the child, the so-called 'father-image', or inner object of the father. Mitscherlich makes the point:

Pioneering work by Freud led him to discover that not only external events and experiences are laid down in the psyche. Fantasies can change the meaning of external events, so a new reality is created, which in its turn has an effect on, and changes the perception of external reality. (1985: 87)

In the study discussed here, the detailed narrative interviews with the subjects provided data on their self-image and self-esteem, and on their life-history, professional career and personality development. The projective drawing test was introduced during the interview when the interviewee was describing his or her family (depending on when they mentioned their family this could be at the middle or end of the interview). After they had already spoken about the atmosphere in the family, how the parents dealt with conflicts, their educational style concerning table manners and sticking to rules, and so on, I introduced the test by taking out a white sheet of paper and saying: 'You have described your family situation with words. Could you be so kind as to describe them in a different medium by making a drawing. Imagine that a magician came and bewitched your family. Could you draw what happened then?' After the interviewee made the drawing he or she was asked to write down 'what they had done' and were asked to talk about their drawing.

The interviewees dealt differently with this task. Some started to draw immediately, some hesitated and were uncertain whether they could produce something meaningful, excusing themselves by saying that they were not good at drawing. I assured them that special talents were not needed, that they should just put down things or symbols as they came into their mind. If their inhibition was too strong they drew lines connecting circles to depict the relationships in the family. The difference in censorship between verbal expression and drawing was demonstrated by a manager who had just described his family as idyllic, as living in harmony. After thinking for a few minutes, he drew his mother as a barking dog, commenting: 'My mother is a barking dog. She constantly nagged and complained about us.'

The principles of interpretation discussed in the earlier examples of children's drawings in an analytic session apply to the adults' drawings in the social science study. The context and the explanations of the person who drew the picture are more important than single elements. Nonetheless there are some important principles to keep in mind: for example, the subjects' use of space on the sheet of paper, the order of appearance of elements and the symbols chosen. The most important figure in a family is drawn first, the size of the person representing their dominant position in the family. The position of the drawing person in the picture shows his or her self-esteem, their perception of their position in the family. The understanding of the drawing is worked out with the interviewee drawing on data from the narrative interview. Below, I give two examples of the use of the drawings to understanding the inner world of two interviewees.

It is not possible to give you a detailed description of these two case studies. I want to illustrate, however, the additional dimensions made visible by the use of the projective drawing test. It gives a glimpse of the hidden complexity of unconscious conflicts and ambivalent relationships. Certainly we cannot say we understand the complexity of each family dynamic but we get an idea of what goes on behind the censored image of the verbal description. We see the outline of hidden areas of the

personality and can draw some conclusions about the unconscious motives and dispositions for a professional career.

Hermann's drawing

Hermann is the chief executive of an international computer company. He got a job there after receiving his degree at university 21 years ago. Hermann gave the following information about his family background: he was the only child who was spoiled by his mother and grandmother, while his father had to return to Germany after World War II.

Figure 6.5 Hermann's drawing.

In the drawing of Hermann (Figure 6.5), who had described himself as a prince in the family, we see the hidden negative aspects of his special position. We see him being dominated by two powerful women and the loss of the father, who had to leave the family because he couldn't get citizenship and Hermann's mother didn't want to move to Germany. Hermann draws himself as a helpless baby dependent on the two women. His central position in the family is expressed by the throne. But his mouth is closed with a pacifier, and he has no arms, while his legs are in a sack. Both women are turned towards him and give him their full attention. The second person he draws is the grandmother who provides food for him, while the mother represents the male role of the breadwinner, earning a living and dealing with the world. He was kept dependent. Mother didn't want him to leave the family when he went to university, but he did it in spite of her. His aggression towards being kept in this dependent position was mainly unconscious, since he was always an obedient boy and a good pupil. The emotional relationship with his mother seems to be ambivalent. She treats him as a part of herself but also represents a role model for being successful and independent, a gifted merchant. He says that he inherited his economic talent from his mother – it's 'in his blood'. His professional career seems to be a compromise between identification and competition with his mother. He was able to leave his mother to study at university and to live in a different city; later working for an international company took him to different jobs abroad. On the other hand, he works in the same profession as she did and fulfils her wish to be successful.

Erika's drawing

Erika is a manager in the marketing department of a big company. She is an only child. Her father has a leading position in a small trading company, while her mother is a housewife. Erika was always a good pupil, but in spite of the teacher's recommendation

she did not go to university, preferring to work as a secretary in order to earn her own money.

On the conscious level Erika describes her mother as a housewife who has suffered all her life from the fact that she did not have an education and never worked outside the home. She was unhappy with her tight financial situation. The father is described by Erika in derogatory terms as a person without any ambitions, a little clerk who was only fond of card games and preferred the pub to the family home.

Erika first draws her father, then her mother, and only after my question about where she would put herself in the picture does she reluctantly draw herself in the middle (see Figure 6.6). The comments she makes while she draws are very important as they often contrast with what she actually does. First she wants to draw her father as 'a little, unimportant guy', she says, but she starts with him first, which means that emotionally he is the most important for her. She says: 'Well, I would somehow see my father as a little mouse. But I cannot draw a mouse – this looks like a little pig, oh no, this is terrible.' Erika's picture of her father does look like a mouse. A mouse is a weak animal. Erika puts him first but uses an inferior symbol. While she

Figure 6.6 Erika's drawing.

draws her mother, she says it should be 'a lion, a fierce animal', but what comes out is a cute animal which looks rather like a bear. The animals characterize an antipathy such as that found between a cat and a mouse. The rejection of the father is enhanced by the pig which signifies on the one hand the maternal–nursing quality and on the other hand the low–dirty aspect. Her rejection of her father may also include a rejection of the pleasure principle in Erika's life. To Erika, her father's way of enjoying his life is indulgence and laziness. The more Erika talks about her father the more she sounds like her own mother, echoing her mother's reproaches and complaints about the father being a failure. Erika seems to identify with her unhappy mother, so she has to fulfil her mother's ambitions. She says: 'After three or four years at this company I earn more money than my father ever did.' Only reluctantly does she admit that her father advanced to a leading position as director of his company, but still earned less than she does now.

Erika strongly dislikes drawing herself in the family between her parents, which she finally does, contradicting it by saying: 'Well, no, I have surely never been a connecting link between my parents – probably I was somewhere there.' And then she adds that her father was always proud of her, proud of her excellent grades at school. The belittling of and contempt for Erika's father seem to result from a disillusionment. He might have been a promising person to her mother, offering material security and social acceptance, but he didn't live up to her expectations. Erika's professional career seems to be emotionally a present to her mother to fulfil her dreams.

In summary, I would like to clarify a possible misconception. I am not implying that career success depends on having a mature personality, mental stability or a successful upbringing. In fact my aim is to show that a variety of interpretations are

possible in explaining career success. In the case of some subjects, involvement in a career can be seen as a form of hyperactivity that helps to ward off a threatening depression. With other career women and men, we find that personality development has remained at the emotional level of a child, but that they are able to apply their intellectual and emotional abilities to one particular area, namely to their careers. However, in both academia and business there are emotionally mature people of both sexes who are able to sublimate their tension and aggression, and exploit their abilities to the full.

CONCLUSION

In this chapter I have described and discussed the use of drawings as a path to unconscious wishes and conflicts in child psychoanalysis and (to a lesser extent) in social science research. The focus lay in the therapeutic communication of making the drawing one special way of expressing feelings and as a response to an interpretation. If we allow the dynamics in the session to play the main role we are less likely to be 'thrown off track' by a rigid perception of elements of the drawing. It is important, therefore, to keep the principles highlighted in this chapter in mind (what element is drawn first, the sign and symbolic meaning, etc.), although they should never distract us from concentrating on the vivid interaction in the 'here and now', the unfolding of the inner world of the subject.

The applied form of psychoanalytic understanding in collecting data in social research is more complicated. A projective drawing test should, in my opinion, only be used as an additional method – for example, in combination with a narrative interview (see Chapter 3). Using drawings as a form to express feeling can be helpful if it is combined with talking about them with the interviewee. In this way it can provide understanding on a deeper level and can make the subject aware of hidden aspects of his or her feelings. When the picture is described by the interviewee, and questions are asked and comments made by the researcher, the distinction between data collecting and interpreting begins to blur. It is useful, therefore, for projective drawing tests to be conducted by a researcher familiar with psychoanalytic thinking and with sensitive interviewing skills in order to maintain the integrity of the data and the sensibilities of the interviewee.

NOTE

The names of the people discussed in this chapter have been changed.

REFERENCES

Abraham, E. (1950) 'Zeichnung und Farbe als seelischer Ausdruck', *Psyche*, 4 (5): 237–40.
Diem-Wille, G. (1996a) *Karrierefrauen und Karrieremanner. Eine psychoanalytisch orientierte Untersuchung ihrer Lebensgeschichte und Familiendynamik.* Opladen: Westdeutscher Verlag.

Diem-Wille, G. (1996b) 'Femininity and professionalism: a psychoanalytic study of ambition in female academics and managers in Austria', in D.F. Good, M. Grandner and M. Maynes (eds), *Austrian Women in the Nineteenth and Twentieth Centuries*. Providence and Oxford: Berghan Books.

Feldman, M. and Spillius, E.B. (1991) 'General introduction', in B. Joseph, *Psychic Equilibrium and Psychic Change*. London and New York: Routledge.

Freud, S. (1900) Die Traumdeutung, G.W.,II–III, Frankfurt: Fischer (1968), Eng.: *The Interpretation of Dreams*, Standard Edition (SE) *The Complete Psychological Works of Sigmund Freud*, 2 and 3, London: Hogarth Press (1950–1974).

Freud, S. (1916–17) *Introductory Lectures on Psycho-Analysis* (Standard Edition) 15–16. London: Hogarth Press (1950–1974).

Joseph, B. (1985) 'Transference: the total situation', in *Psychic Equilibrium and Psychic Change*. London and New York: Routledge.

Joseph, B. (1998) 'Child psychoanalysis today', *The Institute of Psycho-Analysis News*, 2 (1): 1–3.

Klein, M. (1975) *The Psycho-Analysis of Children*. London: Hogarth Press.

Kos, M. and Biermann, G. (1973) 'Die verzauberte Familie', *Ein tiefenpsychologischer Zeichentest*. Munich: Basel.

Mitscherlich, M. (1985) *Die friedfertige Frau: Eine psychoanalytische Untersuchung zr Aggression der Geschlechter*. Frankfurt: S. Fischer.

Sandler, J., Holder, A., Dare, C. and Dreher, A.U. (1997) *Freud's Models of the Mind: An Introduction*. London: Karnac Books.

7 Visual Meaning: a Social Semiotic Approach

CAREY JEWITT AND RUMIKO OYAMA

INTRODUCTION

Social semiotics of visual communication involves the description of semiotic resources, what can be said and done with images (and other visual means of communication) and how the things people say and do with images can be interpreted.

Describing semiotic resources

The term 'resource' marks one of the key differences between social semiotics and Paris school structuralist semiotics (see Chapter 4). In Paris school semiotics the key word was 'code', not 'resource'. It conceived of semiotic systems as codes, sets of rules for connecting signs and meanings. Once two or more people have mastered the same code, it was thought, they would be able to connect the same meanings to the same sounds or graphic patterns and hence be able to understand each other. How these codes came about, who made the rules and how and why they might be changed was not considered a key issue.

Some forms of visual communication actually work like this, for instance the highway code, a key example in early Paris school visual semiotics. In other forms of visual communication, for instance children's drawings and many forms of modern art, there are no such codes. Like the highway code they draw from the visual resources which Western culture has developed over the centuries, but the way they use these resources is not subject to the same kinds of rules. The highway code is governed by strict prescriptions, children's drawings and modern art by creative invention, the influence of examples and conventions, and so on. The same applies to the interpretation, the 'take-up' of images. Some viewers interpret 'according to the book' (in educational contexts you usually have to do this if you want to get a good grade), others use whatever resources of interpretation and intertextual connection they can lay their hands on to create their own new interpretations and interconnections.

For social semiotics this is a vital point. There are kinds of 'rules', from laws and mandatory prescriptions to 'best practice', the influence of role models, expert advice, common habits, and so on. Different kinds of rules apply in different contexts. As for breaking the rules, only people with a large amount of cultural power are

given permission to do this, at least in public places. Most of us have to conform. In private, in the smaller groups and 'sub-cultures' we live in, we may have more free-dom, but our semiotic productions and interpretations are not likely to spread much beyond those small circles. They will remain relatively marginal. Sometimes, however, society needs something new, and then novel modes of production and interpretation will stand more of a chance of being added to the culture's treasury of visual resources.

Let us give an example of such a 'resource', that of 'point of view' (Kress and van Leeuwen, 1996: 135–53) (see Chapters 4 and 9). This resource allows people, places and things to be depicted from above or below (or at eye-level), and from the front, the side or the back. Both these dimensions, the vertical and the horizontal, are graded, a matter of degree. There is, for instance, a range of vertical angles between the 'bird's eye' view and eye-level, and a range of horizontal angles between frontal-ity and the profile. Point of view also creates a meaning potential. This does not mean that it is possible to say what different points of view will mean exactly. But it is possible to describe the kinds of meaning they will allow image producers and viewers to create, in this case, the kinds of symbolic relations between image producers/viewers and the people, places or things in images. In the case of the vertical angle this relation will be one of symbolic power. If you look down on something, you look at it from a position of symbolic power. If you look up at something, that some-thing has some kind of symbolic power over you. At eye-level there is a relation of symbolic equality. In the case of the horizontal angle, the relation will be one of involve-ment with, or detachment from, what is represented. Frontality allows the creation of maximum involvement. The viewer is directly confronted with what is in the picture. If something is depicted from the side, the viewer literally and figuratively remains on the sidelines. Again, there are of course many degrees of involved or detached engagement in between.

Two points need to be made. First, 'power', 'detachment', 'involvement', and so on, are not 'the' meanings of these angles. They are an attempt to describe a meaning potential, a field of possible meanings, which need to be activated by the producers and viewers of images. But this field of possible meanings is not unlimited. If you want to express that something or someone is impressive and powerful, you are unlikely to choose a high angle, and if you see someone depicted from a high angle, you are unlikely to conclude that he or she is represented as an impressive and powerful person (although it is always possible: sometimes we say the opposite of what we mean and are never-theless perfectly understood). Secondly, symbolic relations are not real relations, and it is precisely this which makes point of view a semiotic resource. It can 'lie'. Photographs can symbolically make us relate as an equal to people who in fact have very considerable power over our lives (for example, politicians), or it can make us look in a detached way at people who we are involved with (see Chapter 4).

To map out meaning potentials, Kress and van Leeuwen use 'system networks', a style of diagramming that derives from the work of M.A.K. Halliday (1978), whose linguistic theories have been a decisive influence on this kind of visual analysis. The system network below encapsulates the resource of 'point of view' (square brackets mean either/or).

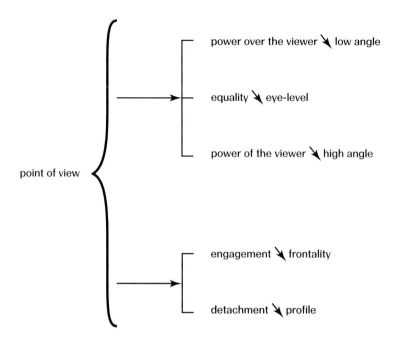

Such resources have histories. They were invented in the context of specific interests and specific purposes. Point of view, as we have described it here, became possible as a result of the invention of perspective in the Renaissance. Before that time pictures were surfaces on which to make marks, and 'the world in the picture was experienced as a direct continuation of the observer's own space' (Arnheim, 1974: 274). After that pictures became 'windows on the world' (Panofsky, 1953) which allowed a particular subjective point of view to be realized – and this happened in a time in which subjectivity and individuality became significant social values. That it happened through a geometric system was one of the paradoxes of the invention. As Kress and van Leeuwen say: 'Socially determined viewpoints could, in this way, be naturalised and presented as studies of nature' (1996: 137). This is another key emphasis of the social semiotic approach: semiotic resources are at once the products of cultural histories and the cognitive resources we use to create meaning in the production and interpretation of visual and other messages.

Describing and explaining how semiotic resources are used

The second type of semiotic work is describing and explaining how semiotic resources are used in specific domains. Social semiotics is not an end in itself. It is meant as a tool for use in critical research. It only becomes meaningful once we begin to use its resources to ask questions. In this chapter we draw on several studies which apply visual social semiotics. The first is a study exploring the visual representation of male heterosexuality in British sexual health materials aimed at people aged 13 to 19 years old

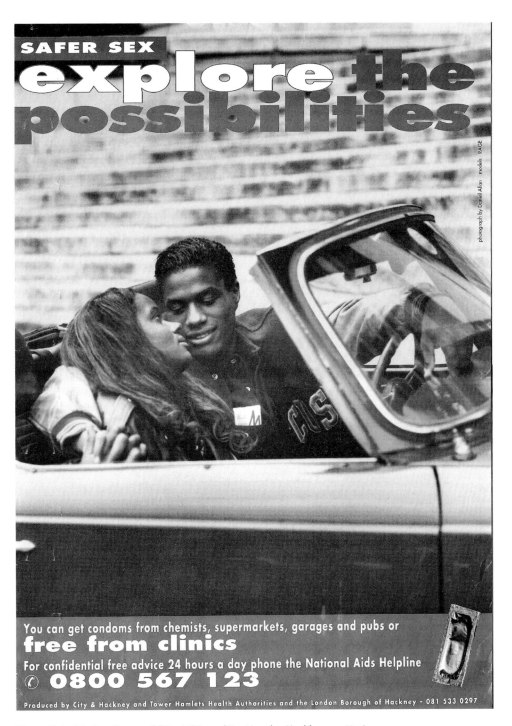

Figure 7.1 'Explore the possibilities' (City and East London Health promotion).

(Jewitt, 1997, 1999). The study revealed that images can reinforce stereotyped forms of masculinity which in words would probably be unacceptable to many sexual health workers and young people. It compiled a detailed and systematic description of these images based on 18 descriptive dimensions developed from Kress and van Leeuwen's social semiotic approach to the analysis of images (Jewitt, 1997). The main dimensions will be described in detail including the form of representation, the setting and the props, the actors' appearance, the composition of each image and the relationship between the represented actors and the viewer (encoded through the use of point of view, distance and contact). These descriptions were entered on to grid-charts (the columns representing the dimensions outlined above, the rows representing each image – a total of 74 images were analysed). The charts were then analysed using the framework process (Ritchie and Spencer, 1994), which identifies the patterns and relationships between and across the descriptions of the images (for example, the relationship between actors and setting) and can therefore be used both to generate ideas and to systematically test the hypothesis which emerged from the literature on masculinity and gender and from preliminary analysis of the images (see Chapter 2).

How was 'point of view' used in this material? To start with the horizontal dimension, the frontal angle was used to increase audience identification and involvement with represented participants who reduce sexual risk. For instance, a frontal angle was used to present the male actor carrying condoms in Figure 7.1, while the woman was presented in profile, at an oblique angle: this use of 'point of view' presents the man as a figure to identify with, and objectifies the woman as the 'other'. The use of frontal angle also related to hegemonic norms of masculinity. Throughout the sample of images the men shown frontally were 'real men', whereas oblique angles were used to depict men who failed to acquire the norms of hegemonic masculinity and therefore should not be identified with. For instance the oblique angle in Figure 7.2 frames the boy on the far right of the image in a way which emphasizes the difference between him and the other boys (all of whom are presented frontally), his 'otherness' being confirmed by his unbalanced posture, 'limp wrist', foppish hair and glasses: he represents 'wimp'. While the other boys in the image are represented as looking at us the boy on the far right is represented as looking away: like the woman in Figure 7.1, he is represented as an object for the viewer to look at rather than engage with. As for the vertical angle, men in the sample were portrayed as powerful by the use of a low vertical angle in particular roles: as fathers, and when they were shown as actively engaged in education, asserting their knowledge, planning sex and being sexually unrestrained (Jewitt, 1997).

In this study visual social semiotics revealed things which were not evident at first sight, and even brought to light contradictions between the verbal and the visual message. But visual social semiotics by itself is not enough. To explain the results of the analysis, the study had to draw on other sources, on social theories of gender and masculinities (Wight, 1992; Holland et al., 1993) and on earlier studies of gender construction in images (Millum, 1975; Graham, 1977; Goffman, 1979). In studies of the use of semiotic resources, visual social semiotics can only ever be one element of an interdisciplinary equation which must also involve relevant theories and histories.

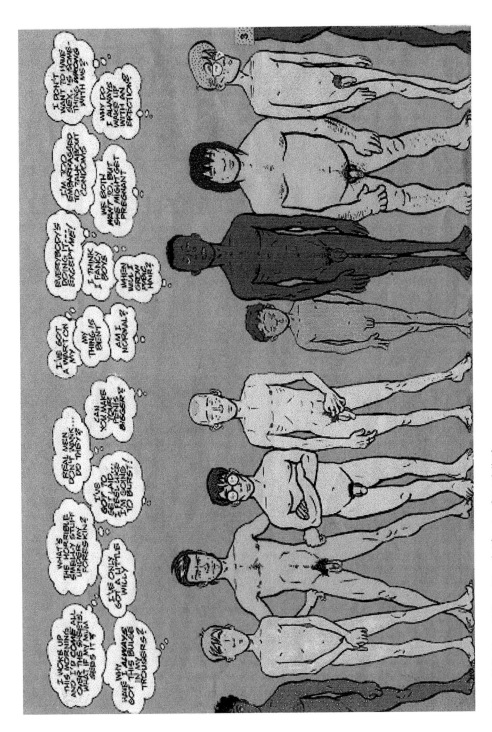

Figure 7.2 From '4 Boys '(Family Planning Association).

Expanding semiotic resources

Finally, there is a third contribution semioticians can make. They can also explore how semiotic resources may be expanded so as to allow more options, more tools for the production and interpretation of images and other forms of visual communication. In other words, semiotics can be a tool for design. In the past this was a by-product of semiotics. Semiotics was supposed to be 'the science of signs', and science is supposed to be about 'what is' not about 'what could be' or 'what might be'. Still, just as science can unlock doors to new technical possibilities, so semiotics can unlock doors to new semiotic possibilities, whether in the form of new resources (for example, the study of sexual health leaflets discussed in this chapter informed the production of guidelines on sexual health resources for young men (Jewitt, 1998)) or of new uses of existing resources. In the case of the representation of gender and masculinities, contemporary artists and performers, those practical semioticians, are well ahead of the theorists in this respect.

SOCIAL SEMIOTIC ANALYSIS OF VISUAL COMMUNICATION

Visual social semiotics is functionalist in the sense that it sees visual resources as having been developed to do specific kinds of semiotic work. It follows Halliday (for example, 1978) in recognizing three main kinds of semiotic work, which are always performed simultaneously. Halliday calls these three kinds of work 'metafunctions', and distinguishes between: the ideational metafunction, the function of creating representations; the inter-personal metafunction, the part language plays in creating interactions between writers and readers or speakers and listeners; and the textual metafunction, which brings together the individual bits of representation-and-interaction into the kind of wholes we recognize as specific kinds of text or communicative event (advertisements, interviews, dinner table conversations, etc.) (see Chapter 9 for discussion of filmic texts). Kress and van Leeuwen (1996) have extended this idea to images, using a slightly different terminology: 'representational' instead of 'ideational'; 'interactive' instead of 'inter-personal'; and 'compositional' instead of 'textual'. Any image, they say, not only represents the world (whether in abstract or concrete ways), but also plays a part in some interaction and, with or without accompanying text, constitutes a recognizable kind of text (a painting, a political poster, a magazine advertisement, etc.). The image of the young black couple in the sports car in Figure 7.1 first of all represents a particular kind of relationship (sexual) in a particular kind of setting (urban street). This is the representational work the photograph does. But the woman's look is not directed at the viewer, while the man's look is, and this shows that the picture also plays a role in an interaction founded on gendered power relations. Through the man's look and gesture (encircling the woman in his arms, the car being an 'extension of his domain'), a health organization asks young men to engage with a discourse of sexual safety. This is the interactive work the picture does. Finally, the layout, the placement and relative salience of picture (for instance, the central position of the condom packet) and text,

and so on, do the compositional work that allows us to recognize the text as a health advertisement.

REPRESENTATIONAL MEANING

Representational meaning is first of all conveyed by the (abstract or concrete) 'participants' (people, places or things) depicted. For example, in Figure 7.2 the young man on the right signifies 'wimp' because, on the basis of certain visual semantic features (longish hair, submissive pose, averted gaze, glasses, 'limp wrist') we recognize him as belonging to the class of 'wimp'. This is the visual equivalent of lexis, of the vocabulary, and in this respect visual social semiotics has not added much to the work of structuralist semioticians and iconographers (see Chapter 5). Where it has contributed new ideas for the visual analysis of representational meaning is in its emphasis on the 'syntax' of images as a source of representational meaning. In time-based semiotic modes such as language and music, 'syntax' is a matter of sequencing order (for example, word order). In space-based semiotic modes such as images and architecture it is a matter of spatial relationships, of 'where things are' in the semiotic space and of whether or not they are connected through lines, or through visual 'rhymes' of colour, shape, and so on. Such forms of spatial 'syntax' have of course been described before, for instance by art theorists such as Arnheim (1969, 1974, 1982), but for the most part only in formalist and aesthetic terms (or sometimes in terms of psychological theories of perception), not as contributing to representational meaning (see Chapter 6).

Kress and van Leeuwen (1996) describe visual syntactic patterns in terms of their function of relating visual participants to each other in meaningful ways. There are two kinds of pattern. Narrative representations relate participants in terms of 'doings' and 'happenings', of the unfolding of actions, events, or processes of change. Conceptual patterns, represent participants in terms of their more generalized, stable or timeless 'essences'. They do not represent them as doing something, but as being something, or meaning something, or belonging to some category, or having certain characteristics or components. The choice is important, since the decision to represent something in a narrative or conceptual way provides a key to understanding the discourses which mediate their representation.

Narrative structures

Narrative pictures (or scenes within pictures) are recognized by the presence of a vector. A vector is a line, often diagonal, that connects participants, for instance an arrow connecting boxes in a diagram, or the outstretched arms of the man in a leaflet on sexual health represented in Figure 7.3. The vector expresses a dynamic, 'doing' or 'happening' kind of relation. In the case of Figure 7.3, the syntax suggests something like the following meaning. The man does something to the woman. What that something is may then be filled in differently by different viewers (engage, dominant, argue), but the range of possible interpretations is not unlimited.

In Figure 7.3 the 'actor', the 'doer' of the action is the man. More generally, 'actors' are the participants from whom or which the vector emanates, or who themselves form the vector. Here the vector is formed by the strong downward diagonal vector of the man and woman's arms and their eyeline. The vector is bi-directional (that is, the woman's arms also form a vector which 'acts on' the man). However, the primary 'goal', the participant to whom or which the action is done, is formed by the woman as the upward directionality of the vector depicting her action is more weakly articulated. The woman is represented as involved in 'stopping' his movement forward (echoed in the caption 'If he won't use a condom he needs to be told'). In this image, as in many others in the study, images visually confirmed the role of women as the mediators of sexuality: besieged by predatory male sexuality (here depicted by 'black maleness') and at the same time depicted as able to control male sexuality by the 'threat

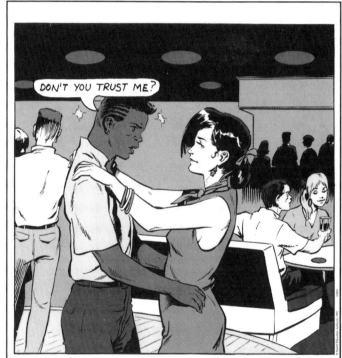

Figure 7.3 Sketch of 'If he won't use a condom' (Health Education Authority poster).

of withdrawal'. More generally, 'goals' are the participants at whom the vector is directed. When a picture or a scene within a picture has both an actor and a goal it is 'transactive', representing an action taking place between two parties. But it is also possible to have a picture or scene containing only an actor and a vector.

The eyeline, the direction of the gaze of represented participants (insofar as it is not directed at the viewer), is a special kind of vector. It creates a reaction rather than an action. Such a reaction can, again, be transactive or non-transactive. It can be that we see both the person (or perhaps animal) who is looking and the object of his or her gaze (transactive reaction), or only the person looking and not what he or she is looking at (non-transactive); for example, the woman in Figure 7.1 looks but we do not know at what. Facial expressions and gestures can then 'colour in' the nature of the reaction as pleased or displeased, deferential or defiant, and so on.

The concepts of narrative visual analysis (action, reaction, transactive, non-transactive) can help 'interrogate' a visual text, help to frame questions such as who are playing the active roles of doing and/or looking and who the passive roles of being acted upon and/or being looked at in visual texts with certain kinds of participants (for example, minorities). Who are shown as people who act, who as people who react in visual texts about certain issues? This kind of analysis of the narrative processes in the study of sexual health education leaflets and posters revealed that men and women were represented as equally active – which is not always the case in images showing men and women. However, the nature and the occasion of men's and women's action in the images differed in important ways. Overall, women were represented as passive, or less active, in the context of sexual activities, where they were shown as 'reacters' rather than 'actors', or as involved in non-transactive actions, actions that have no effect or impact on some other entity. Men were more often shown in transactive actions: it was men who were represented as initiating sexual activities and as most sexually active, literally in the driving seat, while women were more often presented as sexually passive (literally a 'passenger' in the case of Figure 7.1). The study showed that women were shown as enforcing sexual protection by insisting on condom use, as in Figure 7.3. The goals of male and female actions also differed, and women were more frequently the goal of actions than men. The goals (objects) of the female actors' transactive actions can be characterized as risk reducers (for example, condoms, information booklets). In contrast, the cultural symbolism of the goals (objects) of the male actors' actions can, with the exception of condoms, be described as risk enhancers (for example, contact sport or, as in Figure 7.1, a convertible sports car) with the associated wealth and success.

Conceptual structures

Images which do not contain vectors are 'conceptual'. They visually 'define' or 'analyse' or 'classify' people, places and things (including again abstract things). One kind of conceptual pattern is the classification structure. Classification structures bring different people, places or things together in one picture, distributing them symmetrically across the picture space to show that they have something in common, that

they belong to the same class. Figure 7.2 for instance, offers such a classification of the male body. Throughout the images visual classification structures were used which consistently highlighted the individuality of men. For instance, men in the images rarely looked at one another and were separated (disconnected) by the use of space on the page. In contrast women were visually represented as connected both to one another, and to men in terms of gaze, and the 'occupation of space on the page'.

Symbolic structures define the meaning or identity of a participant. In the symbolic attributive structure the identity or meaning of one participant (the 'carrier') is established by another (the 'symbolic attribute'). Here Kress and van Leeuwen (1996) rely on iconography (see Chapter 5). Symbolic attributes are recognized through one or more of the following characteristics: they are made salient in the representation, for example by their size, position, colour, use of lighting; they are pointed out by means of a gesture; they look out of place in the whole; they are conventionally associated with symbolic values.

A range of props conferred symbolic meaning or attributes on the represented participants. Cars and motorbikes, both potent cultural symbols of male virility and sexual prowess in Western industrial society, were used to confer masculinity on the men in some of the images (as in Figure 7.1). Sports equipment and settings were used to signal competitiveness between men and as signifiers of their heterosexuality.

Analytical structures, finally, relate participants to each other in terms of a part–whole structure. Maps are analytical structures and so are pie charts. In all these cases a concept or entity is defined by showing how it is made up out of which parts. Whatever the concept or entity, this can always be done in more than one way. A map of Europe, for instance, may analyse Europe as consisting of countries or as consisting of different kinds of soil, or of different altitudes. Analytical structures always have two key participants: the carrier (the whole) and any number of 'possessive attributes' (the parts). Diagrams of male sexual and reproductive organs were the main use of analytical diagrams in the study of sexual health leaflets and posters. In these diagrams the carrier was the male or female sexual and reproductive system, which consisted of labelled possessive attributes (parts). The inclusion and exclusion of elements in these diagrams served to define the whole, that is what was legitimately considered 'sexual'. It also served to realize the norms of sexuality. For example, many of the diagrams only included a representation of the anus in the context of disease, rather than sexual pleasure, thus confirming heterosexual norms.

Kress and van Leeuwen (1996: Chs 2 and 3) distinguish further sub-types of many of these 'syntactic' patterns, but the ones discussed here are the most important. This is not to say that they provide all that is necessary for studies of the visual representation of specific issues of social significance. In the study of sexual health leaflets and posters two aspects were added that clearly belong to the sphere of representational meaning: the setting of images and the visual appearance of social actors.

Settings were associated with the 'level of male sexual control' and with signifying whether or not sexual activity had taken place. In the study, 'level of male sexual control' was defined by such factors as: who initiates and directs the action; the difference in eye-levels of the represented participants (as an indication of the power relationship between them); who vetoes sexual activity; and who possesses or provides

sexual information. The settings in the images indicated that women and men were represented as having sexual control in different environments. Women were represented as possessing sexual control in the home/domestic settings, in leisure (public) venues, in medical settings and in 'nature' – outdoors with grass and trees. Men were depicted as having sexual control in the urban (outdoor) environment. For example, the man in Figure 7.1 is in the driving seat, literally and metaphorically – it is his car and the condoms are in his pocket. Men on the street were represented as sexually in control or 'predatory', but once in domestic settings they were shown to relinquish control to women.

The dominant representation of men in the sample, as judged by analysis of the actors' hair, clothes, posture, facial expression, the relative eye-levels of participants and their actions, was one of conventional hegemonic masculinity. Within the images men were shown in competition in relation to masculinity and sexual prowess. The notion of a continuum of male sexuality is visualized in the leaflet '4 Boys' (Figure 7.2) which shows a row of eight boys. The dichotomy between gladiator and wimp is apparent as two extremes on a continuum of masculinity, with a visual image of a strong boy on the left of the image through to a weaker looking boy on the right. Men's individuality is emphasized by the difference in their appearance, posture, age, height, ethnicity and props. The symmetry of the men in these images suggests that while being an individual is a defining feature of being a man, masculinity is a unifying experience which transcends individual difference.

INTERACTIVE MEANING

Images can create particular relations between viewers and the world inside the picture frame. In this way they interact with viewers and suggest the attitude viewers should take towards what is being represented. Three factors play a key role in the realization of these meanings: distance, contact and point of view (see Chapters 2 and 9). Together they can create complex and subtle relations between the represented and the viewer. As will be shown, the relationship between the viewer and the men represented in the sample of sexual health leaflets and posters is presented as visually more demanding but more socially distant and less involved than the relationship between the viewer and the women represented.

Contact

Many pictures show people who, from inside the picture frame, look directly at the viewer. In this way they 'make contact' with the viewers, establish an (imaginary) relation with them. Kress and van Leeuwen (1996) call such pictures 'demand' pictures – the people in the picture symbolically demand something from the viewer. Facial expression and gestures then fill in what exactly they 'demand' in this way: they can demand deference, by unblinkingly looking down on the viewers, or pity, by pleadingly looking up at them; they can address viewers with an ingratiating smile or unsettle

them with a penetrating stare (for example, the defiant posture – hands on hips, legs astride – and stare of the boy on the left in Figure 7.2). Gestures can further modify what is demanded, as in the famous 'Your Country Needs YOU!' recruitment poster. Without this kind of 'imaginary contact' we look quite differently at the people inside the picture frame. We 'observe' them in a detached way and impersonally as though they are specimens in a display case. Kress and van Leeuwen (1996) call such pictures 'offers' – an 'offer of information' is made (for example, the boy on the far right of Figure 7.2). The terms 'offer' and 'demand' were taken from Halliday (1985) who uses them to distinguish between different classes of speech act, questions and commands, which 'demand', respectively, 'information' and 'goods and services', and statements and offers, which 'offer', respectively, 'information' and 'goods and services'. In the study of sexual health leaflets and posters, contact between the viewer and the images of the men was more often in the form of a demand; in contrast women were more often portrayed in the form of an offer. That is, women were visually represented as more sexually passive and available than men who were visually represented as sexually active or demanding.

Distance

Images can bring people, places and things close to the viewer or 'keep them at arm's length'. In everyday interaction the norms of social relations determine the distance we keep from each other. This translates into the 'size of frame' of shots. To see people close up is to see them in the way we would normally only see people with whom we are more or less intimately acquainted. Every detail of their face and their expression is visible. We are so close to them we could almost touch them. They reveal their individuality and their personality. To see people from a distance is to see them in the way we would normally only see strangers, people whose lives do touch on ours. We see them in outline, impersonally, as types rather than as individuals. This does not mean of course that the people we see represented in close-up are actually close to us, or vice versa. It means they are represented as though they belong or should belong to 'our group', and that the viewer is thereby addressed as a certain kind of person. There are of course many intermediate degrees between close-up and distance, just as there are, in everyday life, many intermediate degrees between the most intimate relations and the total absence of a relation. To describe these the terminology of film and television can be used. A close-up (head and shoulders or less) suggests an intimate/ personal relationship; a medium shot (cutting off the human figure somewhere between the waist and the knees) suggests a social relationship (as in the couple in Figure 7.1); and a 'long shot' (showing the full figure, whether just fitting in the frame or even more distant) suggests an impersonal relationship (such as in Figure 7.2). In the study of sexual health leaflets the relationship between the viewer and the represented men was presented as more intimate when the men were accompanied by women: perhaps the presence of women in images enabled a more intimate portrayal of men as they resolved the problematic issue of men looking at other men (see Chapter 4 for a discussion of audience 'gaze').

Point of view

The third factor is point of view (see Chapters 4 and 9). We have already described how frontal angles were used to increase audience identification and involvement with represented participants who reduce sexual risk and vertical angles were used to represent men as powerful in particular roles. Detachment was illustrated by a male-represented participant's failure to acquire the norms of hegemonic masculinity (as in Figure 7.2).

One further aspect of interactive meaning, modality (see Chapter 2, this volume), will be discussed in relation to the application of visual social semiotics to explore the rhetorics of the science classroom (Kress et al., in press).[1] So at this point it is useful to summarize the role of visual social semiotics in the study of sexual health promotion materials we have used so far. Visual social semiotics helped illuminate how the structures of the images contributed to the representation of concepts of masculinity. The message of the leaflets and posters clearly was not only verbally but also visually conveyed. In particular the method of analysis identified visually signified meanings which, in words, would have been unacceptable to many professionals and young people. It highlighted the visual oversimplification of male sexuality, the failure of the materials to address young people's emotional concerns, the visual polarization of men and women, and the visual legitimating of a narrow definition of male and female sexuality.

COMPOSITIONAL MEANING

Further resources of social semiotic visual analysis will be explored in relation to another example, in which we focus on how two 11-year-old students grappled with the problem of how to make a visual and written text 'scientific'. They had looked at the cells of an onion under the microscope and were asked to draw 'what they saw' and describe in writing 'what they did'. The teacher gave explicit instructions on how to compose the text, to place the image in the bottom part of the page and the writing in the top part of the page. Below we first introduce some further social semiotic resources for visual analysis, and then discuss their use in the work of Ramendeep and another student from the same class, Amy, who used them quite differently. They include three resources of compositional meaning: information value; framing; and salience and modality, an important 'interactive' resource we have not yet discussed. The compositional structures discussed below can also be applied to the layout of composite texts such as magazine pages, illustrated books, and so on.

Information value

Information values are realized by the placement of the elements of a composition. The idea is that the role of any particular element in the whole will depend on whether it is placed on the left or on the right, in the centre or the margin, or in the upper or the lower part of the picture space or page.

In societies which use Roman script the direction of the reading of a text (left to right, from top to bottom) has led to different cultural values being awarded to the left and the right. According to Kress and van Leeuwen (1996), left–right placement creates a 'given-new' structure. The elements placed on the left are presented as 'given', the elements placed on the right as 'new'. For something to be 'given' means that it is presented as something the viewer or reader already knows, as a familiar and agreed departure point for the message. For something to be 'new' means that it is presented as something not yet known and not yet already agreed upon by the viewer or reader, hence as something to which the viewer or reader must pay special attention. The 'new' is therefore problematic, contestable, the information 'at issue', while the 'given' is presented as commonsensical and self-evident. Again, this is a meaning potential which will get more specific contours in the context of specific images.

As for top and bottom, again, if some of the constituent elements are placed on top and others at the bottom, then what is placed on top is presented as what Kress and van Leeuwen (1996) call the 'ideal' and what is placed at the bottom as the 'real'. For something to be 'ideal' means that it is presented as the idealized or generalized essence of the information, hence usually also as its ideologically most salient part. The 'real' is then opposed to this in that it is its meaning potential to present more 'down to earth information'. According to the context this can become more specific information (for example, details), more practically oriented information (for example, practical consequences, directions for action) or more real information (for example, photographs as documentary evidence). In Figure 7.2, the writing in the text of men realizing their sexual fears and concerns will be the 'ideal', the image of sexual bravado the 'real'.

Figure 7.4 Onion cell text by Ramendeep, aged 11 years.

Centrality, finally, means what it is: what is placed in the centre is thereby seen as what holds the 'marginal' elements together. The marginal elements are then in some sense the elements that are held together by the centre – belonging to it, subservient to it, and so on, depending on the context.

The teacher's instruction to place the writing in the top part of the page and the image in the bottom part carried with it a particular notion of text as primarily a written entity: the writing was the prior process, placing the image in the role of outcome. The pupils responded to this instruction differently: Ramendeep recast the instruction using composition to produce an different design (Figure 7.4); Amy did not transform the teacher's design, but adapted it slightly to integrate the image as 'illustration' through the partial merging of writing and image in her text.

The question becomes one of whether the pupils are treating the text as being primarily logged in writing or image. In both cases the texts are designed to be read top–down. In Ramendeep's text (Figure 7.4) her use of the top and the bottom of the page gives the information value of abstract ideal to the image (top) and the value of the empirical real to the written element. That is, the visual element of the text, her drawing, represents the means of carrying the abstract theoretical representation of 'scientificness'. In contrast, the written element of her text is an empirical account of 'what she did' indicated by the diary-like genre of the writing: a narrative, personal voice, past tense declaratives and the recounting of particular events. The 'scientificness' is primarily logged visually in Ramendeep's text. In Amy's text (Figure 7.5) her arrangement of elements in the top and bottom of the page presents the writing as the abstract theoretical representation of 'scientificness', and her drawing as the empirical real, the 'outcome' of the procedure. Her writing achieves the genre of science: a procedural account with numbered steps, agentless voice and imperative statements. Her drawing provides a specific sensory image of what she saw – the evidence. Amy's text nonetheless shows a move to integrate the process and evidence by the partial integration of the visual and written in the way title and image intersect one another.

Figure 7.5 Onion cell text by Amy, aged 11 years.

Framing

The term 'framing' indicates that elements of a composition can either be given separate identities, or represented as belonging together. In other words, framing 'connects' or 'disconnects' elements. Disconnection can be created in many ways,

through framelines (which may be thick or thin: there are degrees of framing), through empty space between elements, but also through contrasts of colour or form, or any other visual feature – in short, through any form of discontinuity, disconnection or contrast that can be visually signified. Connection can be achieved in exactly the opposite way, through similarities and rhymes of colour and form, through vectors that connect elements, and of course through the absence of framelines or empty space between elements. In every case the discontinuity or continuity between elements in a sense expresses what it is, that is the elements are separated or made to belong together. This broad meaning potential can then be made more precise through the context, and also through the means of framing chosen.

In Ramendeep's text (Figure 7.4) these compositional resources are used in a variety of ways. The image is first and arguably the most salient element of the text. Image and writing are presented under different titles and the date heads each section of the text. The image is entitled 'looking at onion cells' and the writing is entitled 'looking at cells' and 'what I did'. Image and writing are presented as two quite distinct parts of the same text and their disconnection is strengthened by a line separating them (the fact that they are on the same page maintains their connection as one textual unit). This separation of the visual and written elements of the text marks a shift from the abstract (visual) to the specific 'concrete actions' located in the pupil's personal experience (written). Two different modes are used to realize different communicative functions – the writing to convey the personal, the visual to convey the scientific. At another level, the framing of the visual sets scientific reality apart from everyday reality and also indicates that what is seen 'through the microscope' is only a selection of what can be seen: it is a visual abstraction or generalization of the cell. The frame of the image, a rectangle with an 'open' (left) side presents the cell as an instance taken out of the empirical. In Amy's text (Figure 7.5) the written element and the visual element of the text partially merge – they are less strongly framed as separate. The written element is strongly framed in terms of scientific genre – the steps of the experiment are clear. The circular framing at the level of the image frames the visual information as 'empirically real' – what is there for Amy. In other words, both pupils have used framing at the level of the text and at the level of image to realize their different interests.

Salience

The term 'salience' is used by Kress and van Leeuwen (1996) to indicate that some elements can be made more eye-catching than others. This again can be made in many different ways, through size, through colour contrasts (red is always a very salient colour), tonal contrast – in short through anything that can make a given element stand out from its surroundings. In Figure 7.1, for instance, the car and man are the most salient elements of the picture because of their size, the way the man's face is foregrounded (displayed) and the way the car's sleek smoothness contrasts to the less sharply defined textured wall in the background.

The pupils' different decisions in the positioning of, and amount of page given to, the visual and written elements of the text gave different salience to each of these

elements within their texts. The drawing is most salient in Ramendeep's text (Figure 7.4) (it comes first and occupies 40 per cent of the page), whereas the writing is most salient in Amy's text (Figure 7.5) (it comes first and occupies 60 per cent of the page). Ramendeep's use of a yellow-green in her drawing (despite being instructed not to use colour by the teacher) and her use of shading added to its salience.

Modality

Photographs are often thought of as 'images of the real', as images that show things exactly as they might also be seen in reality with the naked eye (see Chapters 3 and 4). On the other hand, graphs and diagrams can also be thought of as true to reality, as images that depict the world as it is, objectively, scientifically – and yet they lack all the characteristics that contribute to the photographic impression of reality. They are general where photos are specific, abstract where photos are concrete, conventional where photos appear to be an 'imprint of reality'. How can these two modes of representation both claim to be real when they are so very different? They can both claim to be real because the claims are based on different definitions of reality. Naturalistic modality (modality = 'reality value') defines visual reality as follows: the greater the congruence between what you see of an object in an image and what you can see of it in reality with the naked eye, in a specific situation and from a specific angle, the higher the modality of that image. That, at any rate, is the theory, for the modality of photographs is, in the end, also based on convention, namely on the conventions built into the most widely used realistic image technologies. Modern 35mm photography, not reality, is the contemporary standard of high naturalistic modality, and as soon as an image displays more sharpness, more colour saturation, a deeper perspective, than the average colour photo, its modality decreases again and it begins to look 'more than real', or 'surreal', 'fantastic' or 'ghostly', depending on the way this particular meaning potential of what Kress and van Leeuwen (1996) call sensory modality is actualized in the specific context. Scientific modality on the other hand is based not on what things, in a specific situation and from a specific angle, look like, but on how things are in general, or regularly, or according to some deeper, 'hidden' truth. The scientific image probes beyond the surface and abstracts from detail. There often is no background, detail is simplified or left out, colour and depth regarded as superfluous. Precisely those means of expression which ensure high modality from the point of view of naturalism are here regarded as unreal and irrelevant indicators of low modality.

Ramendeep's image (Figure 7.4) uses the resources of scientific modality (for example, the waving lines in the left section of the image and the lack of depth of the image) to realize an abstracted account of cells. The drawing appears to be primarily concerned with the idea of regularity and sameness: a visual search for, and presentation of, scientificness as a generalized pattern of meaning. The distinctly different pattern of the air bubble (the circle on the left of the image) and the cells visually marks their difference. As Ramendeep looked through the microscope in the lesson, she said 'It looks like a brick wall'. This visual analogy is also apparent in her drawing of cells. The analogy focused on the positive elements of regularity

and uniformity of cells and embodies the relationship of the part (the cell or brick) to the whole (the onion or brick wall). A brick wall is a familiar thing in an urban environment and the familiarity implied by the visual analogy comments on its everydayness: cells are everywhere.

Amy on the other hand realized the key conventions of scientificness text in the written element of her work (Figure 7.5). The voice is impersonal and the agent unnamed. Imperatives give the reader directives for re-creating the experiment. These imperatives have a generalizing effect. They convey 'what one should do' to repeat 'what I did'. The effacing of the narrator presents the writing as factual and objective. The absent narrator serves to absent the audience: they are nowhere addressed and yet they are assumed to be completely known and therefore present in every facet of the language (Kress, 1994). The voice of the writing serves to distance Amy from the experience of the experiment (in contrast to her excited exclamations in the classroom). The visual element, on the other hand, is more personal and less scientific. The teacher's somewhat desperate comment on the drawing ('Did what you saw look like "my diagram" in any way?') suggests that he might agree with this assessment.

Although Amy uses some of the resources of visual scientificness, she also makes them more personal and affective. The circular frame of the image, for instance, is a convention generally used to encode the experience of seeing through a microscope, making the equipment, the microscope, part of the representation. But the organic flow of the lines in her image suggest an emphasis on 'the experience of looking' rather than on 'what I saw'. Similarly the lack of colour and the flatness of the image both suggest an abstract representation, moving more towards the scientific than towards the naturalistic modality. But the frame was tentatively drawn with a compass and so suggested a tension between the certainty of a mechanistically produced circle and the hesitancy of the maker, and realized a sensory or aesthetic modality focusing on the emotion and affect of the event rather than on scientific realism. It realized Amy's involvement and excitement. This interest in the sensory modality was carried through in Amy's use of the analogy 'a wavy weave – in and out of each other in our microscopes'. The image is represented beneath the title 'what we saw' and the title for the writing is 'looking at cells'. These titles suggest that the agency involved in the visual experience of looking at the cells is different from the agency involved in making them visible. Through her writing Amy transformed her experience of doing the experiment into a generalized set of actions, whilst through her image she asserted her individual experience of seeing the cells.

Using the social semiotic approach to image analysis in the context of this part text-analytical, part ethnographic-like research showed that the concepts of composition, frame and modality were useful in drawing attention to how these texts reflected the consequences of pupils' differently interested use of genre resources and differently emerging expressions of scientificness. It highlighted how the pupils' experiences were mediated differently through their use of image and writing in the texts: that is, the visual and written elements of the texts contributed differently to the realization of 'being scientific'; and the experience of the experiment for each pupil. The texts can be explained by seeing them as the product of the different stances each pupil adopted to the recording of their experience of learning and to the protocol of 'being scientific'.

In short, the visual and the written elements of a text appeared to attend to different aspects of meaning, that is, they realized different functions.

CROSS-CULTURAL STUDIES USING SOCIAL SEMIOTICS

Kress and van Leeuwen (1996) see their work as valid for the broad domain of contemporary Western visual culture, as globally distributed through the hegemony of Anglo-American mass media in the world, albeit of course with all kinds of local accents. Our last example is from a study which used visual social semiotics to explore cultural difference in the realm of the advertising image, through a comparative analysis of British and Japanese advertisements (Oyama, 1999). We will focus on one aspect of the study: the cultural meanings of the left–right, given–new type information structure posited by Kress and van Leeuwen (1996).

Figure 7.6 represents two public signs for 'exit' that make use of a type of visual image called isotype. A system of isotypes was devised by the Viennese philosopher and social scientist Otto Von Neurath (1937, 1948) to convey information to the general public. Von Neurath believed this system to be universally communicative, as opposed to the opacity of verbal language, which he viewed as 'a disfiguring medium for knowledge' in that 'its structure and vocabulary fail to be a consistent, logical model of objects and relations in the physical world' (Lupton, 1989: 145).

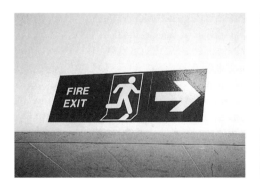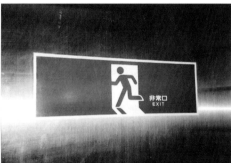

Figure 7.6 British and Japanese 'exit this way' signs.

Both signs in Figure 7.6 realize the same meaning ('exit this way') but their visual directionality differs. In the British example (first image) the orientation of the human figure is to the right, whereas in the Japanese example it is to the left. If, as Von Neurath suggested, the isotype provides universality in the manifestation of visual information, the question arises as to how this difference can be explained. Clearly the lexical aspect (content of the visual images: 'exit') is independently variable in relation to spatial orientation, and spatial orientation (visual syntax) creates, implicitly, an indication of visual directionality which is culturally different. If the meaning potential of the given is, informationally, 'where you come from', your 'point of departure', and the meaning potential of the new, 'where you are going to', 'what you must attend to', then it may

be that the visual realization of these informational meaning potentials is not the same in the two cultures.

The key role of directionality in meaning-making and its difference in British and Japanese cultures can be seen in another Japanese example, which advertises male hairpieces and appeared in a Japanese magazine. There are two photographs above the lead copy, both of which show a family of three (who appear to be on holiday; there is a suitcase, on which a little girl is sitting, and the man is carrying a travel bag on his shoulder). These two photographs indicate the difference in the man's hair: in the left photograph the man has hair, whereas in the right photograph he is bald. An advertisement for cosmetic surgery by a clinic taken from a British women's magazine shows parts of a patient's body before and after cosmetic surgery. For example, one photograph on the top left shows two states of a woman's nose, before and after surgery. Clearly both examples have a 'before and after' structure, with a problem forming the 'given', the point of departure for the message, and a 'new' forming the solution. But in the Japanese example the given is on the right and the new on the left, whereas in the British example it is the other way around. Clearly, like horizontal directionality, horizontal distribution of space also differs in the two cultures, and along the same lines. The Japanese example realizes given in the right and new in the left. The British example realizes given in the left and new in the right. Different kinds of visual semiotics operate in the context of Japanese and British representations.

CONCLUSIONS

Kress and van Leeuwen's method of visual analysis provides essentially a descriptive framework. For this reason it does not, on its own, offer all that is needed for the sociological interpretation of images. As already mentioned, the study of sexual health promotion campaigns we used as one of our key examples not only had to draw on social theories of gender and masculinities and earlier studies of gender construction in images, but also on methodologies allowing a more systematic analysis of the similarities, differences and patterns in the sample of images (Ritchie and Spencer, 1994). Kress and van Leeuwen's (1996) method (which is simplified here) is also quite complex and introduces a great deal of new terminology which can appear pedantic to the outsider and requires elaborate explanation every time the method is used in writings that will be read by audiences who are not familiar with it.

That said, the method is effective in bringing out hidden meanings. In the case of the sexual health study, it brought out that leaflets and posters which were meant to communicate to all young people (some specifically to young men) were in fact quite strongly oriented towards heterosexual norms. There was, for instance, a visual association of anal sex with disease which would not be conducive to the aim of the leaflets to practise safe sex and which appealed to fear and homophobia. The method also revealed gender representations which were not apparent in the written text, such as over-simplifications of male sexuality and portrayals of men as sexually less complex than women. Analysing the action processes, the symbolic attributes and the composition of the images the study found that sex was portrayed as a skill or technique to

be acquired by men, comparable to driving a car or playing a sport, and a physical activity rather than an emotional experience. This clearly reinforces society's message that women, not men, have sexual problems, that men are not sexually emotional, and serves to maintain the invisibility of male sexual problems. The study also used semiotic analysis to show how the images failed to address young men's emotional concerns and responses to sexual experiences. Setting, symbolic attributes, composition and framing visually asserted competitiveness as a key aspect of heterosexual male sexuality and the visual display of intimacy between men was restricted to designated social contexts such as sports, business and family groups. Men were not shown in caring roles. Finally, the study showed how the visual polarization of men and women conflicted with the verbal assertion of the need for them to negotiate. The images represented men in a negative way and women in a positive (or at least morally superior) way. This is unlikely to contribute to the desired effect of the campaigns. Roles were polarized. Men were shown as taking risks, women as protecting; men as sexually knowing, women as innocent; men as simple, women as complex; men as physical, women as emotional; men as irresponsible, women as responsible. This polarization undermined the textual message of shared sexual goals and emotions, and the positive potential of this for the negotiation of safer sex. The images in the sample thus reflected the traditional reliance of health promotion materials on women to mediate HIV prevention and sexual health messages to young men. The images emphasized the ability of women to ignore their own sexual desires and represented heterosexual male sexuality as more potent than female sexuality, while depicting woman as sexual mediators and guardians of sexual morality.

Clearly this shows that in sexual health promotion materials, science education and society more generally, images play a role which goes far beyond the mere illustration of what is communicated in language, and images can contradict and work against spoken or written messages. If image analysis can bring this out, it can help improve and change practices (such as the production of information leaflets, or the teaching and assessment of learning), which can then lead to that third kind of social semiotic work we mentioned at the outset of this chapter – developing new semiotic resources and new uses of existing semiotic resources.

NOTE

1 This example is drawn from an ESRC-funded research project entitled 'The rhetoric of the science classroom: a multimodal approach' undertaken by C. Jewitt, G. Kress, J. Ogborn and C. Tsatsarelis for the Institute of Education, University of London.

REFERENCES

Arnheim, R. (1969) *Visual Thinking*. Berkeley and Los Angeles: University of California Press.
Arnheim, R. (1974) *Art and Visual Perception*. Berkeley: University of California Press.
Arnheim, R. (1982) *The Power of the Center*. Berkeley and Los Angeles: University of California Press.

Goffman, E. (1979) *Gender Advertisements.* London: Macmillan.

Graham, H. (1977) 'Images of pregnancy in antenatal literature', in R. Dingwall, C. Heath and M. Ried (eds), *Health Care and Health Knowledge.* London: Croom Helm.

Halliday, M.A.K. (1978) *Language as Social Semiotic.* London: Edward Arnold.

Halliday, M.A.K. (1985) *An Introduction to Functional Grammar.* London: Edward Arnold.

Holland, J., Ramazanoglu, C. and Sharpe, S. (1993) *Wimp or Gladiator: Contradictions in Acquiring Masculine Sexuality.* London: Tufnel Press.

Jewitt, C. (1997) 'Images of men', *Sociological Research Online*, 2 (2).

Jewitt, C. (1998) 'How to produce inclusive resources', in G. Lenderyou and C. Ray (eds), *Let's Hear It for the Boys!* London: National Children's Bureau.

Jewitt, C. (1999) 'A social semiotic analysis of male heterosexuality in sexual health resources: the case of images', *International Journal of Social Research Methodology: Theory and Practice*, 1 (4): 263–80.

Kress, G. (1994) *Learning to Write*, 2nd edn. London: Routledge.

Kress, G. and van Leeuwen, T. (1996) *Reading Images: The Grammar of Visual Design.* London: Routledge.

Kress, G., Jewitt, C., Ogborn, J. and Tsatsarelis, C. (in press) *Multimodal Teaching and Learning: The Rhetorics of the Science Classroom.* London: Continuum.

Lupton, E. (1989) 'Reading isotype', in M. Victor (ed.), *Design Discourse – History /Theory/ Criticism.* Chicago: University of Chicago Press.

Millum, T. (1975) *Images Of Women, Advertising In Women's Magazines.* London: Chatto.

Oyama, R. (1999) 'Visual semiotics in a cross-cutural perspective: a study of visual images in Japenese and selected British advertisements', PhD dissertation, University of London.

Panofsky, E. (1953) *Early Netherlandish Painting.* New York: Harper and Row.

Ritchie, J. and Spencer, L. (1994) 'Qualitative data analysis for applied policy research', in A. Bryman and R. Burgess (eds), *Analyzing Qualitative Data.* London: Routledge.

van Leeuwen, T. (1999) *Speech, Music, Sound.* London: Macmillan.

Von Neurath, O. (1937) *International Picture Language.* London: London Basic Publishing Company.

Von Neurath, O. (1948) *Basic by Isotype.* London: London Basic Publishing Company.

Wight, D. (1992) 'Boys' thoughts and talk about sex in a working class locality of Glasgow', unpublished paper, MRCMSU, Glasgow.

8 Practices of Seeing Visual Analysis: an Ethnomethodological Approach

CHARLES GOODWIN

INTRODUCTION

A primordial site for the analysis of human language, cognition and action consists of a situation in which multiple participants are attempting to carry out courses of action together while attending to each other, the larger activities that their current actions are embedded within and relevant phenomena in their surround. Vision can be central to this process.[1] The visible bodies of participants provide systematic, changing displays about relevant action and orientation. Seeable structure in the environment can not only constitute a locus for shared visual attention, but can also contribute crucial semiotic resources for the organization of current action (consider, for example, the use of graphs and charts in a scientific discussion). For the past thirty years both conversation analysis and ethnomethodology have provided extensive analysis of how human vision is socially organized. Both fields investigate the practices that participants use to build and shape in concert with each other the structured events that constitute the lifeworld of a community of actors. Phenomena investigated in which vision plays a central role range from sequences of talk, through medical and legal encounters, to scientific knowledge.

The approach taken by both ethnomethodology and conversation analysis to the study of visual phenomena is quite distinctive. At least since Saussure proposed studying *langue* as an analytically distinct sub-field of a more encompassing science of signs, different kinds of semiotic phenomena (language, visual signs, etc.) have typically been analysed in isolation from each other. However in the work to be described here neither vision, nor the images or other phenomena that participants look at, are treated as coherent, self-contained domains that can be subjected to analysis in their own terms. Instead it quickly becomes apparent that visual phenomena can only be investigated by taking into account a diverse set of semiotic resources and meaning-making practices that participants deploy to build the social worlds that they inhabit and constitute through ongoing processes of action (see Chapter 9). Many of these, such as structure provided by current talk, are not in any sense visual, but the visible phenomena that the participants are attending to cannot be properly analysed without them. The focus of analysis is not thus representations or vision *per se*, but instead the part played by visual phenomena in the production of meaningful action.

Both the methodology and the forms of analysis used in this approach can best be demonstrated through specific examples.

GAZE BETWEEN SPEAKERS AND HEARERS

In formulating the distinction between competence and performance, Chomsky (1965: 3–4) argued that actual speech is so full of performance errors, such as sentence fragments, restarts and pauses, that both linguists and parties faced with the task of acquiring a language should ignore it. Investigating a corpus of conversation recorded on video, C. Goodwin (1980, 1981: Chapter 2) indeed found precisely the 'false starts' and 'changes of plan in mid-course' that Chomsky describes. In the following, instead of producing an unbroken grammatical sentence, the speaker says:[2]

> Cathy: En a couple of girls- *One* other girl from there,

However, as shown in Figure 8.1, when the video is examined it is found that the restart occurs at a specific place: precisely at the point where the speaker brings her gaze to her addressee and finds that her addressee is looking elsewhere. Moreover, the restart acts as a request for the hearer's gaze. Thus immediately after the restart the hearer starts to move her gaze to the speaker. Paradoxically, if the speaker had not produced a restart at this point she could have said something that would appear to be an unbroken grammatical unit if one examined only the stream of speech (for example, 'En a couple of girls from there . . .'), but which would in fact be interactively a sentence fragment since her addressee attended to only part of it.

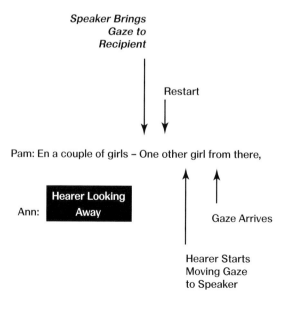

Figure 8.1 Gaze between speakers and hearers: transcript of Pam and Ann.

The identities of speaker and hearer are the most generic participant categories relevant to the production of a strip of talk. The phenomena examined here (which occur pervasively in conversation) provide evidence that the work of being a hearer in face-to-face interaction requires situated use of the body, and gaze in particular, as a way of visibly displaying to others the focus of one's orientation. Moreover speakers not only use their own gaze to see relevant action in the body of a silent hearer, but actively change the structure of their emerging talk in terms of what they see.

What relevance do processes such as these have to the other issue raised by Chomsky (1965: 3), that of determining 'from the data of performance the underlying system of rules mastered by the speaker–hearer'? Many repairs involve the repetition, with some significant change, of something said elsewhere in the utterance:

We wen t- I went to
If he could- If you could

Such repetition has the effect of delineating the boundaries and structure of many different units in the stream of speech. Thus, by analysing what is the same and what is different in these examples one is able to discover the following: first, where the stream of speech can be divided into significant sub-units; second, that alternatives are possible in a particular slot; third, what some of these alternatives are (here different pronouns); and fourth, that these alternatives contrast with each other in some significant fashion, or else the repair would not be warranted. Repairs in other examples not only delineate basic units in the stream of speech (noun phrases, for example), but also demonstrate the different forms such units can take and the types of operations that can be performed upon them (see Goodwin, 1981: 170–3). Repairs further require that a listener learn to recognize that not all of the sequences within the stream of speech are possible sequences within the language, for example that 'I' does not follow 'to' in 'We went t- I went to . . .'. In order to deal with such a repair a hearer is thus required to make one of the most basic distinctions posed for anyone attempting to decipher the structure of a language: to differentiate what are and are not possible sequences in the language, that is between grammatical and ungrammatical structures. The fact that this task is posed may be crucial to any learning process. If the party attempting to learn the language did not have to deal with ungrammatical possibilities, if for example she was exposed to only well-formed sentences, she might not have the data necessary to determine the boundaries, or even the structure of the system. Chomsky's argument that the repairs found in natural speech so flaw it that a child is faced with data of very 'degenerate quality' does not appear warranted. Rather it might be argued that if a child grew up in an ideal world where she heard only well-formed sentences she would not learn to produce sentences herself because she would lack the analysis of their structure provided by events such as repair. Crucial to this process is the way in which visual phenomena, such as dispreferred gaze states, can both lead to repair and demonstrate that the participants are in fact attending in fine detail to what might appear to be quite ephemeral structure in the stream of speech.

What has just been described provides one example of the methodologies and forms of analysis used to investigate visual phenomena within conversation analysis.

Several observations can be made. First, the focus of analysis is not visual events in isolation, but instead the systematic practices used by participants in interaction to achieve courses of collaborative action with each other – in the present case the interactive construction of turns at talk and the utterances that emerge with those turns. Visual events, such as gaze, play a central role in this process but their sense and relevance is established through their embeddedness in other meaning-making tasks and practices, such as the production of a strip of talk that is in fact heard and attended to by its addressee. This links vision to a host of other phenomena, including language and the visible body, as an unfolding locus for the display of meaning and action.

Second, what the analyst seeks to do is not to provide his or her own gloss on how visual phenomena might be meaningful, but instead to demonstrate how the participants themselves not only actively orient to particular kinds of visual events (such as states of gaze), but use them as a constitutive feature of the activities they are engaged in (for example, by modifying their talk in terms of what they demonstrably see).

Third, in addition to the spatial dimension that is naturally associated with vision, these processes also have an intrinsic temporal dimension as changes in visual events are marked by, and lead to, ongoing changes in the organization of emerging action. If one had only a static snapshot, or measured only a single structural possibility, such as mutual gaze, instead of looking at the temporally unfolding interplay of different combinations of participant gaze, the type of analysis being pursued here would be impossible.

Fourth, such analysis requires data of a particular type, specifically a record that maintains as much information as possible about the setting, embodied displays and spatial organization of all relevant participants, their talk, and how events change through time. In practice no record is completely adequate. Every camera position excludes other views of what is happening. The choice of where to place the camera is but the first in a long series of crucial analytical decisions (see Chapter 9). Despite these limitations a video or film record does constitute a relevant data source, something that can be worked with in an imperfect world (see Chapter 3).

Fifth, crucial problems of transcription are posed. The task of translating the situated, embodied practices used by participants in interaction to organize phenomena relevant to vision poses enormous theoretical and methodological problems. Our ability to transcribe talk is built upon a process of analysing relevant structure in the stream of speech and marking those distinctions with written symbols, that extends back thousands of years and is still being modified today (for example, the system developed by Gail Jefferson (Sacks et al., 1974: 731–3) for transcribing the texture of talk-in-interaction, including phenomena, such as momentary restarts and sound stretches, that are crucial for the analysis being reported here). When it comes to the transcription of visual phenomena we are at the very beginning of such a process. The arrows and other symbols I've used to mark gaze on a transcript (see Goodwin, 1981) capture only a small part of a larger complex constituted by bodies interacting together in a relevant setting. The decision to describe gaze in terms of the speaker–hearer framework is itself a major analytic one, and by no means simple, neutral description. Moreover a gazing head is embedded within a larger postural configuration, and indeed different parts of the body can simultaneously display orientation to different

participants or regions (see Kendon, 1990b; Schegloff, 1998), creating 'participation frameworks' of considerable complexity. Thus on occasion a transcriber wants some way of indicating on the printed page posture and alignment. In addition, not only the bodies of the participants, but also phenomena in their surround, can be crucial to the organization of their action. To try to make the phenomena I'm analysing independently accessible to the reader so that she or he can evaluate my analysis, I've experimented with using transcription symbols, frame grabs, diagrams and movies embedded in electronic versions of papers. Multiple issues are involved and no method is entirely successful. On the one hand the analyst needs materials that maintain as much of the original structure of the events being analysed as possible, and which can be easily and repetitively replayed. On the other hand, just as a raw tape recording does not display the analysis of segmental structure in the stream of speech provided by transcription with a phonetic or alphabetic writing system, in itself a video, even one that can be embedded within a paper, does not provide an analysis of how visible events are being parsed by participants. The complexity of the phenomena involved requires multiple methods for rendering relevant distinctions (e.g. accurate transcription of speech, gaze notation, frame grabs and diagrams; see also Ochs, 1979). Moreover, like the two-faced Roman god Janus, any transcription system must attend simultaneously to two separate fields, looking in one direction at how to accurately recover through a systematic notation the endogenous structure of the events being investigated, while simultaneously keeping another eye on the addressee/reader of the analysis by attempting to present relevant descriptions as clearly and vividly as possible. In many cases different stages of analysis and presentation will require multiple transcriptions. There is a recursive interplay between analysis and methods of description.

Work in conversation analysis has provided extensive study of how the gaze of participants toward each other is consequential for the organization of action within talk-in-interaction. Phenomena investigated include the way in which speakers change the structure of an emerging utterance, and the sentence being constructed within it, as gaze is moved from one type of recipient to another, so that the utterance maintains its appropriateness for its addressee of the moment (Goodwin, 1979, 1981); how speakers modify descriptions in terms of their hearer's visible assessment of what is being said (M.H. Goodwin, 1980); how genres such as stories are constructed not by a speaker alone, but instead through the differentiated visible displays of a range of structurally different kinds of recipients (speaker, primary addressee, principal character, etc. – see Goodwin, 1984); the organization of gaze and co-participation in medical encounters (Heath, 1986; Robinson, 1998); the interactive organization of assessments (Goodwin and Goodwin, 1987); gesture (Goodwin, 2000; Streeck, 1993, 1994); the use of gaze in activities such as word searches (Goodwin and Goodwin, 1986); and so on. Though not strictly lodged within conversation analysis the work of Kendon (1990a, 1994, 1997) on both the interactive organization of bodies as they frame states of talk and on gesture is central to the study of visible behaviour in interaction. Haviland (1993) provides important analysis of the interactive organization of gesture within narration (for extensive analysis of gesture from a psychological perspective, see McNeill, 1992).

SCIENTIFIC IMAGES

The visible, gazing body, and the orientation of participants toward each other as they co-produce states of talk, is central to the work in conversational analysis just examined. By way of contrast much work within ethnomethodology has focused not on the bodies of actors, but instead on the images, diagrams, graphs and other visual practices used by scientists to construct the crucial visual working environments of their disciplines. As noted by Lynch and Woolgar:

> Manifestly, what scientists laboriously piece together, pick up in their hands, measure, show to one another, argue about, and circulate to others in their communities are not 'natural objects' independent of cultural processes and literary forms. They are extracts, 'tissue cultures,' and residues impressed within graphic matrices; ordered, shaped, and filtered samples; carefully aligned photographic traces and chart recordings; and verbal accounts. These are the proximal 'things' taken into the laboratory and circulated in print and they are a rich repository of 'social' actions. (1990: 5)

Despite important differences in subject-matter and methodology, both fields emphasize the importance of focusing not on representations or other visual phenomena as self-contained entities in their own right, but instead on how they are constructed, attended to and used by participants as components of the endogenous activities that make up the lifeworld of a setting. Thus, in introducing their important volume *Representation in Scientific Practice*, Lynch and Woolgar define their enquiry as follows: 'Instead of asking "what do we mean, in various contexts, by 'representation'?" the studies begin by asking, "What do the participants, *in this case*, treat as representation?"' (1990: 11). Note that what must be investigated is specified both in terms of the orientation of the participants and with respect to the features of the relevant local setting (for example, '*in this case*'). This leads to a distinctive ethnomethodological perspective on *reflexivity*: '"Reflexivity" in this usage means, not self-referential nor reflective awareness of representational practice, but the inseparability of a "theory" of representation from the heterogeneous social contexts in which representations are composed and used' (Lynch and Woolgar, 1990: 12).

In a classic article Lynch formulates the task of analysing scientific representations as that of describing the publicly visible 'externalized retina' that is the site for the practices implicated in the social constitution of the objects that are the focus of scientific work:

> This study is based on the premise that visual displays are more than a simple matter of supplying pictorial illustrations for scientific texts. They are essential to how scientific objects and orderly relationships are revealed and made analyzable. To appreciate this, we first need to wrest the idea of *representation* from an individualistic cognitive foundation, and to replace a preoccupation with images on the retina (or alternatively 'mental images' or 'pictorial ideas') with a focus on the 'externalized retina' of the graphic and instrumental fields upon which the scientific image is impressed and circulated. (1990: 153–4)

Using as data images from scientific journal articles and books, Lynch describes two families of practices used to constitute the visible scientific object: 'selection'

and 'mathematization'. Selection, illustrated through double images in which a photograph and a diagram of entities visible in the photograph are presented side by side, is described as a host of practices that iteratively transform one image of an entity into another (for example, the photograph to the diagram) while simultaneously structuring and shaping what it is that is being represented. Crucial to this process is the fact that different selective/shaping practices, including filtering, uniforming, upgrading and defining, can be repetitively applied creating not just a single image, but a linked, directional chain of representations. Indeed much of the work of actually doing science consists in building and shaping what Latour (1986) has called *inscriptions* in this fashion (see also Latour and Woolgar, 1979). 'Mathematization' refers not simply to the use of numbers, but instead to the host of practices used to transform recalcitrant events into mathematically tractable visual and graphic displays, for example graphs, charts and diagrams. Thus an image showing a map of lizard territories is assembled through, among other operations, driving stakes into the lizards' environment to create a grid for measurement (and thus injecting a scientif- ically relevant Cartesian space into the very habitat being studied), repetitively capturing lizards, distinguishing them from each other by cutting off a different pattern of toes on each lizard, recording each capture on a paper map of the staked out territory, and finally drawing lines around collections of points to create the map. As noted by Lynch the product of these practices, for example the published map, 'is a hybrid object that is demonstrably mathematical, natural and literary' (1990: 171). Note how in all of these cases the focus of analysis is on the contextually based practices of the participants who are assembling and using these images to accomplish the work that defines their profession.

Though emerging from psychological anthropology, rather than ethnomethod- ology, Hutchins's (1995) ground-breaking study of the cognitive practices required to navigate a ship outlines a major perspective for the analysis of both images and seeing as forms of work-relevant practice. Hutchins demonstrates how the practices required to navigate a ship are not situated within the mental life of a single individual, but are instead embedded within a distributed system that encompasses visual tools, such as maps and instruments for juxtaposing a landmark and compass-bearing within the same visual field and actors in structurally different positions who use alternative tools and, in part because of this, perform different kinds of cognitive operations, many of which have a strong visual component (e.g. locating landmarks and plotting positions on a map).

IMAGES IN INTERACTION

All of the work discussed so far takes as its point of departure for the investigation of visual phenomena the task of describing and analysing the practices used by partici- pants to construct the actions and events that make up their lifeworld. Rather than standing alone as a self-contained analytic domain, visual phenomena are constituted and made meaningful through the way in which they are embedded within this larger set of practices. However, within this common focus, two quite different orders of

visual practice have been examined. Research in science studies has investigated the images produced by scientists, and the way in which they visually and mathematically structure the world that is the focus of their inquiry, without however looking in much detail at how scientists attend to each other as living, meaningful bodies, or structure what they are seeing through the organization of talk-in-interaction. By way of contrast, studies of the interactive organization of vision in conversation looked in considerable detail at how participants treat the visual displays of each other's bodies as consequential, and how this is relevant to the moment-by-moment production of talk, but did not focus much analysis on images in the environment. Clearly all of the phenomena noted – the visible body, participation, gesture, the details of talk and language use, visual structure in the surround, images, maps and other representational practices, the public organization of visual practice within the worklife of a profession, and so on – are relevant. The question arises as to whether it is possible to analyse such disparate phenomena within a coherent analytic framework.

Before turning to studies that have probed such questions several issues must be noted. First, it is clearly not the case that the only acceptable analysis is one that includes this full range of all possible visual phenomena. Both participants and the structures that provide organization for action and events use visible phenomena selectively. Parties speaking over the telephone can see neither each other's bodies nor events in a common surround. A scientific journal can be read in the absence of the parties who constructed its text and diagrams. More interestingly within face-to-face interaction participants can continuously shift between actions that invoke, and perhaps require, gaze towards specific events in the surround and those that make relevant gaze towards no more than each other's bodies. Even in this more limited case there may be a real issue as to whether it is relevant to attend to everything that a body does; for example, some gestures made by a speaker may not require gaze toward them from an addressee. There is thus an essential contingency, not only for the analyst but more crucially for the participants themselves, as to what sub-set of possible visual events are in fact relevant to the organization of the actions of the moment. Moreover, this means that in addition to investigating how different kinds of visible phenomena are organized, the analyst must also take into account how participants show each other what kinds of events they are expected to take into account at a particular moment, for example to indicate that a participant, gesture or entity in the surround should be gazed at. There is thus not only communication through vision, but also ongoing communication about relevant vision (Goodwin, 1981, 1986, in preparation; Streeck, 1988).

Second, visual events are quite heterogeneous, not only in what they make visible, but more crucially in their structure. Consider for example the issue of temporality. Both gestures and the displays of postural orientation used to build participation frameworks are performed by the body within interaction. However, while gestures, like the bits of talk they accompany, are typically brief (for example, they frequently fall within the scope of a single utterance) and display semantic content relevant to the topic of the moment, participation displays frame extended strips of talk and typically provide information about the participants' orientation rather than the specifics of what is being discussed. Bodily displays with one kind of temporal

duration (and information content) are thus embedded within another class of visual displays being made by the body which have a quite different structure.

Third, the structure of visual signs, including their possibilities for propagation through space and time, can be intimately tied to the medium used to construct them. A major theme of Shakespeare's sonnets focuses on the contrast between the temporally constrained human body, condemned to inevitable decay, and the (limited) possibilities for transcending such corruption provided by language inscribed on the printed page which can remain fresh and alive long after its author and subject have passed into dust. This contrast between the temporal possibilities provided by alternative media (e.g. the body and documents) constitutes an ongoing resource for participants in vernacular settings as they build, through interaction with each other, the events that make up their lifeworld. In addition to the displays made by a fleeting gesture or local participation framework, participants also have access to images and documents which can encompass multiple interactions and quite diverse settings. This arises in part from the specific media used to constitute the signs they contain. Rather than being lodged within an ever-changing human body, such documents constitute what Latour has called immutable mobiles, portable material objects that can carry stable inscriptions of various types from place to place and through time (1987: 223).

However, despite the way in which crucial aspects of the structure of images and documents remain constant in different environments, they are not self-contained visual artefacts that can be analysed in isolation from the processes of interaction and work practices through which they are made relevant and meaningful. The same image or document can be construed in quite different ways in alternative settings. For example, a schedule listing all arriving and departing flights was a major tool for almost all work groups at the airport studied by the Xerox PARC workplace project (Brun-Cottan et al., 1991; Goodwin and Goodwin, 1996; Suchman, 1992), and indeed it linked diverse workers throughout North America into a common web of activity. However while baggage loaders carefully structured their work to anticipate arriving flights, so that planes could be speedily unloaded, these same arrival times were almost ignored by gate agents looking at the same schedule, but concerned with the departure of passengers. Each work group highlighted the common document in ways relevant to the specific work tasks it faced.

Similarly, on the oceanographic ship reported in Goodwin (1995), a map showing where samples would be taken in the Atlantic at the mouth of the Amazon was a major document at all stages of the research project. Before the ship sailed the places where samples could be taken were the focus of intense political debate between different groups of scientists and the Brazilian and American governments. After the project was completed the map provided an infrastructure for graphic displays that could be used in published journal articles to show what the scientists had found about how the waters of the Amazon and the Atlantic interacted with each other, that is, a way of making visible relevant scientific phenomena. During the voyage itself the map not only provided a common framework for the quite different work of various teams of scientists and the crew navigating the ship, but could also be looked at by lab technicians, not able to go to bed for days at a time because of the map's incessant

sampling demands, to locate places where stations were far apart and rest was possible. In brief, though the material form of images and documents gives them an extended temporal scope, and the ability to travel from setting to setting, they cannot be analysed as self-contained fields of visually organized meaning, but instead stand in a reflexive relationship to the settings and processes of embodied human interaction through which they are constituted as meaningful entities. To explicate such events analysis must deal simultaneously with the quite different structure and temporal organization of both local embodied practice and enduring graphic displays.

Finally, the visual (and other) properties of settings structure environments that shape, on an historical time-scale, the activities systematically performed within those settings. A very simple example is provided by the bridge of the oceanographic ship which not only had a window facing forward so the helmsman could steer the ship and watch for trouble, but also a window facing backwards. This was used by a winch operator who had the task of lifting heavy instrument packages in and out of the sea. Though being used here to do science, this arrangement is in fact a systematic solution to a repetitive problem faced by sailors, such as fishermen using nets, who have to manoeuvre heavy objects while at sea. Solutions found to these tasks, such as the rear-facing window with the visual access it provides (as well as the forward window facilitating navigation), are built into the tools that constitute the work environments used by subsequent actors faced with similar tasks. See Hutchins (1995) for illuminating analysis of this process, including tools that visually structure complex mathematical calculations, as well as maps. Both work environments and many of the tools used within them (computer displays, etc.) structure in quite specific ways the embodied visual practices of those who inhabit such settings.

In an attempt to come to terms with such issues Goodwin (2000) has proposed that images in interaction are lodged within endogenous activity systems constituted through the ongoing, changing deployment of multiple 'semiotic fields' which mutually elaborate each other. The term semiotic field is intended to focus on signs-in-their-media, that is the way in which what is typically been attended to are sign phenomena of various types (gestures, maps, displays of bodily orientation, etc.) which have variable structural properties that arise in part from the different kinds of materials used to make them visible (for example, the body, talk, documents, etc.). Bringing signs lodged within different fields into a relationship of mutual elaboration produces locally relevant meaning and action that could not be accomplished by one sign system alone. Consider for example a place on a map indicated by a pointing finger which is being construed in a specific fashion by the accompanying talk. Not the map as a whole, that is a self-sufficient representation, nor the pointing finger in isolation from (a) its target (the spot on the map) and (b) the construal being provided by the talk, nor the talk alone, would be sufficient to constitute the action made visible by the conjoined use of the three semiotic fields, each of which provides resources for specifying how to relevantly see and understand the others (see the brief discussion of the Rodney King data below for a specific example; see Goodwin (in preparation) for more detailed analysis of pointing). The particular sub-set of semiotic fields available in a setting that participants orient to as relevant to the construction of the actions of the moment constitutes a 'contextual configuration'. As interaction unfolds

contextual configurations can change as new fields are added to, or dropped from, the specific mix being used to constitute the events of the moment. Thus, as contextual configurations change there is both unfolding public semiotic structure and contingency (and, indeed, in some circumstances actions can misfire when addressees fail to take into account a relevant semiotic field, such as the sequential organization provided by a prior unheard utterance – see Goodwin (in preparation) for an example).

PROFESSIONAL VISION

Work settings provide one environment in which the interplay between situated, embodied interaction and the use of visual images of different types can be systematically investigated. In many work settings participants face the task of classifying visual phenomena in a way that is relevant to the work they are charged with performing. Frequently they must also construct different kinds of representations of visual structure in the environment that is the focus of their professional scrutiny. I will now briefly examine how such vision is socially organized in two tasks faced by archaeologists: first, colour classification and, second, map-making. Then I will look at how such professional vision was both constructed and contested in the trial of four policemen charged with beating an African-American motorist, Mr Rodney King, where the key evidence was a videotape of the beating.

Colour classification as historically structured professional practice

As part of the work involved in excavating a site, archaeologists make maps showing relevant structure in the layers of dirt they uncover. In addition to *artefacts*, such as stone tools, archaeologists are also interested in *features*, such as the remains of an old hearth or the outlines of the posts that held up a building. Such features are typically visible as colour differences in the dirt being examined (for example, the remains of a cooking fire will be blacker than the surrounding soil, while the holes used for posts will also have a different colour from the soil around them). Field archaeologists thus face the task of systematically classifying the colour of the dirt they are excavating. The methods they use to accomplish this task constitute a form of professional visual practice. As demonstrated by the discussion of Lynch's analysis of scientific representation, and the brief description of the oceanographers, crucial work in many different occupations takes the form of classifying and constructing visual phenomena in ways that help shape the objects of knowledge that are the focus of the work of a profession (for example, architects, sailors plotting courses on charts, air traffic controllers and professors making graphs and overheads for talks and classes). Such professional vision constitutes a perspicuous site for systematic study of how different kinds of phenomena intersect to organize a community's practices of seeing.

Goodwin (1996, 2000) describes how archaeologists code the colour of the dirt they are excavating through use of a Munsell chart. Figure 8.2 shows two archaeologists

performing this task: the Munsell page that they are using and the coding form where they will record their classification. Within this scene are a number of different kinds of phenomena relevant to the organization of visual practice, including tools that structure the process of seeing and classification and documents that organize cognition and interaction in the current setting while linking these processes to larger activities and other settings. These archaeologists are intently examining the colour of a tiny sample of dirt because they have been given a coding form to fill out. That form ties their work at this site to a range of other settings, such as the offices and lab of the senior investigator, where the form being filled in here will eventually become part of the permanent record of the excavation and a component of subsequent analysis. The multivocality of this form, the way in which it displays on a single surface the actions of multiple actors in structurally different positions, is shown visually in vivid fashion by the contrast between the printed coding categories and the hand-written entries of the field workers.

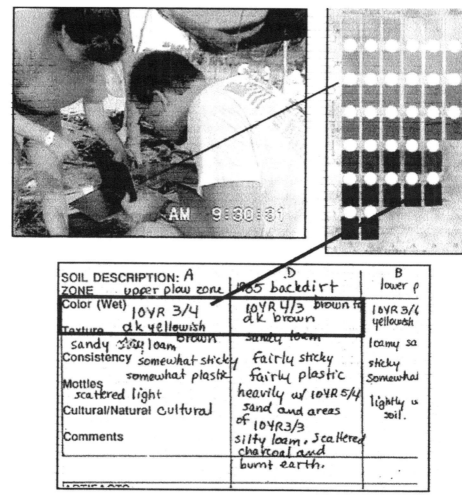

Figure 8.2 Transcript of archaeologists coding and recording the colour of the dirt they are excavating through use of a Munsell chart.

The use of a coding form such as this to organize the perception of nature, events or people within the discourse of a profession carries with it an array of perceptual and cognitive operations that have far-reaching impact. Coding schemes distributed on forms allow a senior investigator to inscribe his or her perceptual distinctions into the work practices of the technicians who code the data. By using such a system a worker views the world from the perspective it establishes. Of all the possible ways that the earth could be looked at, the perceptual work of field workers using this form is focused on determining the exact colour of a minute sample of dirt. They engage in active cognitive work, but the parameters of that work have been established by the classification system that is organizing their perception. Insofar as the coding scheme establishes an orientation toward the world, a work-relevant way of seeing, it constitutes a structure of intentionality whose proper locus is not the isolated, Cartesian mind, but a much larger organizational system, one that is characteristically mediated through mundane bureaucratic documents such as this form.

Rather than standing alone as self-explicating textual objects, forms are embedded within webs of socially organized, situated practices. In order to make an entry in the slot provided for colour an archaeologist must make use of another tool, the set of standard colour samples provided by a Munsell chart. This chart incorporates into a portable physical object the results of a long history of scientific investigation of the properties of colour.

The Munsell chart being used by the archaeologists contains not just one but three different kinds of sign systems for describing each point in the colour space it provides:

1 A set of carefully controlled *colour samples* arranged in a grid to demonstrate the changes that result from systematic variation of the variables of Hue, Chroma and Value used to define each colour (each page displays an ordered set of Value and Chroma variables for a single hue).
2 *Numeric co-ordinates* for each row and column; their intersection specifies each square as a pair of numbers (such as 4/6 on the 10YR Hue page).
3 *Standard colour names* such as 'dark yellowish brown' (these names are on the left-facing page which is not reproduced here). Moreover these systems are not precisely equivalent to each other. For example, several colour squares can fall within the scope of a single name.

Why does the Munsell page contain multiple, overlapping representations of what is apparently the same visual entity (for example, a particular choice within a larger set of colour categories)? The answer seems to lie in the way that each representation as a semiotic field with its own distinctive properties makes possible alternative operations and actions, and thus fits into different kinds of activities. Both the names and numbered grid co-ordinates can be written, and thus easily transported from the actual excavation to the other work sites, such as laboratories and journals, that constitute archaeology as a profession. The numbers provide the most precise description and do not require translation from language to language. However locating the colour indexed by the co-ordinates requires that the classification be read with a Munsell book at hand. By way of contrast the colour names can be grasped in a way

that is adequate for most practical purposes by any competent speaker of the language used to write the report. The outcome of the activity of colour classification initiated by the empty square on the coding form is thus a set of portable linguistic objects that can easily be incorporated into the unfolding chains of inscription that lead step by step from the dirt at the site to reports in the archaeological literature. However, as arbitrary linguistic signs produced in a medium that does not actually make visible colour, neither the colour names nor the numbers allow direct visual comparison between a sample of dirt and a reference colour. This is precisely what the colour patches and viewing holes make possible. Thus, rather than simply specifying unique points in a larger colour space, the Munsell chart is used in multiple overlapping activities (comparing a reference colour and a patch of dirt as part of the work of classification, transporting those results back to the lab, comparing samples, publishing reports, etc.), and so represents the 'same' entity, a particular colour, in multiple ways, each of which makes possible different kinds of operations because of the unique properties of each representational system.

In addition to its various sign systems the chart also contains a set of circular holes, positioned so that one is adjacent to each colour patch. To classify colour the archaeologist puts a small sample of dirt on the tip of a trowel, puts the trowel directly under the Munsell page and then moves it from hole to hole until the best match with an adjacent colour sample is found. With elegant simplicity the Munsell page, with its holes for viewing the sample of dirt on the trowel, juxtaposes in a single visual field two quite different kinds of spaces: (a) actual dirt from the site at the archaeologists' feet is framed by (b) a theoretical space for the rigorous, replicable classification of colour. The latter is both a conceptual space, the product of considerable research into properties of colour, and an actual physical space instantiated in the orderly modification of variables arranged in a grid on the Munsell page. The pages juxta-posing colour patches and viewing holes that allow the dirt to be seen right next to the colour sample provide an historically constituted architecture for perception, one that encapsulates in a material object theory and solutions developed by earlier workers at other sites faced with the task of colour classification. By juxtaposing unlike spaces, but ones relevant to the accomplishment of a specific cognitive task, the chart creates a new, distinctively human, kind of space. It is precisely here, as bits of dirt are shaped into the work-relevant categories of a specific social group, that 'nature' is transformed into culture.

How are the resources provided by the chart made visible and relevant within talk-in-interaction? At line 17 Pam moves her hand to the space above the Munsell chart and points to a particular colour patch while saying 'En this one'. Within the field of action created by the activity of colour classification, what Pam does here is not simply an indexical gesture, but a proposal that the indicated colour might be the one they are searching for. By virtue of such conditional relevance (Schegloff, 1968) it creates a new context in which a reply from Jeff is the expected next action. In line 19 Jeff rejects the proposed colour. His move occurs after a noticeable silence in line 18. However that silence is not an empty space, but a place occupied by its own relevant activity. Before a competent answer to Pam's proposal in line 17 can be made, the dirt being evaluated has to be placed under the viewing hole next to the sample she

indicated, so that the two can be compared. During line 18 Jeff moves the trowel to this position. Because of the spatial organization of this activity, specific actions have to be performed before a relevant task, a colour comparison, can be competently performed. In brief, in this activity the spatial organization of the tools being worked with and the sequential organization of talk-in-interaction interact with each other in the production of relevant action (e.g. getting to a place where one can make an expected answer requires rearrangement of the visual field being scrutinized so that the judgement being requested can be competently performed). Here socially organized vision requires embodied manipulation of the environment being scrutinized.

It is common to talk about structures such as the Munsell chart as 'representations'. However exclusive focus on the representational properties of such structures can seriously distort our understanding of how such entities are embedded within the organization of human practice. With its viewholes for scrutinizing samples, the page is not simply a perspicuous representation of current knowledge about the organization of colour, but a space designed for the ongoing production of particular kinds of *action*.

We will now look at how a group of archaeologists make a map. This process will allow us to examine the interface between seeing, writing practices, talk, human interaction and tool use (see Goodwin, 1994 for more detailed analysis).

Map-making and the practices of seeing it requires

Maps are central to archaeological practice. The professional seeing required to produce and make use of a visual document, such as a map, encompasses not only the image itself but also the ability to competently see relevant structure in the territory being mapped, mastery of appropriate tools and, on occasion, the ability to analyse the work-relevant actions of another's body. These different kinds of phenomena can be brought together within the temporally unfolding process of human interaction used to accomplish the activity of making a map.

In the following example, two archaeologists are making a map to record what they have found in a profile of the dirt on the side of one of the square holes they have excavated. Before actually setting pen to paper some relevant events in the dirt, such as the boundary between two different kinds of soil, are highlighted by outlining them with the tip of a trowel. The structure visible in the dirt is then mapped on a sheet of graph paper. Typically this task is done by two participants working together. One uses a pair of rulers (one laid horizontally on the surface and the other a hand-held tape-measure used to measure depth beneath the surface) to measure the length and depth co-ordinates of the points in the dirt that are to be transferred to the map, and then speaks these co-ordinates as pairs of numbers (e.g. 'at fifteen three point two'). The second person plots the points specified on the graph paper, and draws lines between successive measurements. What we find here is a small activity system that encompasses talk, writing, tools and distributed cognition as two parties collaborate to inscribe events they see in the earth on to paper. In the transcript in Figure 8.3, Ann, the party drawing the map, is the senior archaeologist at the site, while Sue, the person making

measurements, is her student. The sequence to be examined begins with a directive: Ann, the writer, tells Sue, the measurer, to 'Give me the ground surface over here to about *ninety*'. However before Sue has produced any numbers, indeed before she has said anything whatsoever, Ann in lines 4 and 5 challenges her, telling her that what she is doing is wrong: 'No- No- Not *at* ninety. *F*rom you *to* about ninety'.

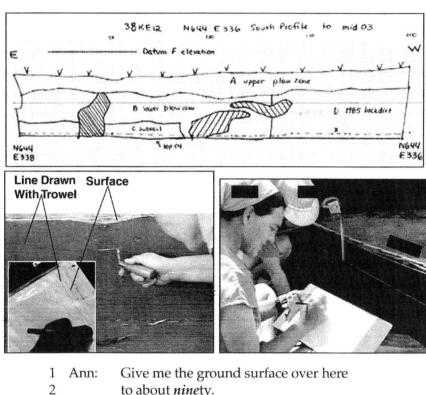

1	Ann:	Give me the ground surface over here
2		to about *ninety*.
3		(1.6)
4	Ann:	No- No- Not *at* ninety.
5		From you to about ninety.
6		(1.0)
7	Sue:	°Oh.
8	Ann:	Wherever there's a change in slope.
9		(0.6)
10	Sue:	°Mm kay.
11	Ann:	See so if its *fairly flat*
12		I'll need one
13		⌐where it *stops* being fairly flat.
14	Sue:	⌐Okay.
15	Ann:	Like right there.

Figure 8.3 Transcript of Ann (the senior archaeologist at the site) drawing a map, and Sue (her student) making measurements.

Directives are a classic form of speech action that sociolinguists have used to probe the relationship between language and social structure, and in particular issues of power and gender. Here Sue formats both her directive and her correction in very strong, direct 'aggravated' fashion. No forms of mitigation are found in either utterance, and Ann is not given an opportunity to find and correct the trouble on her own. Directives formatted in this fashion have frequently been argued to display a hierarchical relationship: Ann is treating Sue as someone that she can give direct, unmitigated orders to. And indeed Ann is a professor and Sue is her student.

Issues of power do not however exhaust the social phenomena visible in this sequence. Equally important are a range of *cognitive processes* that are as socially organized as the relationships between the participants. For example, in that Sue has not produced an answer to the directive, how can Ann see that there is something wrong with a response that has not even occurred yet? Crucial to this process is the phenomenon of *conditional relevance* first described by Schegloff (1968). Basically a first utterance creates an interpretative environment that will be used to analyse whatever occurs after it. Here no subsequent talk has yet been produced. However, providing an answer in this activity system encompasses more than talk. Before speaking the set of numbers that counts as a proper next bit of talk, Sue must first locate a relevant point in the dirt and measure its co-ordinates. Both her movement through space, and her use of tools such as a tape-measure, are visible events. As Ann finishes her directive, Sue is holding the tape-measure against the dirt at the left or zero end of the profile. However, just after hearing 'ninety' Sue moves both her body and the tape-measure to the right, stopping near the '90' mark on the upper ruler. By virtue of the field interpretation opened up through conditional relevance, Sue's movement and tool use can now be analysed by Ann as elements of the activity she has been asked to perform, and found wanting. Sue has moved immediately to ninety instead of measuring the relevant points between zero and ninety. The sequential framework created by a directive in talk thus provides resources for analysing and evaluating the visible activity of an addressee's body interacting with a relevant environment.

Additional elements of the cognitive operations and kinds of seeing that Ann requires from Sue in order to make her measurements are revealed as the sequence continues to unfold. Making the relevant measurements presupposes the ability to locate where in the dirt measurements should be made. However Sue's response calls this presupposition into question and leads to Ann telling her explicitly, in several different ways, what she should look for in order to determine where to measure. After Ann tells Sue to measure points between zero and ninety, Sues does not immediately move to points in that region but instead hesitates for a full second before replying with a weak '°Oh' (line 7). Ann then tells her what she should be looking for 'Wherever there's a change in slope' (line 8). This description of course presupposes Sue's ability to find in the dirt what will count as 'a change in slope'. Sue again moves her tape-measure far to the right. At this point, instead of relying upon talk alone to make explicit the phenomena that she wants Sue to locate, Ann moves into the space that Sue is attending to and points to one place that should be measured while describing more explicitly what constitutes a change in slope: 'See so if it's *fairly flat* I'll need one where it *stops* being fairly flat like right there.'

One of the things that is occurring within this sequence is a progressive expansion of Sue's understanding as the distinctions she must make to carry out the task assigned to her are explicated and elaborated. In this process of socialization through language there is a growth in intersubjectivity as domains of ignorance that prevent the successful accomplishment of collaborative action are revealed and transformed into practical knowledge, a way of seeing, that is sufficient to get the job at hand done, such that Sue is finally able to understand what Ann is asking her to do (that is to see the scene in front of her in a manner that permits her to make an appropriate, competent response to the directive). It would however be wrong to see the unit within which this intersubjectivity is lodged as simply these two minds coming together in the work at hand. Instead the distinction being explicated, the ability to see in the very complex perceptual field provided by the landscape they are attending to, those few events that count as points to be transferred to the map, are central to what it means to see the world as an archaeologist and to use that seeing to build the artefacts, such as this map, which are constitutive of archaeology as a profession. Such seeing would be expected of any competent archaeologist. It is an essential part of what it means to *be* an archaeologist, and it is these professional practices of seeing that Sue is being held accountable to. The relevant unit for the analysis of the intersubjectivity at issue here – the ability of separate individuals to see a common scene in a congruent, work-relevant fashion – is thus not these individuals as isolated entities, but instead archaeology as a profession, a community of competent practitioners, most of whom have never met each other, but who nonetheless expect each other to be able to see and categorize the world in ways that are relevant to the work, scenes, tools and artefacts that constitute their profession.

The phenomena examined so far provide some demonstration of how what is to be seen in a map, scene, human body or image stands in a reflexive relationship to other semiotic structures that participants are using to constitute visual phenomena as a relevant component of the events and activities that make up their lifeworld. These structures include language, the constitution of action and context provided by sequential organization and ways of seeing events and using images of different types that are lodged within the practices of particular social communities, such as the profession of archaeology.

Professional vision in court

Parties who are not competent members of relevant social communities can lack the ability and/or the social positioning to see and articulate visual events in a consequential way. These issues were made dramatically visible in the trial of four Los Angeles policemen who were recorded on videotape administering a beating to an African-American motorist, Mr Rodney King, whom they had stopped after a high-speed pursuit triggered by a traffic violation. When the tape of the beating was shown on national television there was outrage, and even the head of the Los Angeles police department thought that conviction of the officers was almost automatic. However, at their first trial (they were later tried again in a federal rather than a state court for violating

Mr King's civil rights) all four policemen were acquitted, a verdict that triggered an uprising in the city of Los Angeles, with neighbourhoods being burned, federal troops being called in, and so on. The crucial evidence at the trial was a visual document: the videotape of the beating. Rather than transparently proving the guilt of the policemen who were seen on it beating a man lying prone on the ground, the tape in fact provided the policemen's lawyers with their evidence for convincing the jury that their clients were not guilty of any wrongdoing. They did this by using language, pointing and expert testimony to structure how the jury saw the events on the tape in a way that exonerated the policemen. In essence they used the tape of the beating to demonstrate that Mr King was the aggressor, not the policemen, and that the policemen were following proper police practice for subduing a violent, dangerous suspect (see Goodwin, 1994 for a more detailed analysis of such professional vision). Crucial to their success was their use of another policeman, Sergeant Duke, as an expert witness. It was argued that laypeople could not properly see the events on the tape. Instead, the ability to legitimately see what the body of a suspect was doing, such as Mr King's as he lay on the ground being beaten, and specifically whether the suspect was being aggressive or compliant, was lodged within the work practices of the social group charged with arresting suspects: the police. The ability to see such a body, and code it in terms of its aggressiveness, was a component of the professional practices that policemen use to code the events that are the focus of their work. Insofar as such vision is a public component of the work practices of a particular social group, someone who wasn't present but who is a member of the profession, a policeman, can make authoritative statements about what can be legitimately seen on the tape. However, while policemen constitute a socially organized profession, suspects and victims of beatings don't. Therefore there is no one with the social standing, that is membership and mastery of the practices of a relevant social group, to act as an expert witness to articulate what was happening from Mr King's perspective.

What was to be seen on the tape was structured through the way in which different semiotic fields, such as structure in the stream of speech, pointing which highlighted specific places and phenomena in the image being looked at and events in the image itself mutually elaborated each other to provide a construal of events that served the purposes of the party articulating the image. The following transcript (Figure 8.4) provides an example. At the point where we enter this sequence the prosecutor has noted that Mr King appears to be moving into a position appropriate for handcuffing him, and that while one officer is in fact reaching for his handcuffs the suspect is being co-operative.

By noting the submissive elements in Mr King's posture, and the fact that one of the officers is reaching for his handcuffs, the prosecutor has shown that the tape demonstrates that Mr King is being co-operative. If he can establish this point, hitting Mr King again would be unjustified and the officers should be found guilty of the crimes they are charged with. The contested vision being debated here has very high stakes.

To rebut the vision proposed by the prosecutor, Sgt Duke uses the semantic resources provided by language to code as aggressive extremely subtle body movements of a man lying face down beneath the officers (lines 7–11). Note, for example, not

only line 13's explicit placement of Mr King at the very edge, the beginning, of an aggressive spectrum introduced in earlier testimony, but also how very small movements are made much larger by situating them within a prospective horizon through the repeated use of 'starting to' (lines 6, 8, 11). The events visible on the tape are structured, enhanced and amplified by the language used to describe them.

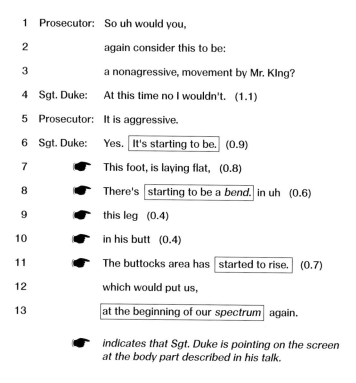

Figure 8.4 Transcript of use of video in the trial of Rodney King.

This focusing of attention organizes the perceptual field provided by the videotape into a salient figure, the aggressive suspect, who is highlighted against an amorphous background containing non-focal participants, the officers doing the beating. Such structuring of the materials provided by the image is accomplished not only through talk, but also through gesture. As Sgt Duke speaks he brings his hand to the screen and points to the parts of Mr King's body that he is arguing display aggression. The pointing gesture and the perceptual field which it is articulating mutually elaborate each other. The touchable events on the television screen provide visible *evidence* for the description constructed through talk. What emerges from Sgt Duke's testimony is not just a *statement*, a static category, but a *demonstration* built through the active interplay between coding scheme and the image to which it is being applied. As talk and image mutually enhance each other a demonstration that is greater than the sum

of its parts emerges, while simultaneously Mr King, rather than the police officers, becomes the focus of attention as the expert's finger articulating the image delineates what is relevant within it.

By virtue of the category system erected by the defence, the minute rise in Mr King's buttocks noted on the tape unleashes a cascade of perceptual inferences that have the effect of exonerating the officers. A rise in Mr King's body becomes interpreted as aggression, which in turn justifies the escalation of force. Like other parties, such as the archaeologists, faced with the task of coding a visual scene, the jury was led to engage in intense, minute cognitive scrutiny as they looked at the tape of the beating to decide the issues at stake in the case. However, once the defence coding scheme is accepted as a relevant framework for looking at the tape, the operative perspective for viewing it is no longer a layperson's reaction to a man lying on the ground being beaten, but instead a micro-analysis of the movements being made by that man's body to see if it is exhibiting aggression.

In the first trial, though the prosecution disputed the analysis of specific body movements as displays of aggression, the relevance of looking at the tape in terms of such a category system was not challenged. A key difference in the second trial, which led to the conviction of two of the officers, was that there the prosecution gave the jury alternative frameworks for interpreting the events on the tape. These included ways of seeing the movements of Mr King's body that Sgt Duke highlighted as normal reactions of a man to a beating rather than as displays of incipient aggression. In the prosecution's argument Mr King 'cocks his leg', not in preparation for a charge, but because his muscles naturally jerk after being hit with a metal club.

The study of the practices used to structure relevant vision in scientific and workplace environments, what Hutchins (1995) has called 'Cognition in the Wild', has become the focus of considerable research. A major initiative for such studies was provided by Lucy Suchman in the early 1990s when she initiated the workplace project while at Xerox PARC. The site chosen for research was ground operations at a mid-sized airport. Documents and images of many different types, and the ability of actors in alternative structural positions to see and analyse events in relevant ways, were crucial to the work of the airport. Phenomena that received extensive study included work-relevant seeing of documents, aeroplanes and events (Goodwin and Goodwin, 1996), the constitution of shared workspaces (Suchman, 1996), the study of how a common document co-ordinated different kinds of work in different work settings, and the practices involved in seeing and shaping phenomena in collaborative work (Brun-Cottan, 1991; Suchman and Trigg, 1993). In part because of the central role played by visual phenomena in the work being analysed, the project's final report was submitted as a videotape (Brun-Cottan et al., 1991). Subsequent analysis growing from this project has focused on the organization of both documents and visual phenomena in a range of occupational settings, such as law firms and the work of architects. In England Christian Heath and his collaborators have investigated the structuring of vision within interaction in a range of settings including the control room for the London Underground, centres for the production of electronic news, art classes, and so on (Heath and Luff, 1992b, 1996; Heath and Nicholls, 1997). In much of this research there is a focus on how core practices for the organization of talk,

reference, gesture and other phenomena central to the production of action within human interaction can encompass not only talk but also embodiment in a world populated by work-relevant objects.

Hindmarsh and Heath (in press) investigate reference within such a framework. LeBaron (1998), Streeck (1996) and LeBaron and Streeck (in press) examine how gesture emerges from the interaction of working hands acting in the world in settings such as architects' meetings and auto body shops. Robinson (1998) has provided analysis of how participants in medical interviews organize their interaction by attending to how gaze is shifted from other participants to relevant visual materials in the setting, such as medical records. Whalen (1995) analysed how the talk of operators responding to emergency 911 calls was organized in part by the task of filling in required information on a computer screen with a specific visual organization. Rogers Hall and Reed Stevens have investigated visual practices in a range of school, scientific and occupational settings (Hall and Stevens, 1995; Stevens and Hall, in press). Research in computer-supported co-operative work has focused specifically on new forms of visual access created by electronic media. Heath and Luff (1992b, 1993) have done considerable research on interaction mediated through video, demonstrating the crucial ways in which resources available to parties who are actually co-present to each other are not available in media spaces. Yamazaki and his colleagues have explored the systematic problems that arise when particular kinds of directives, such as instructions for how to use CPR to start a heart attack victim's heart, are given through talk alone, for example over the phone, without access to a relevant visual environment. Patients usually die since the novice is not able to place his or her hands at the appropriate spot on the patient's body. To remedy some of these issues technologies that incorporate basic resources available for doing reference in face-to-face interaction, such as pointing, have been developed. These include a remote-controlled car with a laser that has the ability to move while clearly marking the specific places being pointed at in a remote environment (Yamazaki et al., 1999). Nishizaka (in press) has investigated how participants co-ordinate gaze both spatially and temporally on electronic documents such as computer screens. Kawatoko (in press) has investigated how lathe workers organize perceptual fields so to make visible the invisible movements of their cutting tools. Both Kawatoko and Ueno (in press) have examined the organization of vision on many different levels (from documents to systematic placement of objects on the warehouse floor as part of its work flow) in the work practices of a large warehouse. In all of this, work practices for seeing relevant phenomena are systematically embedded within processes of social organization, structures of mutual accountability and the organization of activity.

CONCLUSION

Within both conversation analysis and ethnomethodology visual phenomena have been analysed by investigating how they are made meaningful by being embedded within the practices that participants in a variety of settings use to construct the events and actions that make up their lifeworld. This has led to the detailed study of a range

of quite different kinds of phenomena, from the interplay between gaze, restarts and grammar in the building of utterances within conversation, to the construction and use of visual representations in scientific practice, to how the ability of lawyers to shape what can be seen in the videotape of policemen beating a suspect can contribute to disruption of the body politic that leaves a city in flames, to the part played by visual practices in both traditional and electronic workplaces. Visual phenomena that have received particular attention include:

1 The body as a visible locus for displays of intentional orientation through both gaze and posture.
2 The body as a locus for a variety of different kinds of gesture, from iconic elaboration on what is being said in the stream of speech, to pointing, to the hand as an agent engaged with the world around it.
3 Visual documents of many different types used in both scientific practice and the workplace, for example, maps, graphs, Munsell charts, coding forms, schedules, television screens providing access to distant sites, architectural drawings and computer screens.
4 Material structure in the environment where action and interaction are situated.

This perspective brings together within a common analytic framework both the details of how the visible body is used to build talk and action in moment-to-moment interaction and the way in which historically structured visual images and features of a setting participate in that process (see Chapter 4). Rather than standing alone as self-contained, self-explicating images, visual phenomena become meaningful through the way in which they help elaborate, and are elaborated by, a range of other semiotic fields – sequential organization, structure in the stream of speech, encompassing activities, etc. – that are being used by participants to both construct and make visible to each other relevant actions. The focus of analysis is always on how the participants in a setting themselves display a consequential orientation to visual phenomena (for example, by shifting gaze after a restart, focusing their work on a Munsell chart or building images as a core component of the practices used to make visible scientific phenomena). A variety of different methodologies are employed. However a basic component of many research projects includes going to the site where the activities being investigated are actually performed and examining what the participants are doing there as carefully as possible. Videotape records are frequently most useful because of the way in which they preserve limited but crucial aspects of the spatial and environmental features of a setting, the temporal unfolding organization of talk, the visible displays of participants' bodies and changes in relevant phenomena in the setting as relevant courses of action unfold (see Chapter 3). Analysis typically requires not only viewing the tape, ethnographic records and documents collected in a setting, but also the construction of new visual representations such as transcripts of many different types (note how some in this paper incorporate both detailed transcription of the talk and a variety of different kinds of graphic representations). While this analysis sheds much important new light on how visual phenomena are organized through systematic discursive practice, it is not restricted to vision *per se* but is instead investigating the more general practices used to build action within situated human interaction.

NOTES

1 Vision is not, however, essential as both the competence of the blind and telephone conversations demonstrate. Below it will be argued that situated action is accomplished through the juxtaposition of multiple semiotic fields, only some of which make vision relevant.

2 Talk is transcribed using the system developed by Gail Jefferson (see Sacks et al., 1974: 731–3). Talk receiving some form of emphasis is marked with *underlining* or ***bold italics***. Punctuation is used to transcribe intonation: a period indicates falling pitch, a question mark rising pitch and a comma a falling contour, as would be found for example after a non-terminal item in a list. A colon indicates lengthening of the current sound. A dash marks the sudden cut-off of the current sound (in English it is frequently realized as glottal stop). Comments (e.g. descriptions of relevant non-vocal behaviour) are printed in italics within double parentheses. Numbers within single parentheses mark silences in seconds and tenths of a second. A degree sign (°) indicates that the talk that follows is being spoken with low volume. Left brackets connecting talk by different speakers mark the point where overlap begins.

REFERENCES

Brun-Cottan, F. (1991) 'Talk in the work place: occupational relevance', *Research on Language and Social Interaction*, 24: 277–95.

Brun-Cottan, F., Forbes, F., Goodwin, K., Goodwin, C., Harness, M., Jordan, B., Suchman, L., Randall, L. and Randall, T. (1991) *The Workplace Project: Designing for Diversity and Change*, video produced by Xerox Palo Alto Research Center.

Chomsky, N. (1965) *Aspects of the Theory of Syntax*. Cambridge, MA: MIT Press.

Goodwin, C. (1979) 'The interactive construction of a sentence in natural conversation', in G. Psathas (ed.), *Everyday Language: Studies in Ethnomethodology*. New York: Irvington Publishers.

Goodwin, C. (1980) 'Restarts, pauses, and the achievement of mutual gaze at turn-beginning', *Sociological Inquiry*, 50(3–4): 272–302.

Goodwin, C. (1981) *Conversational Organization: Interaction Between Speakers and Hearers*. New York: Academic Press.

Goodwin, C. (1984) 'Notes on story structure and the organization of participation', in Max Atkinson and John Heritage (eds), *Structures of Social Action*. Cambridge: Cambridge University Press.

Goodwin, C. (1986) 'Gesture as a resource for the organization of mutual orientation', *Semiotica*, 62 (1/2): 29–49.

Goodwin, C. (1994) 'Professional vision', *American Anthropologist*, 96 (3): 606–33.

Goodwin, C. (1995) 'Seeing in depth', *Social Studies of Science*, 25: 237–74.

Goodwin, C. (1996) 'Practices of color classification', *Ninchi Kagaku* (Cognitive Studies: Bulletin of the Japanese Cognitive Science Society), 3 (2): 62–82.

Goodwin, C. (2000) 'Action and embodiment within situated human interaction', *Journal of Pragmatics*, 32.

Goodwin, C. (in preparation) 'Pointing as situated practice', in Sotaro Kita (ed.), *Pointing: Where Language, Culture and Cognition Meet*.

Goodwin, C. and Goodwin, M.H. (1987) 'Concurrent operations on talk: notes on the interactive organization of assessments', *IPRA Papers in Pragmatics 1*, no. 1:1–52.

Goodwin, C. and Goodwin, M.H. (1996) 'Seeing as a situated activity: formulating planes', in Y. Engeström and D. Middleton (eds), *Cognition and Communication at Work*. Cambridge: Cambridge University Press.

Goodwin, M.H. (1980) 'Processes of mutual monitoring implicated in the production of description sequences', *Sociological Inquiry*, 50: 303–17.

Goodwin, M.H. and Goodwin, C. (1986) 'Gesture and coparticipation in the activity of searching for a word', *Semiotica*, 62 (1/2): 51–75.

Hall, R. and Stevens, R. (1995) 'Making space: a comparison of mathematical work in school and professional design practices', in S.L. Star (ed.), *The Cultures of Computing.* pp. 118–145.

Haviland, J.B. (1993) 'Anchoring, iconicity, and orientation in Guugu Yimidhirr pointing gestures', *Journal of Linguistic Anthropology*, 3 (1): 3–45.

Heath, C. (1986) *Body Movement and Speech in Medical Interaction.* Cambridge: Cambridge University Press.

Heath, C. and Luff, P. (1992a) 'Media space and communicative asymmetries', *Human Computer Interaction*, 7: 315–46.

Heath, C. and Luff, P. (199b) 'Crisis and control: collaborative work in London Underground Control Rooms', *Journal of Computer Supported Cooperative Work*, 1 (1): 24–48.

Heath, C. and Luff, P. (1993) 'Disembodied conduct: interactional asymmetries in video-mediated communication', in G. Button (ed.), *Technology in Working Order.* London and New York: Routledge.

Heath, C. and Luff, P. (1996) 'Convergent activities: line control and passenger information on the London Underground', in Y. Engeström and D. Middleton (eds), *Cognition and Communication at Work.* Cambridge: Cambridge University Press.

Heath, C. and Nicholls, G. (1997) 'Animating texts: selective readings of news stories', in L.B. Resnick, R. Säljö, C. Pontecorvo and B. Burge (eds), *Discourse, Tools and Reasoning: Essays on Situated Cognition.* Berlin, Heidelberg, New York: Springer.

Hindmarsh, J. and Heath, C. (in press) 'Embodied reference: a study of deixis in workplace interaction', *Journal of Pragmatics.*

Hutchins, E. (1995) *Cognition in the Wild.* Cambridge, MA: MIT Press.

Kawatoko, Y. (in press) 'Organizing multiple vision', *Mind, Culture and Activity*, 7 (1–2).

Kendon, A. (1990a) *Conducting Interaction: Patterns of Behavior in Focused Encounters.* Cambridge: Cambridge University Press.

Kendon, A. (1990b) 'Spatial organization in social encounters: the f-formation system', in A. Kendon (ed.), *Conducting Interaction: Patterns of Behavior in Focused Encounters.* Cambridge: Cambridge University Press.

Kendon, A. (1994) 'Introduction to the special issue: gesture and understanding in social interaction', *Research on Language and Social Interaction*, 27 (3): 171–4.

Kendon, A. (1997) 'Gesture', *Annual Review of Anthropology*, 26: 109–28.

Latour, B. (1986) 'Visualization and cognition: thinking with eyes and hands', *Knowledge and Society: Studies in the Sociology of Culture Past and Present*, 6: 1–40.

Latour, B. (1987) *Science in Action: How to Follow Scientists and Engineers through Society.* Cambridge, MA: Harvard University Press.

Latour, B. and Woolgar, S. (1979) *Laboratory Life: The Social Construction of Scientific Facts.* London: Sage.

LeBaron, C. (1998) 'Building communication: architectural gestures and the embodiment of ideas', PhD dissertation, University of Texas, Austin.

LeBaron, C. and Streeck, J. (in press) 'Gestures, knowledge, and the world', in D. McNeill (ed.), *Gestures in Action, Language, and Culture.* Cambridge: Cambridge University Press.

Lynch, M. (1990) 'The externalized retina: selection and mathematization in the visual documentation of objects in the life sciences', in M. Lynch and S. Woolgar (eds), *Representation in Scientific Practice.* Cambridge, MA: MIT Press.

Lynch, M. and Woolgar, S. (1990) 'Introduction: sociological contributions to representational practice in science', in M. Lynch and S. Woolgar (eds), *Representation in Scientific Practice.* Cambridge, MA: MIT Press.

McNeill, D. (1992) *Hand & Mind: What Gestures Reveal about Thought.* Chicago: University of Chicago Press.

Nishizaka, A. (in press) 'Seeing what one sees: perception, emotion and activity', *Mind, Culture and Activity*, 7 (1–2).

Ochs, E. (1979) 'Transcription as theory', in E. Ochs and B.B. Schieffelin (eds), *Developmental Pragmatics*. New York: Academic Press.

Robinson, J.D. (1998) 'Getting down to business: talk, gaze, and body orientation during openings of doctor-patient consultations', *Human Communication Research*, 25 (1): 97–123.

Sacks, H., Schegloff, E.A. and Jefferson, G. (1974) 'A simplest systematics for the organization of turn-taking for conversation', *Language*, 50: 696–735.

Schegloff, E.A. (1968) 'Sequencing in conversational openings', *American Anthropologist*, 70: 1075–95.

Schegloff, E.A. (1998) 'Body torque', *Social Research*, 65 (3): 535–96.

Stevens, R. and Hall, R. (1998) 'Disciplined perception: learning to see in technoscience', in M. Lampert and M. Blunk (eds), *Mathematical Talk and Classroom Learning: What, Why and How*. pp. 107–49. Cambridge: Cambridge University Press.

Streeck, J. (1988) 'The significance of gesture: how it is established', *IPRA Papers in Pragmatics*, 2 (1): 60–83.

Streeck, J. (1993) 'Gesture as communication I: its coordination with gaze and speech', *Communication Monographs*, 60 (4): 275–99.

Streeck, J. (1994) 'Gesture as communication II: the audience as co-author', *Research on Langauge and Social Interaction*, 27 (3): 223–38.

Streeck, J. (1996) 'How to do things with things', *Human Studies*, 19: 365–84.

Suchman, L. (1992) 'Technologies of accountability: of lizards and airplanes', in G. Button (ed.), *Technology in Working Order: Studies of Work, Interaction and Technology*. London: Routledge.

Suchman, L. (1996) 'Constituting shared workspaces', in Y. Engeström and D. Middleton (eds), *Cognition and Communication at Work*. Cambridge: Cambridge University Press.

Suchman, L. and Trigg, R. (1993) 'Artificial intelligence as craftwork', in S. Chaiklin and J. Lave (eds), *Understanding Practice: Perspectives on Activity and Context*. Cambridge: Cambridge University Press.

Ueno, N. (in press) 'Technologies of mutual accountability of society, social organization, and activity for collaborative activity', *Mind, Culture and Activity*, 7 (1–2).

Whalen, J. (1995) 'A technology of order production: computer-aided dispatch in public safety communications', in P. Have and G. Psathas (eds), *Situated Order: Studies in the Social Organization of Talk and Embodied Action*. Washington, DC: University Press of America.

Yamazaki, K., Yamazaki, A., Kuzuoka, H., Oyama, S., Kato, H., Suzuki, H. and Miki, H. (1999) 'GestureLaser and GestureLaser Car: development of an embodied space to support remote instruction', in S. Bødker, M. Kyng and K. Schmidt (eds), *Proceedings of the European Conference on Computer-Supported Cooperative Work, 12–16 September 1999, Copenhagen, Denmark*. Dordrecht/Boston/London: Kluwer Academic.`

9 Analysing Film and Television: a Social Semiotic Account of *Hospital: an Unhealthy Business*

RICK IEDEMA

INTRODUCTION

The following still (Figure 9.1) is taken from a documentary about a Melbourne hospital. It shows a frame from a scene (about 7 minutes into the documentary) in which a clinician walks through a hospital corridor while speaking over her shoulder

Figure 9.1 Frame one: frame from a scene about 7 minutes into the documentary.

to an interviewer who follows her with a camera. While negotiating the maze of corridors which connect offices and wards, the clinician says:

> It's easy for some people to say, you know, this is the fine line, you don't step over it. Whereas for us, we actually see the patient, and I'd be more inclined to look for less urgent or emotive places to save money. I mean cardiology is, uh, a life threatening and an acute situation and I'd prefer not to save money there, you know, You don't treat public patients like second class citizens, if we can afford it. They get the best treatment in the private hospital. Why don't they get the same treatment in a public hospital? I mean, they're still somebody's mother or father, they're still deserving the respect to be treated . . . [passes through door; cut]

The scene is highly dynamic as several things are going on: the talking and walking, which involves looking where we're going, turning corners and opening doors, against a background of hustle and bustle of the hospital. The impression it leaves is that this clinician's world is an active and busy one.

The documentary is about hospital waiting lists, budget blow-outs and rising costs of health and aged care. The dilemma which the programme poses is: we have the know-how and the technology to treat people and make them better, but according to the present Australian government we can't afford it. The management of hospitals is nowadays more concerned to curb doctors' use of resources needed to cure patients than with ensuring proper standards of clinical care.

Just before the clinician scene, we see the Head of the Cardiothoracic Unit, Dr Keith Stockman, and the Manager of Clinical Services, David Hillis, talking about how cardiothoracic services are an exceptional drain on the hospital's budget. We are also shown patients and their reactions to illness. And there is the chaos in the hospital where patients sometimes have to wait for up to two days for a bed on a ward. We see how 80-year-old Mrs Biggs ends up waiting for over a day in emergency after she suffers a debilitating heart attack, and how, after her acquittal from hospital, her bewildered 83-year-old husband wanders around their old house in a daze upon leaving his wife behind in a distant nursing home.

We are likely to be overwhelmed with grief at being confronted with the humiliations to which these patients are subjected. After Mrs Biggs leaves the hospital her patient record goes up to administration where she is entered into the computer and filed away as a $5400 loss. As the keyboard taps out this cost–benefit analysis across the screen, its rattle evokes the steady advance of steely industrial mechanization and cold economic rationalization.

Could there possibly be another side to this story? Is it possible that the means of representation have been exploited to favour one viewpoint and render all other viewpoints irrelevant? How many television-watching people would think of asking questions like this when confronted with such a moving account about the deplorable state of the current health care system and the money-centred mentality of its hospital managers? Only those who have some knowledge about the politics of hospital administration and health policy will know whose views the documentary takes as given and what (other) questions could be asked here.

But let's not worry for now about the politics of the views presented in this documentary. Let's first look at *how* they are represented. A systematic look at how the documentary visually represents the various stakeholders reveals important differences. First, both patients and clinicians (that is, doctors and nurses) occupy a space much closer to the camera than administrators and managers. Moreover, clinicians are shown in action (arranging beds over the phone, wheeling patients about, talking to patients and family, doing operations), while administrators merely address meetings or stare intently at computer monitors. Further, clinicians appear together in shots (sometimes as many as five or six of them), whereas administrators usually appear alone in shots.

There are more 'patterns' worth commenting on. Rarely do clinicians and administrators appear in the same shot: either a cut or a swerve will separate them.

The administrators are often filmed from low angles (suggesting a degree of power), while clinicians are generally level with the camera. Last but not least, the doctors are consistently shown on the left of the screen (constructed as what is familiar: the Given), and the administrators are consistently shown on the right (as the unfamiliar: the New) (see Chapter 7).[1] The patterns just listed suggest that the documentary's filmic structure and editing conventions position clinicians and manager-administrators as different, and that the clinicians are favoured.

There are still other things that support this reading. Apart from the different means by which they are visually represented, stakeholders are also made to perform very different 'subject roles'. Clinicians are interviewed on camera, while the administrators are only shown speaking to clinicians and writing on whiteboards during meetings. Clinicians have longer 'visual turns': we see and hear more of them than of the administrators. The camera will follow clinicians around the hospital, while a foray by one of the younger administrators into the surgery ward is shown in steady long shot, reinforcing the contrast between the young bureaucrat's diffidence and the bustle of the pulsing surgical ward.

So far we have not said much about how the documentary unfolds overall. At this broader level, the timespan which frames the documentary includes the last few months of the financial year. The narrative centres on management's failure to balance the books. This main thread is punctuated, if you like, by three sub-narratives about patients, one of whom gets cured, one of whom dies and the last of whom ends up in a distant old-age nursing home. Each sub-narrative offers an instance of some medical heroism or other, and invites the inference that curbing medical expenditure is tantamount to letting people die. At the end of the documentary we learn that David Hillis (the Manager) has accepted a job at another hospital, and that the hospital's budget problem is no longer his. We are encouraged, again, to infer the difference between 'mere administrators', who can walk away from their jobs, and doctors, who are committed to the continuity of unconditional patient care and cure ('we could not have done more').

In short, what this documentary favours is the medical-clinical view on hospital organization and health policy: 'we are doing our best to care for the suffering; don't limit us in the work we are doing or cut the resources needed to do it; increase the national health budget if hospitals continue to have budget overruns.'

What the documentary does not show, and what it is structured to suppress, are issues which call clinicians' demand for clinical autonomy and unlimited expenditure seriously in question. Such issues are clinical practice variation (which is to do with, for example, a specific operation rate of 10 per 100,000 in Sydney at a cost of say $1000, which might contrast with a rate of only 3 per 100,000 in Wagga Wagga at a cost of only say $225), wasteful practices (for example, each time a patient shifts to another ward more tests – often ones she or he has already had – are ordered by different doctors), and the widespread occurrence of clinical practices which are not based on medical-scientific evidence but on personal or hospital-specific experiences, and which at times perpetuate questionable and sometimes even fatal treatments (Walton, 1998).

It is obvious now that the scene with which this chapter began bears a significance that goes far beyond what the woman clinician has to say. It is a continuous

51-second shot, which represents a very long 'turn at talk'. It is a hand-held camera shot, which infuses the portrayal with immediacy, urgency and dynamism. It is a medium-close shot which at times becomes a close shot, suggesting closeness and intimacy (see Chapters 2 and 7). It accords the clinician direct address: she, and not the administrator, is given the opportunity to reflect on the health care situation at length, on her terms and in her own territory. It gives the clinician the opportunity to interpersonalize her opinion: 'cardiology is . . . a life threatening and an acute situation' and 'they're still somebody's mother or father'. In sum, close analysis of this shot alone bears out how television documentary is a prime site for creating subtle and powerful kinds of discursive impact.

My comments about this documentary so far have been rather ad hoc. It will be useful to look in more detail at the range of filmic devices which are used to construct argumentative perspective or, if you like, discursive impact. In what follows I will therefore present some of the main categories and tools that play a role in a kind of filmic analysis that aims for both deconstructive and social significance.

ANALYSING FILM AND TELEVISION

Tele-filmic analysis can be done in a wide variety of ways, including thematic, 'auteur'-centred, psycho-analytical or symptomatic, structuralist and semiotic perspectives (see Bordwell, 1989, for a history of trends in film theory and modes of analysis). While each of these perspectives provides interesting contributions, they all tend to be concerned with establishing what the tele-film is ultimately 'really about' (that is, their content). This may not give due attention to issues regarding the sociopolitics of reading position ('above content'), nor to the structural importance of subject selection, framing and editing ('below form').

In contrast, the analytical strategies presented here aim to link the tele-film's sociopolitical intertextualities to the ways in which it hangs together from one second to the next. In that regard, this approach is ambitious.

The approach taken here derives from what has been termed social semiotics (Hodge and Kress, 1988; Lemke, 1995; Thibault, 1997). Social semiotics is concerned with the political understandings, the reading positions and the practical possibilities which analysis makes available (see Chapter 7). Social semiotics promotes detailed analysis, but its starting and end point is about situated praxis (Iedema and Degeling, forthcoming). It acknowledges that the analyst's own reading position is likely to guide her or his interpretations, but it sees that as a strength rather than a failing. Analysis is a sociopolitical relevance, not some theoretical abstraction.

In fact, my reason for choosing a hospital documentary for analysis is that I know that the story is not as simple as the documentary would like to have us believe. I want to find out why the documentary is so powerful, rather than just be content with being saddened by Mrs Biggs or uplifted by heart-patient Mick's recovery. This documentary is – besides being a moving account – a political statement, and it demands an informed reading and reply.

Social semiotics

Social semiotics centres on the issue of how I, the viewer, am positioned by the tele-film in question, and how I see certain social allegiances and values as being promoted over others. In that sense, social semiotics denies there is a gap between text or product and audience. My analysis is a reading largely influenced by my social, ethnic, economic, gender and knowledge backgrounds or 'coding orientations' (Bernstein, 1990). I make no truth claims for the results of my analysis, but I do claim to be able to support my claims with systematic evidence and base my political arguments on them.[2]

A social semiotic analysis aims to enable us to question the ways in which the tele-cinematic text presents 'social reality', and should provide means for me to 'talk back' (Nichols, 1981: 95) rather than be overwhelmed by what is, ultimately, a very sophisticated and powerful medium. It should enable us, in other words, to see the bare bones of the documentary, its nuts and bolts, enabling us to engage with the medium in a systematic and informed way.

Finally, in contrast to traditional semiotics (see Chapter 4), social semiotics does not focus on 'signs', but on socially meaningful and entire processes ('texts'). The sign is an analytical category; text, by contrast, is a social category. Texts, then, are defined as being the semiotic manifestation of material social processes.

Texts are marked off by socially recognized (that is, sanctioned and perhaps policed) beginnings and ends. In that sense, books, films and television shows are texts, but so are birthday parties, interviews, telephone calls and football games. But while birthday parties and telephone conversations and the like take place in ordinary or 'real' time and space and can be called *presentations*, films and television products construct times and spaces which obey and bear out those media's logic(s), and which are therefore *re-presentations*. Our concern here is with re-presentations.

Social semiotic analysis of tele-film

Tele-films are abstract from time and space: they only show as much as is considered artistically or logically necessary. This is what (following Etienne Souriau) Christian Metz calls 'diegesis' (1974: 98; see also Nichols, 1981: 81). Diegesis points to the difference between what the tele-film implies happened in 'real' time and what the film itself actually shows. What the tele-film shows is always and necessarily less and different from that which imputedly went on in 'real' time.[3] The hospital documentary, for example, spans the last five months of the financial year, but lasts itself only half an hour. That is, it *compresses* time and space, or, in Metz's words, '[in] the chain of images the number of units liable to occur is limited' (1974: 99).

Tele-film constructs its own time(s) and space(s) using specialized techniques. One of these techniques is continuity, or continuity-editing (Nichols, 1981: 85). Continuity-editing aims to smoothen out the gaps ('cuts') which mark diegetic shifts of focus. It thus naturalizes the 'shape' of the edited sequence. While spatial continuity

is constructed by making visual fields overlap, temporal continuity is often achieved by maintaining sound continuity across visual cuts. The issue of continuity becomes important when we want to decide whether a tele-film is constituted predominantly of scenes (realising spatial and temporal continuity) or sequences (realising absence of such continuity). The construction of continuity has important implications for how we see (read: construct!) reality (see below).

Social semiotics focuses on these techniques to highlight not only what was edited in and how, but also to show what was left out and thus constructed as unimportant or as natural and taken-for-granted. Next to this structural and intertextual analysis, social semiotics is also crucially concerned with reasoning about the choices film and television producers make in relation to the sociocultural fields which they decide to hone in on.

In what follows, I will first propose six levels of tele-film analysis. Then I will show how visual, linguistic and sound features of tele-film are analysed and what such analysis can reveal. Finally, I will point out that there is never a simple way of determining what specific tele-filmic features mean, such as hand-held camera movability, low camera angles or fast cuts. Features are always embedded in continuously changing cultural trends and tastes, or what have been called 'modalities' (Lotman, 1977: 59; Kress and van Leeuwen, 1996: 159ff.). It is these modalities which will ultimately determine what meanings specific features are likely to attract in the contexts in which they are mobilized or read (see Chapter 4).

SIX LEVELS OF ANALYSIS

Table 9.1 sets out the six levels of analysis proposed here. These six levels bring together analytical categories often used in film theory (frame, shot, scene, sequence) with categories used in genre analysis (stage, genre).

At the lowest level of analysis (1), the frame is what the analyst takes to be the salient aspect of a shot. With long shots, you may decide there is more than one salient frame which needs to be included in the analysis. The 51-second shot discussed at the beginning of this chapter, for example, could be represented by several salient stills or frames, showing how the clinician is shown from different angles and distances and in different locales.

At the next level up (2), shots are uncut camera actions. Shots are like 'cells' or 'distinct spaces the succession of which . . . reconstitutes homogeneous space' (Mitry, cited in Heath, 1986: 395). The clinician's speech quoted at the beginning of this chapter, for example, is filmed as one uncut, continuous shot.[4]

One level up again (3), scenes comprise more than one shot. The defining characteristic of scenes is their continuity of time and place: 'the scene reconstructs a unit still experienced as being "concrete": a place, a moment in time, an action, compact and specific' (Metz, 1974: 127–8). For instance, after the clinician finishes speaking she opens a door and enters a room. The scene cuts to the inside of the room and pans to show her crouched in front of a cupboard full of surgical devices. All this takes place in the same time and space and is part of the same scene.

Table 9.1 Six levels of tele-film analysis.

Level	Description
1 Frame	A frame is a salient or representative still of a shot
2 Shot	In a shot the camera movement is unedited (uncut); if the camera's position changes this may be due to panning, tracking, zooming, and so on, but not editing cuts
3 Scene	In a scene the camera remains in one time–space, but is at the same time made up of more than one shot (otherwise it would be a shot)
4 Sequence	In a sequence the camera moves with specific character(s) or sub-topic across time–spaces; when it is hard to decide whether you're dealing with a scene (1 time–space) or a sequence (multiple time–spaces), this is because editors may render time–space breaks as either more obvious (-> sequence boundary) or less obvious (-> scene boundary)
5 Generic stage	Roughly, stages are beginnings, middles and endings; each genre has a specific set of stages: narratives tend to have an orientation, a complication, a resolution and maybe a coda; factual or expository genres may have an introduction, a set of arguments or facts and a conclusion, or an introduction and a series of facts or procedures
6 Work as a whole	Depending on the lower levels, the work will be more or less classifiable as a particular genre; the primary distinction is between 'narrative' (fictional, dramatic genres) and 'factual' (expository, thematic, issue-oriented genres); genres are predictable relations between social-cultural, industrial–economic and symbolic–mythic orders

Scenes are often structured using what Metz refers to as 'alternating syntagmas' (1974: 103): these are shots of different people or objects participating in one and the same interaction – a game, a pursuit or a dialogue. For example, a typical dialogue scene is often structured as follows[5]:

> 1. Establishing shot . . . ; 2. Long shot (master shot); 3. Medium-two shot; 4. Reverse angles (over-the-shoulder shots); 5. Alternating Medium close-ups; 6. Cut-away (or insert); 7. Alternating Medium close-ups; 8. Re-establishing shot (usually a reverse angle or a two-shot) (Branigan, 1975: 75)

Our decision as to whether different shots belong to one and the same scene will depend on the degree of temporal and spatial continuity or discontinuity we perceive to link the shots, and this is rarely clear-cut (Nichols, 1981: 219 deals with this issue). The tele-film as a whole will be structured according to certain rhythms at each of these levels, and analysis of rhythmic boundaries may help guide our decisions (van Leeuwen, 1985; Martinec, 1997; see below).

At the fourth level up (4), sequences will comprise a range of contiguous scenes which are linked not on the basis of space and time continuity, but on the basis of a thematic or logical continuity. For example, we see Mrs Biggs in emergency waiting for a bed; we see her husband pacing around in confusion, and later he stares at his sick wife in despair as his daughter tries to wake her up. Then follows a scene of several

minutes in which a doctor and a social worker convince the family that Mrs Biggs is unfit to go home and must go to a nursing home. Finally, we see Mr Biggs wandering around his old house, saying amongst other things: 'I only care for her to come back.' All these take place in different places and times, but centre on the same issue – Mrs Biggs – and therefore belong to the same sequence.

In brief, then: 'The shot is a section of film exposed during a single take. A scene is comprised of one or more shots occurring within one time and place. A sequence is composed of a group of scenes having dramatic unity' (Oumano, 1985: 160).

Moving further up the 'hierarchy', sequences combine into generic stages (5), which in turn realize the specific genre they belong to. Stage boundaries mark significant shifts in the narrative or documentary. For example, characters may display a shift from resistance to acceptance, from pursuit to confrontation, or from struggle to abandonment. In a documentary, a new argument may be signalled by a change in topic, time or place. Such narrative or documentary shifts or 'stage boundaries' are often further highlighted by one or more editing features (a change in camera use or effect, or a change in the music or sound track). A stage boundary may also involve a change in how the characters are positioned in relation to one another (especially in fiction film), as well as a change in how I am positioned as viewer by the film.

In short, stages are those elements which tell us where we are in the overall filmic text: 'this is where things are starting to go wrong', 'this is where we enter another argument', 'this is where things come to a kind of conclusion', and so on.

Stages structure the tele-film or 'genre' (5) as a whole. Broadly speaking, we can distinguish factual or 'expository genres' and 'narrative genres' (after Nichols, 1981, 1991).[6] Other labels have been used to capture this distinction, like van Leeuwen's (1985: 223) 'thematic' versus 'dramatic' filmic texts.

Narratives turn on the resolution of some kind of contradiction, problem or lack (Nichols, 1981: 74). This resolution is crucially achieved *through time* and on the basis of characters' involvement. In the classical Hollywood fiction film, the narrative

> presents psychologically defined individuals who struggle to solve a clear-cut problem or to attain specific goals. In the course of this struggle, the characters enter into conflict with others or with external circumstances. The story ends with a decisive victory or defeat, a resolution of the problem and a clear achievement or non-achievement of the goals. (Bordwell, 1989: 18)

Bordwell concludes that the 'principal agency is thus the character, a distinctive individual endowed with an evident, consistent batch of traits, qualities and behaviours' (1989: 18). In short, fiction films centre around, on the one hand, a problematic which requires some form of resolution, and, on the other hand, actions by characters which structure these films' causal logic and progress (Nichols, 1981: 76).

Often narratives promote a liberal-humanist ethos which constructs individual characters as either manipulating a calculative rationality or as at the mercy of a fatal flaw, or both. Such constructions limit the causes behind what people do, the consequences of what they do and the changes they undergo. In reality, of course, what people do and what happens is always and necessarily over-determined by all kinds of factors,

albeit to varying degrees. So narratives have to simplify what goes on or would go on. They do this to be able to imbue individuals' actions or specific events with narrative significance and logic. Thus, it is in both structure and purpose that narratives differ radically from life as we experience it: 'A narrative has a beginning and an ending, a fact that simultaneously distinguishes it from the rest of the world' (Metz, 1974: 17).

If the tele-film appears to make a truth-claim for its content (not its message!) it is, after Nichols (1981), an 'expository genre' – and this is also subject of course to it being 'realistic' rather than 'imagined'. Expositions turn on 'argument or description' (Nichols, 1981: 81), and thus derive from the principle of how certain issues or facts link to others.[7] Expositions cohere insofar as they centre on specific issues or individuals. But, unlike in narratives, this coherence is a logical continuity, in contrast to that which links specific individuals' actions and the times and places of their enactment.

The broad distinction between expositions and narratives has been problematized recently since documentary makers, in doubt as to whether they can portray anybody or anything objectively (cf. Clifford and Marcus, 1986; Marcus and Fisher, 1986), have started to liberally use fictional devices. In other words, factuality has now been acknowledged as being a filmic construction just as is fiction (Nichols, 1991). At the same time, fiction films have started to become more and more 'documentary-like' in the way that they present realistic portrayals of the life of heroin addicts, of the plight of the working class, or of the inhumane practices of the nation's bureaucracy. 'Third (world) films' (Gabriel, 1989; Pines and Willemen, 1989) also often challenge received Western distinctions between narrative and documentary (think, for example, of the Iranian film *The Runner*; Iedema, 1998a).

THE MULTI-FUNCTIONAL NATURE OF MEANING-MAKING

Aside from the six levels discussed above, social semiotics works with yet another tool: the hypothesis that all meaning-making always does three things simultaneously. According to this hypothesis, all meaning-making, whether the images in fiction film or documentary, the music, the actual talk and even the noise–sound track, always performs three overarching functions, or *metafunctions* (Halliday, 1973, 1978). These three metafunctions are 'representation', 'orientation' and 'organization'.[8]

Representation considers meaning insofar as it tells us about the world in some way. Depending on where we stand and who we are, we can say that the documentary we started this chapter with is about a hospital with budget problems, or about the problems doctor managers have in balancing budgets, or about hospital administrators imposing economic rationalism on patient care.

Thus, under the heading representation, we talk about what meanings represent visually, verbally, musically or sound-wise. Accordingly, we can ask what is the subject which the shots portray and what it, he, she or they is/are doing. For example, do we deal with a doctor at work on a patient or an administrator addressing a meeting, or a computer screen showing the inside of a man's heart or a financial spreadsheet?

We can ask related questions about the music track.[9] Is it ethereal church-like music suggesting spirituality and 'higher values' (like during the opening shots of the

hospital documentary), or is it electronic and avant-garde creating associations with technology and science? Is the soundtrack about office noises, such as the shuffling of paper or the creaking of chairs, or is it about ward noises, the squeaking wheels of hospital beds, footsteps echoing through corridors, or the tinkle of surgical tools and the bleeping of heart monitors? And is the verbal or speech track about patients, their suffering and their well-being, or is it about money, budgets and schemes aimed at balancing the books? All these questions address issues of representation.

Second, orientation is to do with how meanings position characters and readers-viewers. The ways in which the administrators are positioned in the hospital documentary are distant, isolated and static. Depending on other aspects of meaning that make up the documentary, this may discourage us from identifying with them and give the impression administrators are cold and calculating. It is in contrast with how the clinicians are positioned: intimate, social and dynamic. They interact with others: they are shown in the same shot with other clinicians and with patients. Their interactions suggest they are social, they do 'real' work and they are concerned and caring.

Specific issues that are important here include the following. Does the camera use a high angle, a low angle, a side-on or oblique angle, or is it positioned behind the subject in question? Do we see people in close up or long shot? Does it move with the subject and in that way construe dynamism, urgency and immediacy, or does it keep its distance and stand steady? All these issues have important consequences for how subjects are positioned (see Chapter 7).

We can also ask what inter-personalizing meanings the soundtrack makes. In van Leeuwen's terms (1999: 28), such questions include the following. What degree of social distance is construed between sound and the listener/viewer? Are we more likely to be impressed by the hustle and bustle of a busy hospital ward, by the swooshing pulsings of a patient's blood rate and by the technical bleeps of a heart monitor, than by the more domesticated noises coming out of the meeting room – the rustle of papers, the squeaking of a felt pen on a whiteboard, the measured speech, the creaking of office chairs, or the rattle of typing on a computer keyboard? The busy noises are more likely to inter-personally appeal to us than the controlled sounds coming from the meeting room.

Third and last, organisation concerns how meanings are sequenced and integrated into dynamic text. The visual editing of the documentary inevitably imposes a peculiar semiotic structure and rhythm: beginning, middle and ending; problem–solution; argument-in-favour, argument-against; and so on. Such sequencings have to do with how meanings are linked together, in what order and in what kinds of rhythmic units. Rhythm and how it interweaves speech, sound, movement, image editing and macro-textual structuring is an important feature of the organization of filmic text. Moreover, the rhythmic cadences of these sequencings have significant consequences for how we 'read' the text (van Leeuwen, 1985; *see also*, van Leeuwen 1986, 1989, 1991, 1996). We will look at this in relation to specific examples in the next section.

The point of asking all these metafunctional questions is that their answers will give us a sense of what kinds of patterns prevail.[10] More importantly, they may give clues about how the various patterns enrich each other. For example, we know that the documentary is about doctors and hospital administrators. We also know that the

orientation of the documentary is to favour the clinicians, with their longer exposures, their more dynamic appearances, and so on. In consonance with this, the textual organization of the documentary is such that each of the administrative–financial sequences (whose orientation is formal and rationalizing) is both preceded and followed by a highly dramatic and inter-personalizing sequence about one of the patients. The point is that these organizational, orientational and representational patterns and choices enhance and reinforce each other. In the case of the hospital documentary, these patterns subtly downplay the significance of the formal administrative and management meetings and highlight that of the patient stories and their hospital experiences.

STRUCTURING THE TELE-FILM: EDITORIAL RHYTHM

Consider the following extract from the documentary (Figure 9.2). The extract represents the first minute or so of the documentary. The numbers under the frames are taken from the video counter, and are meant to give a sense of how long shots are on the screen for.

The extract contains seven shots: the hospital exterior (1a/b); the admissions office on the phone (2); a nurse on the phone on a ward (3); a female patient in bed (4); two nurses walking through a corridor discussing bed issues (5a/b); the female patient again (6), and finally a nurse making a bed (7). As the counter numbers indicate, each of these seven shots lasts around eight digits; that is, they are more or less equal in duration.

Shots 2, 3, 5 and 7 show hospital staff engaged in locating spare beds, not addressing the camera. Shots 4 and 6 involve the patient speaking to us, the viewers, about how desperate the situation is. The shot that follows marks the beginning of the voice-over, announcing that the hospital is over budget. There is thus a rhythmic alternation between the work itself presented through indirect address shots (2, 3, 5, 7) and the comments on the hospital situation through direct address shots (4, 6).

It is in the rhythmic cadences of the text as a whole that speech and sound, movement, music and moving image interweave. In fact, and referring to film, van Leeuwen argues that rhythm is the prime organizer of filmic meaning: 'rhythmic grouping segments the text, at the level of perception, into units which are not only rhythmically but also semantically coherent. Without meaning anything in itself, rhythm is nevertheless a necessary condition for meaning' (1985: 223).

In this view, rhythm is the prime means for creating significances in text:

Figure 9.2 Opening scene of *Hospital: An Unhealthy Business.* **1(a)**

1(b)

2

3

4

5(a)

5(b)

6

7

for [. . .] an element to occur on the beat of the rhythm remains sufficient condition for it to be perceived as more prominent than the other elements in the chain . . . what is rhythmically made to appear prominent will be perceived as more important, more worthy of attention than what is not – regardless of whether it is more important in an objective sense. Thus, by placing a word, a gesture, a sound, a camera movement on a moment rhythmically privileged . . . , the editor can make it salient, draw the viewer's attention to it. (van Leeuwen, 1985: 222)

The argument here draws on speech research, where psycholinguistic experiment has shown that subjects react more to and better remember accented syllables than unaccented ones. On this basis van Leeuwen argues that 'the segmentation of film texts for the purpose of structural analysis should be based on the rhythmic structure of film, rather than on its *découpage* ["segmentation"] into shots' (van Leeuwen, 1985: 223).

The best way to explain how this aspect of the analysis works is by way of a further example. Crucially, the rhythmic alternation described above pervades the rest of the documentary as well. Looking at how the documentary further unfolds, we notice how the editing and cutting construes a kind of 'dialogue' between the two voices in this debate: the imperative of patient care versus the constraints of hospital funding. Table 9.2 sets this alternation out in broad terms. This section of the documentary is structured around Mick's heart operation and the excessive costs of 'stenting' (inserting a metal tube into one of his clogged arteries to open it up again).

The longer extract tabulated in Table 9.2 shows a rhythmic alternation between the two main voices in the debate (marked A and B in the table). The 'patient care' voice (A) centres around Mick's illness and successful heart treatment thanks to stenting. The 'balancing the budget voice' (B) centres around administrative managers telling clinicians they need to cut back the number of stents they use because they are too expensive.

In the introduction to this chapter we commented on the ways in which the documentary as a whole positions the clinicians differently from the administrators. The camera and the editing construct the doctors as actors: they do operations, they wield surgical tools, they install the stents, they cure patients, and so on. The administrators, by contrast, are constructed not as doers but as talkers. Following an almost predictable rhythm, this 'doing–talking' contra-distinction reappears through the documentary. In fact, it *organizes* the documentary.

But, as van Leeuwen says, that which is allowed to occupy or represent the salient rhythmic beats 'will be perceived as more important' (1985: 222). To get a sense of how this doing–talking contrast stacks the case in favour of the clinicians, consider the following extract (row A4 in Table 9.2) from one of the operation scenes (Figure 9.3). In this scene, there is very little talking. When someone does talk, the comments refer to the progress of the operation or to the movements of the inserted device shown on the computer screen. In other words, medical talk relates directly to the 'reality' of the clinical work.

This extract shows that the clinicians (both doctors and nurses) are predominantly actors: that is, they engage most often in doing processes rather than saying processes (as do the administrators). As argued, when they do engage in saying processes,

Table 9.2 The section on 'stenting'.

Step in the argument	Scene	Visuals	Relevant talk
A1	Introduction of the patient: Mick	Mick driving a car delivering mail; Mick entering the hospital	Voice-over: 'To balance the books the hospital must treat more patients. Those who will benefit most of this plan are people sitting on waiting lists, people like Mick, the local post man . . .
B1	Meeting where David Hillis (manager) gets Keith Stockman (clinician) to explain his budget overrun	DH at whiteboard; KS seated; DH and KS never in the same shot	DH: 'We can't afford stenting for the rest of the year'; voice-over: 'Keith Stockman is on the line.'
A2	Operation: doctor speaking to Mick	Mick in bed, doctor and nurse talk to him	'We'll try and make you run on six cylinders.'
B2	KS and DH on their own; KS proposes 25% operation level	KS and DH seated in DH's office sharing desk space	DH: '20% is where I'll try and make it sit for the rest of the financial year'; 'what I'll do is just go bang and stop the lot.'
A3	Female clinician (SG) monologue	Camera follows clinician through corridor	'They're still somebody's mother or father, they're still deserving the respect to be treated.'
B3	Clinician points out cost of stents in cupboard	Clinician pointing at boxes in cupboard	'So there's an awful lot of money in this cupboard, well over a hundred thousand dollars I'd say.'
A4	Operation procedure; doctor arguing that Mick needs stent	Bloody hands manipulating tools, computer screen showing vascular details	
B4	Meeting between KS and administrator who argues that non-stenting is better for the hospital budget; the more often a patient comes back the more treatment units the hospital can mark up	Clinician on the left (Given) listening to administrator on the right (New)	
A5	The operation		'If we leave this now, this man will come back'
B5	DH tells cardiologists that he needs to put a stop on their unit's expenditure	Clinicians gathered in office; DH never in same shot as them	
A6	Operation: Mick speaks from his bed; Mick says goodbye to others in his ward		Doctor: 'You realize you're costing the hospital an arm and a leg here'; nurse says: 'It went very well' [churchy music starts again]

| B6 | doctors are reported to have achieved agreement on 25% operation (rather than DH's 20%) | woman walking through room full of files, picks file, then shown seated in front of computer typing in numbers | Voice-over: 'Calculate his worth': Mick filed away as $6000 cost; 'a numbers game', 'coding patients has become an obsession' |

Table 9.3 Summarizing the analysis.

	Individual frames and shots	Scenes and sequences	Stages and text as a whole
Representation (ideation): what is it about?	A lot of the shots that include doctors also show action or dynamic vectors (arms connecting doctor and patient, etc.); administrators–manager shots tend to lack vectors; doctors are often shown interacting with multiple others (in contrast to administrators)	Doctors enact temporally organized scenes, such as operations or patient consultations; administrators–managers are shown in less logically connected snippets of interaction (sequences)	The doctors enact curing and caring narratives centring around specific people, while the administrators enact financial management narratives centring around 'abstract ideas' and numbers
Orientation (interpersonality): how does it enact the social?	Doctors are often shown closer up, in more colourful and socially significant surroundings than the administrators–managers (who are often portrayed using a low camera angle, with relative distance, and lacking the colour and social intimacy of the doctor-centred interactions	Doctors show their sense of social responsibility by curing patients or facilitating their death; administrators–managers enact a thematic consistency (meeting financial deadlines) but are not implicated in social relations beyond their official administrative role	The doctors are positioned as those who deal with and face what is real – life and death – and they thereby monopolize a host of inter-personalizing resources. The administrators are positioned as those who deal with what is imaginary and 'unreal'– finances, mobilizing control ('mustness', see Iedema, 1998b)
Organisation (textuality): how is it put together as semiotic construct?	Initially administrators–managers are positioned as given (left of screen) and doctors as New (right of screen); once into the documentary this pattern reverses, positioning the doctor consistently as Given	While the doctors engage in long scenes (which temporally unfold) the administrators engage in short sequences (which have no temporal but a thematic logic). Doctor scenes are constructed on the basis of less abstract ('closer-to-home') thematics (time), while administrator sequences are constructed on the basis of a conceptual thematics (finances, overruns, etc.)	The doctor-centred segments punctuate the administrator-centred ones in such a way to suggest (but not state explicitly!) that, whatever cost-overruns they incur, they have 'bloody' good reasons. This implicit argument structure favours the doctors' view: 'don't bother me with your bean-counting problems'

Figure 9.3 An operation scene.

these tend to be linked to what is going on with the patient or on the computer screen, showing the progress of the operation on the artery. The doctors' sayings, therefore, are shown to be grounded in the reality of the patient's body, a reality enhanced by both the blood on the doctors' gloves and the pulsing arteries on the computer screen.

In scenes where the clinicians interact with the administrators, the camera stops tracking people and becomes static. Its shots separate people out rather than showing them working together. The contexts now are silent boardrooms and offices dominated by the lifeless white of the walls, the furniture and people's shirts. Finally, the reality around which everything centres is the computer screen with its rattling sums and totals. Here, reality is not the pulsing heart of a sick patient, or the urgency or medical care, but the mean and spurious logic of accountancy and economic rationalism.

We could delve further into the details of image and sound and 'prove' that what we've exemplified so far is valid for the rest of the documentary. But social semiotic analysis is an interpretative exercise, and not a search for 'scientific proof'. Its purpose is to describe how texts construct 'realities', and to argue the sociohistorical nature of their assumptions and claims (see Chapters 4 and 7). So rather than search for further proof, we should think about how the filmic mode has been exploited to

5

6

7

8

9

10

11

12

serve specific interests. In this specific case, documentary film making has served the interests of a professional minority; medical clinicians.

Table 9.3 summarizes the things I have said about levels of filmic analysis and about their metafunctional aspects.

LIMITATIONS OF SOCIAL SEMIOTIC ANALYSIS

Social semiotics does not accept the claim that 'how something is said/shown/done only relates arbitrarily to what is said/shown/done'. For that reason, the analysis presented above placed the representation of the health debate (the 'what') in direct relation with its filmic realization (the 'how'). The analysis showed that the arguments put forward by the documentary were significantly 'helped along' by how they were realized.

But there are distinct drawbacks to this form of analysis. First, the analysis presented above was laborious (see Chapter 3). It takes a lot of time and concentration to do transcripts of television or film material. Second, the analysis can become quite technical: we were working with six levels of analysis as well as with three metafunctions. Third, while the analysis, though complex, may seem straightforward or even mechanical, there is a strong interpretative component at work. This is especially the case when the formal features of the material have been identified, and they then need to be made sense of.

An interpretative principle I applied without being explicit about it is that of 'redundancy' (Bateson, 1973; Lemke, 1995). This principle helped me determine how patterns 'reinforced' one another. For example, there is a commonality among the following features in the documentary: clinicians appear in groups; clinicians do operations on patients; and clinicians refer to pulsing arteries on a computer screen. Each of these features contributes to clinicians' claim to relevance and importance, emphasizing: their social relevance, their clinical relevance and their scientific relevance. We could equally list the features which create redundancies in the case of the managers and administrators: their white shirts, their concern with talk over action, their filmic isolation, to name but three.

A fourth limitation is that social semiotics is primarily concerned with and is explicit about 'textual' structures and not with categories of viewers and their readings of the texts. While emerging kinds of Web design make the distinction between text and reading tenuous (because viewers construct their own 'hypertext' (Snyder, 1996, 1998)), traditional tele-films (much like books) make it still possible to do a hypothetically 'ideal' reading (Kress, 1985), and to analyse the text in its linear entirety. Actual reading practices, of course, rarely conform to such idealized analytical readings (McHoul, 1991) (see Chapter 4).

The claim social semiotics would make, however, is that the kind of analytical reading presented above gives us a means to understand and manipulate what might otherwise remain at the level of vague suspicion and intuitive response. It also claims that the ability to systematically analyse texts, whether literature (Hasan, 1985), diagrams, maps (Kress and van Leeuwen, 1996), paintings, sculpture, architecture (O'Toole,

1994), or even children's bedroom arrangements and toy design (van Leeuwen, 1998), provides the possibility for renegotiating the meanings inherent in such constructs, rather than seeing these as fixed, irrevocable and natural.

A final limitation of social semiotic analysis is that it reads the tele-film text irrespective of the specific individuals who were involved in its creation. This is not necessarily and always the case (Butt, 1998), but the analysis presented above makes no reference to the social circumstances of the documentary's making: the conflicts and constraints the film-makers may have experienced while filming, the pressures exerted on them by specific stakeholders, or the technical and practical circumstances surrounding its making. Some of these details could shed light on specific camera, script or sound choices in the text and could well inspire different or richer interpretations.

Having pointed to the shortcomings of this kind of analysis, I would also want to point out why I think the analysis is powerful and important. Social semiotics does not accept that texts are made 'by accident': each aspect of tele-film contributes to its meaning potential in a meaningful way. Also, it helps us see that the meanings projected by the various semiotics listed above are less 'natural' and self-evident than they might seem judging from the way their materialities blend in with the other materialities and meanings of everyday life. Social semiotics, in other words, declares anything humans use to exchange and communicate as 'fair game'. It sets no boundaries around what is text and what is not, around what can be analysed and what not. In that sense, social semiotics is a means to 'making strange' (Shklovskii in O'Toole and Shukman, 1977), to consciousness-raising and to informed social action (Lemke, 1995; Iedema and Degeling, forthcoming).

CONCLUSION

This chapter has proposed ways of dealing with moving images in television and film. It has claimed that the analysis of micro-aspects can contribute to our understanding of how narratives unfold, or how arguments are put together and reinforced. The tools put forward are twofold. First, there are six levels of analysis: frame, shot, scene, sequence, stage and genre. Second, there are three metafunctions governing meaning: representation, orientation and organization. Less a tool than an interpretative principle, redundancy, or the question as to how patterns amplify one another through likeness, enables us to make inferences about specific camera and editing choices.

With regard to the documentary used for exemplification of this kind of analysis, it was argued that its organization favours the clinicians' point of view in a host of different ways, most of which were touched on above. As documentary, the text exploits resources typical of genres which aim to construe an 'objective view', such as 'the omniscient narrator' (Leahy, 1996: 45) whose commentary stands 'at a remove, above the fray' (Nichols, 1991: 197). Yet, and in tension with this, the programme relies heavily on editing style, camera use and sound editing to differentiate and calibrate the various viewpoints that are at stake.

Importantly, when watching programmes like *Hospital: an Unhealthy Business* we may be critically attuned to what is said, but less so to what is shown or 'sounded'.

If we turn our attention to images or sound, we often have no other resources for dealing with them than intuition and commonsense. But if we cannot deconstruct editorial and camera strategies, or visuals and sounds, a whole universe of meanings escapes critical notice. To mount a penetrating critique of the kind of documentary looked at here, we need, in addition to a critical linguistic literacy, a critical visual–audial literacy enabled by tools such as made available by social semiotics.

NOTES

1 The concepts Given (left side of the image or frame) and New (right side) were adopted by Kress and van Leeuwen (from Halliday's systemic functional grammar – see Halliday, 1994) to distinguish the different values of the opposite sides of visual space (Kress and van Leeuwen, 1990, 1996).

2 To locate this claim within the self-conscious sphere of current film theory, social semiotics 'declares' its theoretical tools, methods and objectives, and aims for politically meaningful findings and arguments. Social semiotics does not exploit theoretical reflexivity to turn analytically vacuous or hedge about its conclusions to such an extent that no one but the most determined can take issue with them (Eco, 1990, 1992).

3 Warhol's *Empire*, an eight-hour film of night engulfing the Empire State Building, is set in 'real' time, and gets us to question our own (naturalized) expectation that film-making will involve diegetic editing ('we only get the important bits').

4 The average shot length of classical Hollywood films was around 9–10 seconds. Frederick Wiseman's *Hospital* documentary averages 32 seconds per shot (Nichols, 1981: 211; also Heath, 1986: fn. 36). Van Leeuwen notes that 'shots generally last between 2 and 40 seconds, although shots as short as an eighth of a second and as long as 10 minutes do occur' (1985: 220–1).

5 Scenes are generally subject to two camera rules. First, the 180-degree rule ensures that 'one will always find the same characters in the same parts of the screen' (Heath, 1986: 395); this is to prevent confusion about who is where in the two-dimensional filmic space. The 30-degree rule prevents 'jumps in space', ensuring a smooth line in from shot to shot (Heath, 1986: 398).

6 For the sake of brevity and simplicity I will not address those experimental–poetic filmic texts which fall outside this classification.

7 Bill Nichols (1991: 32ff.) distinguishes four expository genres: classic 'voice-of-God' commentaries; observations (minimizing the film-maker's presence); interactives (where film-maker and social actors overtly acknowledge one another); and reflexives (where attention is drawn to the form of the work itself).

8 Halliday's original labels are ideational, inter-personal and textual and applied to language only (1994: 135). Lemke proposed the parallel terms used here to talk about semiotics other than language (1989, 1992).

9 Van Leeuwen argues that in the case of music, about-ness or ideation 'rides on the back of' inter-personal meaning, while in visual representation it is the other way around (1999: 154). Hence the perfect complementarity of course between film and music, and their combined force of impact.

10 Bill Nichols, a renowned film theorist, also uses 'metafunctions' to analyse film and television, but talks about them slightly differently: aesthetic (inter-personal), logic (textual) and diegetic (ideational) temporalities. He remarks on the parallel between these 'temporalities' and his three generic categories of film and television: poetic (aesthetic), expository (logic) and narrative (diegetic). Those familiar with Halliday's metafunctions will appreciate the similarities between Halliday's and Nichols's categories.

11 'Balloon' here refers to an alternative but outdated treatment of these kinds of arterial problems.

REFERENCES

Bateson, G. (1973) *Steps to an Ecology of Mind*. New York: Granada.

Bernstein, B. (1990) *The Structure of Pedagogic Discourse: Class, Codes and Control Vol. VI*. London: Routledge.

Bordwell, D. (1989) *Making Meaning: Inference and Rhetoric in the Interpretation of Cinema*. Cambridge, MA: Harvard University Press.

Branigan, E. (1975) 'The space of Equinox Flower', *Screen*, 17 (2): 104.

Butt, D. (1998) 'Developing a map for English studies', keynote address presented at the Australian Systemic Functional Linguistics Association Conference, Adelaide, 28–30 September.

Clifford, J. and Marcus, G. (eds) (1986) *Writing Culture: The Poetics and Politics of Ethnography*. Berkeley: University of California Press.

Eco, U. (1990) *The Limits of Interpretation*. Bloomington/Indianapolis: Indiana University Press.

Eco, U. (1992) *Interpretation and Overinterpretation*, ed. S. Collini. Cambridge: Cambridge University Press.

Gabriel, T. (1989) 'Towards a critical theory of Third World films', in J. Pines and P. Willemen (eds), *Questions of Third Cinema*. London: British Film Institute.

Halliday, M.A.K. (1973) *Explorations in the Functions of Language*. London: Edward Arnold.

Halliday, M.A.K. (1978) *Language as Social Semiotic*. London: Edward Arnold.

Halliday, M.A.K. (1994 [1985]) *An Introduction to Functional Grammar* (2nd edn). London: Edward Arnold.

Hasan, R. (1985) *Linguistics, Language and Verbal Art*. Geelong, Victoria: Deaking University Press.

Heath, S. (1986) 'Narrative space', in P. Rosen (ed.), *Narrative, Apparatus, Ideology: A Film Theory Reader*. New York: Columbia University Press.

Hodge, B. and Kress, G. (1988) *Social Semiotics*. Cambridge: Polity Press.

Iedema, R. (1998a) 'Comparing filmic constructions of conflict: *Bonnie and Clyde* (USA) versus *The Runner* (Iran)', paper given at the 25th International Systemic Functional Congress, Cardiff, 13–18 July.

Iedema, R. (1998b) 'Appraising the health debate in television documentary, or how to objectify bias', paper given at the Sydney International Workshop on Stance, 17–18 December.

Iedema, R. and Degeling, P. (forthcoming) 'Workplace research: putting discourse analysis to work in organisational settings', *Palmer Centre for Clinical Management Research and Organisational Innovation*. University of New South Wales, Sydney, Australia.

Kress, G. (1985) *Linguistic Processes in Socio-cultural Practices*. Victoria: Deakin University Press.

Kress, G. and van Leeuwen, T. (1990) *Reading Images*. Geelong, Victoria: Deakin University Press.

Kress, G. and van Leeuwen, T. (1996) *Reading Images: The Grammar of Visual Design*. London: Routledge.

Leahy, G. (1996) 'Faith, fidelity and openness: rescuing observational documentary', in *Media International Australia*, no. 82, November: 40–7.

Lemke, J. (1989) 'Semantics and social values', *Word*, 40 (1–2), April–August: 37–50.

Lemke, J. (1992) 'Semantics, semiotics and grammatics: an ecosocial view', paper presented at the International Congress of Systematic Functional Linguistics, Sydney: Maquarie University.

Lemke, J. (1995) *Textual Politics: Discourse and Social Dynamics*. London: Taylor & Francis.

Lotman, I. (1977) *Sémiotique et Esthétique du Cinéma* (trans. S. Breuillard), Collection 'Ouvertures'. Paris: Editions Sociales.

McHoul, A. (1991) 'ReadingS', in C. Baker and A. Luke (eds), *Towards a Critical Sociology of Reading Pedagogy: Papers of the XII World Congress on Reading*. Amsterdam: Benjamins.

Marcus, G. and Fisher, M. (1986) *Anthropology as Cultural Critique: An Experimental Moment in the Human Sciences*. Chicago: University of Chicago Press.

Martinec, R. (1997) 'Rhythm in multimodal texts', mimeo. London: The London Institute.

Metz, C. (1974) *Film Language: A Semiotics of the Cinema*. New York: Oxford University Press.

Nichols, B. (1981) *Ideology and the Image*. Bloomington: Indiana University Press.

Nichols, B. (1991) *Representing Reality: Issues and Concepts in Documentary*. Bloomington: Indiana University Press.

O'Toole, M. (1994) *The Language of Displayed Art*. London: Leicester University Press.

O'Toole, M. and Shukman, A. (1977) 'A contextual glossary of formalist critical terminology', in M. O'Toole and A. Shukman (eds), *Russian Poetics in Translation (Volume 4)*. Oxford: Holdan Books.

Oumano, E. (ed.) (1985) *Film Forum: Thirty-Five Top Filmmakers Discuss Their Craft*. New York: St Martin's Press.

Pines, J. and Willemen, P. (1989) Questions of Third Cinema. London: British Film Institute.

Snyder, I. (1996) *Hypertext*. Melbourne: Melbourne University Press.

Snyder, I. (1998) 'Digitial literacies: moving from page to screen', paper given at the University of Sydney Literacy Symposium 'Changing Visual and Verbal Literacies in Classroom Practice K-12', 19 September.

Thibault, P. (1997) *Re-reading Saussure: the Dynamics of Signs in Social Life*. London: Routledge.

van Leeuwen, T. (1985) 'Rhythmic structure of the film text', in Teun van Dijk (ed.), *Discourse and Communication – New Approaches to the Analysis of Mass Media Discourse and Communication*. Berlin: de Gruyter.

van Leeuwen, T. (1986) 'The consumer, the producer and the state: analysis of a television news item', in Elenor A. Grosz, Terry Threadgold, Gunther Kress and Michael Halliday (eds), *Semiotics, Ideology, Language*. Sydney: Pathfinder Press.

van Leeuwen, T. (1989) 'Changed times, changed tunes: music and the ideology of the news', in John Tulloch and Graeme Turner (eds), *Australian Television: Programs, Pleasures and Politics*. Sydney: Allen & Unwin.

van Leeuwen, T. (1991) 'Conjunctive structure in documentary film and television', *Continuum*, 5 (1): 76–114.

van Leeuwen, T. (1996) 'Moving English: the visual language of film', in S. Goodman and D. Graddol (eds), *Redesigning English: New Texts, New Identities*. London: Routledge.

van Leeuwen, T. (1998) 'Multimodality', plenary paper given at the Australian Systemic Functional Linguistics Association Conference, Adelaide, 28–30 September.

van Leeuwen, T. (1999) *Speech, Sound, Music*. London: Macmillan.

Walton, M. (1998) *The Trouble with Medicine: Preserving the Trust Between Patients and Doctors*. Sydney: Allen & Unwin.

Index